THE
CAMCORDER
USER'S
VIDEO
HANDBOOK

THE CAMCORDER USER'S VIDEO HANDBOOK

The Comprehensive Manual to all Aspects of Video Photography and Editing

PETER DAVISON

The Chapter

COMPUTERS IN VIDEO

by Terence Mendoza BSc (Hons)

BCA

LONDON NEW YORK SYDNEY TORONTO

This edition published 1993 by BCA by arrangement with Boxtree Limited

Designed by Design 23
Typeset by SX Composing Ltd, Rayleigh, Essex
Printed and bound in Great Britain by Butler and Tanner Ltd, Frome

CN 5590

Acknowledgments

The author and writer Ivan Watson FACI died, aged 78, in 1989. The thousands of amateur moviemakers worldwide who read his four books and numerous articles in *Moviemaker, Making Better Movies, Video Making* and *Camcorder User* will remember him for his no-nonsense style and inspirational aproach to the whole subject of making worthwhile movies.

Over several years we communicated by letter, phone and tape-recordings. To his memory I dedicate this book for it was through his teaching and encouragement that in 1984 I started to write for moviemaking and video magazine.

Thanks for encouragement and advice must also go to former editor of *Moviemaker* Tony Rose FACI, and fellow *Camcorder User* writer, John Wright FACI, whose active support of the UK's 350 film and video clubs and the Institute of Amateur Cinematographers has benefited thousands of videomakers.

For the book itself, I thank my top award-winning colleague, Terence Mendoza Bsc (Hons) for proofreading the original manuscript and contributing the chapter *Computers in Video*, and Simon Frith who shot many of the photographs.

Finally, thanks to Pauline, my wife and secretary, who did the real work.

CONTENTS

Introduction

This book is written for the amateur video-camera user yet shows how professional results are easily within the amateur's grasp no matter how humble the equipment or budget. It really isn't a matter of having professional equipment: it's a matter of creative thinking and working within the limits of the equipment available at the price you can afford. And many amateurs use their acquired skill to earn good money from filming weddings, parties and making programs for local authorities, arts councils and businesses.

This does, though, imply that the videographer understands the *craft* of movies – how to shoot and edit a properly structured program. And to this end, some descriptions of technicalities and craft techniques are repeated – albeit in a slightly different way – in various chapters. This is done for three reasons: to reinforce their importance, to show how to vary a technique for different circumstances, and to avoid the reader having to break his concentration by referring back to previous chapters.

As you read through this book the words 'movie' and 'program' will be used often. They are used to describe any type or series of moving images whether they be family records or properly scripted and structured productions.

Whether your intention is to make a 'Hollywood' production, family records or sales promos or simply get the maximum satisfaction out of, arguably, the most creative and satisfying hobby, this book contains all the necessary ingredients to put you on the right road.

Panasonic NV-S95B. One of the first with built-in VITC generator. (Photo: *Panasonic UK*)

Which Camcorder

The design of equipment changes year by year. For this reason there is no chapter on how to choose a camcorder which simply lists various camera-trick functions and describes the various formats available. Most of this information can be found by reading the current monthly video magazines of which *What Camcorder* and *Camcorder User* are undoubtedly the leaders in the UK, *Videomaker* and *Camcorder* in the USA, and *VideoCamera* in Australia.

A further point is that choosing a camcorder is often a case of 'horses for courses.' The newcomer to the hobby is not usually aware of his own potential and does not, initially, have the knowledge, skill or creative flair to handle a camcorder with so-called advanced features.

Many, too, start by requiring a camcorder mainly for capturing holiday memories and other family events, using it for 'point-and-shoot' snapshotting in much the same way as the average amateur uses a compact still camera. Their initial purchase, then, is likely to be a camcorder of lightweight compact design with fully automated functions and an in-built microphone.

More experienced users may want to edit holiday material into a properly crafted travelog. They may also want to enter the world of documentaries or fiction dramas, and enter their movies in club, regional and national and international competitions.

For such use, they are more likely to need a model that offers manual controls to override auto functions, sockets for extension microphones and headphones, and possibly have a time-code generator – VITC (Vertical Integrated Time-code) or RCTC (Rewritable Consumer Time-code).

Formats

Whatever the format, camcorders are available to suit these needs. The only thing to bear in mind is that the main distinction between formats is whether they are *high* or *low* band. The popular domestic lo-band for-

Sony CCDV-6000. Hi-8. (Photo: *Sony UK*)

mats in the UK are VHS, VHS-C and Video 8. The hi-band formats are Super VHS (S-VHS), S-VHS-C and Hi-8.

Hi-band camcorders, using special hi-band tape, offer the best picture quality but, to get its superior picture quality on playback, the mains video recorder and television must also be hi-band compatible. Hi-band equipment, though, can also use lo-band format tapes. More about this later.

Nevertheless, since a tape originated in a camcorder using one particular format can be copied onto a mains-deck video-cassette-recorder (VCR) of any other format the choice of which format to go for is not critical except for one thing: all copy-tapes will have a slightly lower picture quality than the original tape. Therefore, since hi-bands start with a much higher quality, they can be copied to a lower grade with far less loss of picture quality. And, when copying hi-band to hi-band the quality loss is negligible – a serious advantage to those who like to edit since editing is a copying process.

Mainly, though, the initial choice of camcorder is likely to depend less on the format and more on its price, style and the features and functions thought desirable at the time by the user. Studying this book will help you decide which format and which type of camcorder will best suit you.

The main point to remember, though, is that a camcorder is no more than a tool which, despite its automation and wondrous features, is merely a dumb non-thinking instrument that, by itself, cannot render any kind of creative judgment. Only a human operator can make decisions about *how* a movie is to be made.

JVC GR-S707. One of the first with full auto/manual control. (Photo: *JVC UK*)

1

HOW VIDEO WORKS

Making pictures for television;

The illusion of movement;

Connections;

Monitors;

Picture quality;

Video-cassette recorders (VCRs);

Editing VCRs;

How camcorders put pictures on tape:

Gain controls;

Audio age;

Electronic noise;

White-balance and light:

White-balance;

White-balance controls

▲

▲

The world of video is littered with technical terms and phrases – a kind of techno-gobbledygook that often confuses and irritates someone new to the hobby. Sometimes these terms are only of concern to the video design engineer or the video repairer. At other times perfectly good plain English seems to have been replaced by some nameless boffin's desire to seem superior. Why, for example, talk about 'luminance' when the word 'brightness' is more easily understood?

In many instances, though, a new word has to be found to describe a function that is the product of new technology and invention. Once upon a time, even the word 'video' was new and not in everyday use until the mid-eighties. But new inventions and new technological discoveries are pursued restlessly so just keeping abreast of this new vocabulary is almost a full-time job in itself. Small wonder, then, that newcomers feel confused.

The readers of this book need not be daunted by such technical terms since each one is thoroughly explained and only used where plain English alone would either involve using many, many words or create ambiguity.

The point to be made, though, is that since a new function has to be given a name of some sort it might as well be the correct one no matter how strange it looks or sounds.

A/V sockets on rear of Mitsubishi TV. (Photo: *Mitsubishi UK*)

Making pictures for television

Because the end result of using a camcorder ends up on TV it's necessary to know a little about how it's done. And also how broadcast material is slightly different.

For broadcasting, there has to be a TV station transmitting its product over the air. Quite literally, all the pictures are converted into electronic dots (pixels) and, together with a synchronizing signal, are turned into radio frequencies (RF) which travel through the air or bounce off a satellite to be picked up by the TV's antenna (aerial) then into the TV – a receiver. Other methods of transmission are also available – the RF may travel through cable as it does when it comes from the VCR's RF output socket.

As several TV stations are transmitting simultaneously, the TV's tuner (channel buttons) selects those indicated by the chosen channel button and passes them onto other parts of the set that deal with blending the RGB signals (three colors: red, green and blue), the luminance (brightness) and the audio (sound).

It seems remarkable that just three colors, mixed in the right proportions, can produce all other colors but there's also additional decoding circuitry to ensure that they reach the screen as pictures in the correct mix and synchronize with the sound.

The TV builds its picture by turning the pixels into horizontal lines.

Different countries use different systems. For example, 625 lines – known as the PAL system – are used in the UK, Australia, New Zealand

Euro-scart A/V sockets on Mitsubishi TV.

and most Western European countries except France. America and Japan use the 525-line NTSC system, and another 625-line system (SECAM) is used in France, Eastern Europe and Russia. Around 50 lines of any system do not make it to the screen as picture information; they are reserved for engineering and transmission purposes.

Even then, the process of transmitting these lines dilutes or degrades the quality of the picture until a typical domestic TV may be said to resolve no more than approximately 380 lines (see below).

JVC C-S2191 T. (Photo: *JVC UK.*)

The illusion of movement

Moving pictures are, in reality, a series of individual pictures (frames) being shown in quick succession. Each PAL picture is on screen for 1/25th of a second, and NTSC for 1/30th. To prevent flickering, each individual picture is 'scanned' twice by the TV; once for the 'field' containing the odd-numbered lines and once again for the even-numbered field. Each PAL field scan takes 1/50th of a second (1/60th NTSC). For most practical purpose it is only necessary, at this stage, to remember this: to create the illusion of movement a TV displays a series of still frames in quick succession.

Connections

TVs have now become home entertainment centres. Nicam and other forms of digital stereo sound require additional circuitry, and output sockets are provided for connecting loudspeakers and hi-fi systems.

A/V (audio/video) sockets are also provided and most European models are fitted with a 21-pin Scart socket which turns the TV into a monitor so that one or two VCRs or a computer can be connected.

Finally, although hi-band equipment can operate by connecting it to the TV's RF (aerial) socket and the quality will be better than lo-band, it will not be as good as when connected to an S-terminal. This is because hi-band keeps the chrominance (color) and luminance (brightness) signals separated until the last possible moment thus preventing RF conversion and reconversion from diluting the purity of the signal.

Monitors

Although a professional video monitor looks like a TV it may not have a tuner section since its only function is to display video signals from a VCR or camera. This means the picture is purer since it does not have to be converted into radio frequencies first then reconverted for display.

Tuner-monitors also exist which offer the best of both worlds; the tuner operates through one set of circuits that can be by-passed when the equipment is used solely as a video monitor.

A camcorder's viewfinder –

Horizontal Resolution test chart showing 250 lines resolved for VHS format. (Photo: *Panasonic UK*)

whether color or black and white – is also a monitor but it will also accept information from circuitry to show such things as aperture in use, low light, battery state and when various trick modes are being used.

Picture quality

When we talk about picture quality we are really discussing a picture's color, contrast, brightness and sharpness. But most of all we see quality pictures as being those which show the greatest amount of detail. If, for

Test chart for S-VHS showing the greater detail of 400 lines resolved.

This top-end Panasonic S-VHS/VHS edit VCR accepts "C" format cassettes without needing an adaptor.

example, we take a camcorder and video a picture made up of several hundred black and white side-by-side vertical stripes – each stripe from left to right getting thinner and closer to its neighbour – on replay we will be able to count the number of stripes faithfully reproduced (resolved) by the horizontal scanning lines and note the point where the stripes appear to merge or become blurred.

This is the principle of the system for measuring picture quality. A standard vertical-line test card has been produced from which all comparisons of various makes and models can be made. So despite the fact that it contains *vertical* lines, it is known as the Horizontal Resolution Test Card.

Therefore a camcorder or VCR that reproduces the highest number of lines of horizontal resolution produces the best picture quality. Thus, on average, lo-band equipment may resolve no more than 240 lines while hi-band resolves 400 plus.

Video-cassette-recorders (VCRs)

The domestic VCR must, in a sense, be all things to all men. To start with the RF antenna cable is plugged into it and a further RF cable comes out of it and plugs into the TV. It therefore has to have a tuner to decode the channel being recorded while allowing that channel and the others to pass to the TV's tuner. It also requires auxiliary or camera input sockets for directly connecting another VCR or other A/V (audio/video) equipment that may not have to pass through an RF decoder.

Again, various formats are available and a hi-band VCR will do more justice to hi-band tapes recorded in a hi-band camcorder while still being able to record and replay lo-band ones.

Editing VCRs

While all models are capable of copying tapes direct from the camcorder allowing an elementary form of editing, serious enthusiasts will allow special editing features to dominate their choice. For example, a jog-shuttle dial for shuttling pictures backwards and forwards at variable speeds until close to the edit-point then jogging it either way a frame at a time, is essential for locating the point with precision. And an insert-edit facility will allow a shot to replace the one underneath with or without affecting the original shot's sound.

Good editors will also want to add music, mix new sounds and post-dub soundtracks so an audio-dubbing capability is also essential. And most importantly, the editor will want to link his camcorder and VCR (and possibly a second VCR) with a synchronizing cable or edit-controller so that automatic frame-accurate editing is possible. All this is dealt with in detail in separate chapters.

How camcorders put pictures on tape

The word 'camcorder' is derived from two other words – 'camera' and 'recorder'. In a sense, it is a camera with a VCR bolted on. The VCR section, though, only records pictures from the camera although, if it has a line-input facility, it can also record from an auxiliary source such as another

VCR. It does not, then, need a tuner.

All camcorders contain electronic circuits which convert light (video picture) and sound (audio) energy into tiny voltages of electrical current (signals) which in turn are converted into electro-magnetic energy by devices known as recording heads.

When these heads are switched to 'record' they 'write' magnetized tracks onto the video-tape. And when

Note the jog-shuttle dial is duplicated on the remote-control. (Photo: *Panasonic UK*)

they are switched to 'playback' they read the recorded tracks and re-convert them to pictures and sound.

The tape itself is made from very thin polyester which is coated with a paste made from mixing adhesive with finely powdered particles of metal oxide. While in operation the slightly angled video-picture heads spin and, since the tape is also moving, this results in the signals being written diagonally along the centre of the tape – a process known as helical scanning. A camcorder's FM hi-fi audio signals are also recorded via the same method and therefore

both sets of signals are multiplexed (mixed together) and run down the centre of the tape.

A disadvantage of mixing sound and video signals in such a way is that sound cannot be separated for post-production mixing and audio-dubbing, but other methods are available and are covered in the chapters on editing and soundtracking.

Camcorders using the various VHS formats are also capable of recording normal quality sound parallel to, and along, the edges of the tape. These linear tracks can either be recorded while shooting the

pictures or recorded later (post-dubbed) and are a great boon for sound editing.

However, the best quality sound offering the greatest editing flexibility comes from camcorders offering FM hi-fi and linear edge tracks, or FM plus PCM (Pulse Code Modulation) – which gives a hi-fi quality similar to CD (Compact Disc).

We might summarize a description of tape by comparing it to a road which has a pavement/sidewalk on each side. The video and FM signals travel down the centre, and linear sound travels on one pavement/sidewalk for mono sound, or on both pavements/sidewalks for stereo.

Whatever the system, the better the tape's quality the better it accepts the picture and sound signals.

Gain controls

The strength (voltage) of these signals must be controlled since too much may 'burn' out or damage the electronics and too little results in no picture or sound.

The controlling signal amplifiers are called 'gain' controls and may be thought of as being like water pumps; when an incoming signal's strength falls below a precalibrated setting the amplifier pumps up the signal to compensate. If, then, the incoming signal is amplified to five times its original strength the gain is said to be five times.

Most camcorders are fitted with automatic gain controls (agc) which pump up or down to ensure a signal stays within the precalibrated limits.

The video signal agc, for example, starts pumping when the light coming through the lens is so low that it produces a signal too weak to form a watchable picture.

Interior of a Canon camcorder.
(Photo: *Canon UK*)

Audio agc

The sound (audio) signal generated by the microphone may also be controlled by an agc (automatic gain control). If the sound is too loud the recording amplifier in the camcorder might be overloaded which can either distort the sound or damage the amplifier, in much the same way you get distortion in a Walkman. There is, then, a preset signal level at which the camcorder records the optimum level of loudness and sound quality. When the tape and amplifier have reached this maximum level without going into distortion the sound level is said to be at full modulation.

Minolta Autofocus lens system.
(Courtesy: *Minolta UK*)

❶ 6X power zoom lens
❷ Zoom encoder
❸ Zoom/focus buttons
❹ Electronic viewfinder
❺ AF CPU
❻ Zoom motor
❼ AF motor
❽ AF module
❾ CCD image sensor
❿ AF interface IC
⓫ Drive circuitry
 for AF/Zoom motors

VLW 501
Super wide-angle
to standard zoom
4.5 to 12mm

VLW 500
Fixed wide-angle
5.85mm

VLT 500
Telephoto zoom
45 to 81mm

VLT 501
Super telephoto zoom
72 to 108mm

Electronic noise

All electronic circuits and components generate inbuilt 'noise' caused by spurious and randomly produced signals created each time an electrical current passes through them. Noise does not necessarily mean an audible sound since it can also be in the form of a visual interference creating an impure picture.

In the above example of the 10-lux picture, the noise would manifest itself as specks of gray grainy dots or intermittent tiny gray lines and dashes.

Audio agc suffers similar problems; when the camcorder is switched on the audio agc searches for a sound and starts pumping. If the sound is too loud the pump down is virtually immediate but if it's too low the pump up takes several seconds.

If the sound is very low, say, a clock ticking, we again get the problem of the agc also pumping up the inherent noise of the electronics which, this time, manifests itself as a sound – a mushy hiss, hum or crackle.

Agc, like all automatic controls, is a mixed blessing. There will be times, for instance, when you want that clock to remain quiet – not be pumped up until it sounds unnaturally loud. Only manual control can set a sound level that, once set, remains constant.

Using manual control and overcoming audio agc problems is dealt with in the chapters on microphones and soundtracking.

White-balance and light

Light intensity is measured in units called 'lux' (luminous flux) – one lux equals one lumen per square meter. It's easier to grasp this if we remember the older measure of *foot-candles*: one foot-candle is the amount of light emitted by one candle falling on a surface one foot away. And one foot-candle equals 10.76 lux. In theory, then, a camcorder with a lux rating of 10 lux or more should provide a watchable picture of a face lit by a candle from one foot away.

In practise this would be a very poor image – poor definition, virtually no contrast, and muddy colors because the video agc would be pumping flat out. And, as well as amplifying the wanted video signals that produce the picture, it also amplifies unwanted signals known as 'noise' which further degrade it.

Such low lux figures, then, should be accepted with a 'pinch of salt.' Good picture quality requires lots of light – a minimum of 1,000 lux. To illustrate this the following examples should suffice: an average lounge lit by a 150-watt bulb would be around 300 lux; a cloudy day outdoors will average 10,000 lux; and bright summer sun around 35,000 lux.

White-balance

Many people are under the impression that light is colorless. In fact, all light – whether it's natural daylight or artificial – is colored. Sunrise and sunset contain hues of yellow and orange whereas the daylight between these times is blue. The color of light is known as its *temperature* and it's measured in Kelvins (Ks), sometimes mistakenly called *degrees* Kelvin. For example, the color temperature of special video or photographic lights is nominally 3,200K while average natural daylight in Europe is 'hotter' – around 5,000K. The higher the figure the bluer the light. In theory, it could even be so high as to turn white hot. But this is only theory.

To human eyes this makes little difference. No matter what color the light is – and therefore what color cast it puts on anything we happen to be looking at – we know the difference between, say, a piece of pure white paper and a piece that is off-white. Video cameras, unlike eyes, need a little help; the camera needs to be told the color temperature of the ambient light before it can produce pictures with colors that look normal – a process known as setting the white-balance. On early models, and those with manual control, this is done by pointing the lens at a white card or fitting a translucent white lens cap then pressing a white-balance button. The theory is that once the camera is told to recognize white all other colors should be correct.

White-balance controls

Today, most cameras have an automatic white-balance (AWB) function which continuously balances white under any lighting conditions. Eighty per cent of the time this may be satisfactory. But if you want a scene, such as a sunset, to show its natural orange cast you will need a camera with white-balance presets – switches or buttons that lock the system to a particular color temperature. Normally a camera has at least two: one for presetting, or locking, to artificial light at 3,200K and one for daylight at 5,600K. If then, the daylight preset is used the sunset scene will retain its orange cast. On 'auto' it will be rendered castless – as if the sunset didn't exist.

There's a further point to consider. Some cameras have through the lens (TTL) white-balance sensors whereas others have external ones.

The TTL ones have the advantage that they 'read' only what is in the frame. Their disadvantage is that unless they are overridden by a preset they can be over-influenced by large areas of one color – filling the frame with something completely red, for instance, creates a blue cast. Similarly, unless a preset is used to lock the white-balance, colored filters will not produce their true colored effects.

This doesn't happen with external sensors since they measure the overall color temperature of the light falling on the camera. But this can also have disadvantages. If, for example, the camera, set on 'auto', is in the middle of a room lit by artificial light but shooting a daylight scene through a window, the daylight will have an orange cast. The answer in this circumstance is to use the daylight preset button.

Fluorescent tubes can present a greenish caste that is not catered for by the usual artificial light preset. Some camcorders do have a preset specifically designed for fluorescent lights while others have to rely, hopefully, on AWB.

Get to know your camera's system and take into account its limitations. It'll be to your advantage to do so.

2

BATTERIES AND CHARGERS

Although most camcorders can operate from mains (AC) electricity it can only be done using a special adaptor – a transformer which reduces the mains AC voltage to the DC voltage required by the camcorder. Most adaptors double as a battery charger but cannot run the camcorder and charge the battery at the same time.

The battery supplied with most camcorders is usually of the rechargeable nickel cadmium (NiCad) variety and since it supplies the power to drive autofocus, zooming, rewind, replay and a host of other functions, the demands made upon it are considerable. Only rarely, then, will one battery supply enough power for more than 20 minutes of filming so at least one extra battery should be purchased.

Camcorder nickel-cadmium (Nicad) rechargeable batteries.

For filming over long periods, where access to the mains is difficult, a battery belt containing several interconnected battery cells is far better than buying two or more extra single batteries. And, it will supply several hours of running time on one charge.

Batteries contain metals which react with chemicals so their efficiency is affected by temperature. Outdoors, on a freezing winter day, the battery is likely to run out of 'juice' twice as fast as in summer.

Charging is likewise affected: batteries should always be charged at room temperature.

Do not attempt to recharge NiCads until they are completely discharged. If they are only partially discharged, the battery 'remembers' this point and later, it may not deliver its true capacity.

Finally, check the mains voltage is compatible with that of your charger. In the UK this is between 220–240 volts. The voltage in the USA is 110 volts so if your charger is not switchable to this voltage you will not be able to charge the batteries there unless you have a step-down transformer. Similarly, 110 volt users may need a step-up transformer when travelling to 240 volt countries.

Plugs and connectors can also vary; continental plugs are invariably of a 2-pin variety so an adaptor may be necessary.

DSM rechargeable battery belt.

3

LENSES, FOCUS AND EXPOSURE

Focal length and zoom;

The compression effect;

Camera shake;

Exposure:

Shutter speed;

Autoexposure;

Incident light;

Fluctuations and hunting;

Manual controls;

The gray card system;

Contrast;

Backlight;

Neutral density filter;

Fast shutter speeds

This chapter must overlap descriptions of lenses, focus and exposure since all three are interlinked in producing good images – the photographic heart of making movies.

I appreciate that not all camcorders have all the facilities I have described and not all functions will work in exactly the same way. Nevertheless, the same general principles will apply. If you are a comparative newcomer to video or photography, read this chapter through with a view to practising one or two aspects at a time then return to it as a reference guide when you become more experienced.

Describing how lenses work can involve many technical terms: 'circle of confusion, focal lengths, focal plane, depth of field, depth of focus, apertures, iris, f-stops, back focus, curvature field, diopters' and so on. To the non-technical, many of these terms are purely academic; they are not interested in *how* a lens works, they simply want to know how to *use* it.

Patience, then, is required because a good understanding of how such functions work is the key to making them work for you; from being a snapshotter to becoming a creative cameraman.

I shall start by stating the obvious – the function of the lens is to reduce a real-size three-dimensional scene to a two-dimensional image that fits the frame of the tape format. It does this by refracting (bending) the rays of light (light travels in straight lines) inwards thereby squeezing the image and producing much the same effect as looking through a pair of binoculars from the wrong end. This miniaturized image is focused on a charge-coupled-device (CCD) – an electronic chip which converts the light rays into tiny electrical voltages which 'write' an electro-magnetic signal of the image onto the video tape.

Focal length and zoom

The distance between the CCD and the optical centre of the lens is known as the *focal length* and it is measured in millimeters (mm). Using lenses with different focal lengths changes the size of the image – the longer the focal length the larger the image. A way of grasping this is to imagine a torch/flashlight being shone on a wall. At close range the circle of light is very small but as the torch/flashlight is moved farther back the circle gets bigger.

This is the principle upon which the zoom lens works – except that it is not merely one lens. It is made up of several lenses – known as elements – which work in combination; as the zoom is moved some elements also move to maintain focus while others remain static. A zoom lens, then, can vary the focal length in a smooth and continuous manner from 'wide-angle' – used to describe its shortest focal length – to 'telephoto' (telescopic) which describes its longest.

The term 'wide-angle' can be misleading since it implies that the lens has a shorter focal length and wider angle of view than standard. The term 'standard' means the focal length at which the image gives the same view of relative positions, distance and magnitude as the normal perspective of human eyesight. In fact, the wide-angle end of most camcorder zoom lenses is exactly the same as standard so should not really be described as wide-angle. We are, however, stuck with it.

The measurement of this standard focal length depends also on the size of the CCD imaging chip. For a ⅔rd-inch chip the standard length is 12mm whereas for a ½-inch chip it is 9mm. Your camcorder's instruction book should tell you it's size.

Some zooms may have a shorter focal length and therefore a wider angle of view than standard but the average camcorder's (½-inch chip) range of focal lengths is 9mm–54mm. And for a ⅔rd-inch chip the range is 12mm–72mm.

These figures are usually inscribed on the lens barrel. If the largest figure is divided by the smallest the result is the lens's magnifying power (zoom ratio). For example, 54mm ÷ 9mm gives a ratio of 6:1 which is often referred to as a 6 × zoom lens. In other words the standard/wide-angle image size – when set to telephoto – is magnified by a factor of six. Other camcorders may have a much larger range – 8x, 10x and 12x etc.

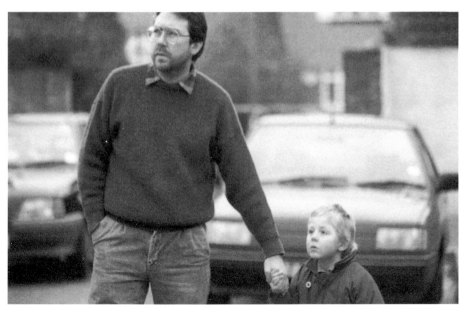

As the focal length increases (zooms-in) the image gets larger but appears to be "squashed" closer to the background.

The compression effect

Increasing the focal length towards the telephoto end of the zoom also narrows its angle or field of view and changes the perceived perspective. For example, the 'standard' horizontal angle of view is approximately 40 degrees. At 6x zoom the angle narrows to less than 7 degrees. At 10x it reduces to 4 degrees – the standard angle divided by the zoom factor.

This narrowing of angle drastically alters the perceived perspective; distances between objects will appear squashed or compressed. The longer the focal length the greater the 'squash' effect.

To illustrate this, imagine the shot of a long road upon which a distant runner, running quite fast towards us, is followed by a car some distance behind him. At the wide-angle end of the zoom the runner appears quite small and because the perspective is approximately the same as that of human eyesight we are able to see that the car is rather a long way behind. Then we zoom in to the longest telephoto setting and although the runner is greatly magnified he appears to be running much slower – hardly making any progress at all – and the following car appears to be almost on top of him.

This compression effect can be used deliberately where, say, you want to create the impression that objects such as crowds of people or moving traffic are much closer together than they really are. Portraits too are often filmed using long focal lengths since the squashed perspective minimizes protruding noses and presents a more flattering image.

Camera shake

There is, however, one major problem with magnifications of more than 2x that is rarely desirable: it is almost impossible to shoot a rock-steady shot when the camcorder is hand-held because of camera shake, and also any tiny movement of the camcorder is magnified. If such shots are attempted they are best made

with the camcorder mounted on a tripod. Hand-held shots are smoother and less prone to shake and wobble if made at the wide-angle end.

To sum up: wide-angle-end focal lengths produce 'normal' images. The greater the focal length the more it enlarges the image size, compresses perspective, perceived distance and speed – the overall picture is flatter and less three-dimensional. The greater the magnification the greater the amplification of camera shake.

Exposure

To make a perfect picture in terms of light, contrast and color, the amount of light entering the lens has to be controlled. Too much and the picture will be *overexposed*. The colors will appear bleached or wishy-washy and may even wash out to white. Too little and the picture is *underexposed* – the picture and colors are too dark. In other words, correct exposure only happens when the CCD has been exposed to just the right amount of light – no more and no less.

The light-controlling devices are the shutter speeds and the aperture. The aperture may be thought of as being like a round hole in a light-proof diaphragm behind the lens. The hole is capable of being made smaller or larger by closing or opening its iris. It works in much the same way as the iris in a human eye; in order to restrict bright light the aperture has to be made smaller and if the light is too low it has to be opened wider to let more in. And completely closing it blocks out all light resulting in no image at all – just a black picture. Camcorders fitted with manual iris or fade buttons use the principle of gradually closing the iris to fade the picture to black – a fade-out. And gradually opening the iris from its closed position produces a fade-in.

Note, though, that some fade controls work the other way round and fade the picture to white.

The size of the aperture (hole) is measured in numbers called f-stops: f/1.0, f/1.4, f/2, f/2.8, f/4, f/5.6, f/8, f/11, f/16, f/22, f/32, f/64. And contrary to normal sizing logic the larger the

f-number the smaller the aperture. Domestic camcorders will not have such a complete range. The largest aperture is likely to be f/1.4 and the smallest f/16.

A stop-size is related to its area, not its diameter, and each time an aperture is made smaller by one f/stop the amount of light is halved. If the size of the aperture is widened by one f-stop the amount of light is doubled.

Most systems also employ a range of f-numbers that allow an aperture to be increased or decreased by fractions of a stop while others may be limited to adjustments of half a stop. These ½-stops are not always shown on camcorders but their f-numbers are: f/1.2, f/1.6, f/2.7, f/3.2, f/4.5, f/6.3, f/9, f/12.5, f/18.

Shutter speed

The term 'shutter' is inherited from film photography where it describes a mechanical device – similar to a sliding door – behind the aperture which opens for a split second to let light through then drops back to block it out. The speed at which it

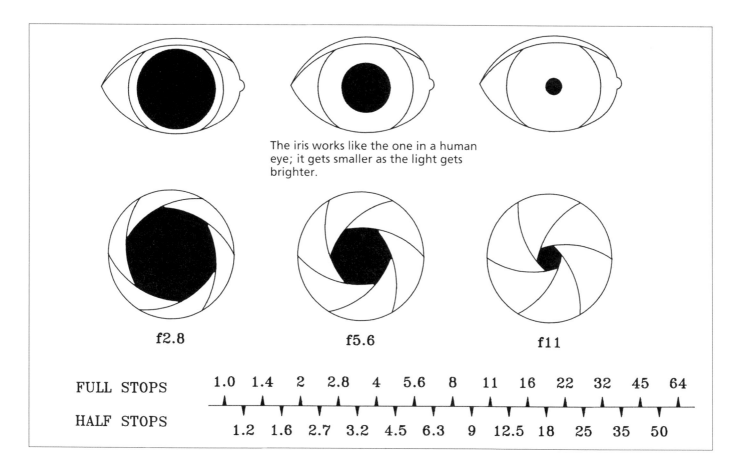

The iris works like the one in a human eye; it gets smaller as the light gets brighter.

f2.8 f5.6 f11

FULL STOPS	1.0	1.4	2	2.8	4	5.6	8	11	16	22	32	45	64
HALF STOPS		1.2	1.6	2.7	3.2	4.5	6.3	9	12.5	18	25	35	50

does this is referred to as the shutter speed. Camcorders don't have mechanical shutters but they achieve the effect electronically and a variety of shutter speeds can be set from the standard speed of 1/50th (1/ 60th NTSC) of a second to – in some cases – 1,000th or even faster.

In theory, then, the correct exposure is set by selecting the correct combination of f-stop and shutter speed – a procedure that is readily accepted and understood by 35mm SLR stills photographers. We might say that on an European gray day the average outdoor exposure is f/5.6 at 1/50th of a second (PAL), (1/60th NTSC) while in sunlight it would be f/8 – or possibly f/11. If, though, we select a shutter speed twice as fast we would be halving the amount of light reaching the chip so the aperture must be opened one stop wider to compensate. And when using a shutter speed of 1/1,000th the aperture must be opened four-and-a-quarter f-stops wider than when using 1/50th.

Autoexposure

In practise these calculations are not so difficult since all camcorders have an in-built automatic system – an electronic means of measuring or metering the light coming through the lens and working out and setting the exposure. Usually, at switch-on, the camcorder selects the standard shutter speed, measures the light being reflected from the scene and automatically adjusts the aperture size accordingly. If we then choose to manually increase the shutter speed the aperture automatically changes to match.

The f-stop employed on more advanced camcorders is normally displayed somewhere on the camcorder such as in the viewfinder or on an LCD display panel and, as we shall see, this, plus manual control, is vital for the creative user.

The automatic exposure (AE) control is all that's required for most rof the time since its function is designed to cope with average lighting conditions – where the light, coming from behind or one side of the camcorder, shines on a scene containing a mixture of colors and is reflected back into the auto-meter system.

Autoexposure (AE) can be fooled into giving false readings if the lens is pointed closer or directly towards where the light is coming from because the light is not then being *reflected* – it is direct into the lens. Objects between the lens and the source of light are then lit from behind – (backlight). The meter doesn't understand this and, incorrectly thinking the reflected light is extra strong, closes down two or three f-stops too much, creating a very dark picture indeed – the objects will be underexposed into dark silhouettes.

Even where reflected light is being correctly measured the auto system can still be fooled because reflected light is not the same as the actual *incident* light falling on the scene. This is a very important difference that must be grasped if the videographer is to cope with correctly exposing lighting conditions that are not average.

Auto exposure: the camcorder has been fooled into thinking too much light is coming from behind the subject, so the picture is too dark.

Incident light

Outdoors, all light comes from the direction of the sun. The fact that it is sometimes filtered through cloud makes no difference to the direction. The strength of the sun's light reaching a particular point on earth depends upon the line of latitude, the season, the time, and the sun's apparent daily passage from rising to setting.

Without getting bogged down in geography, astronomy and the physics of light it is possible to say that, since the sun is constant light at 93 million miles away, the strength of its light from 10am to 5pm on a cloudless European summer day must also remain constant. This strength can be accurately measured with a light meter known as an *incident* meter. And whether that measurement is taken at the top of the highest mountain or in the deepest valley the reading will be the same since such differences in height have no measurable effect on the strength of sunlight.

If, then, the correct exposure for such conditions at 10am is 1/50th at f/11 it will remain correct until 5pm regardless of whether it is made at

the top of a snowcapped mountain or along a black tarmac road in a valley: the actual strength of the light has not changed so neither must the exposure.

However, camcorders cannot measure incident light – they measure the light that reflects back from a scene or object into the lens. And it's this reflected light process that causes problems because some colors and surfaces reflect more light than others. Black, for instance, reflects very little so the autoexposure system is fooled into believing that the light is too weak and opens up the aperture too wide. This means the black will be overexposed and its screen-color will not be black – it will be a dark shade of gray.

White, on the other hand, reflects nearly all light which fools the autoexposure into believing the light is too strong so it selects a smaller f-stop than it should which darkens (underexposes) the white into a light gray. Therefore, camcorder meter readings taken of sunlit snowscapes

Widening the aperture or pressing the BLC button is the answer.

are not measuring an average scene; they are measuring the light reflected by the white snow so gross underexposure is inevitable. Other areas where underexposure is likely are: sunlit beaches, landscapes of golden corn, sandy deserts and where the sky – being one giant reflector – forms more than 1/5th of the area of the framed shot or is further reflected by large areas of water.

Fluctuations and hunting

When autoexposure is switched on it works continuously, constantly adjusting the aperture to suit the strength of the reflected light. The problem of exposure fluctuation can arise because objects moving through a scene contain a variety of colors with different reflective qualities – lighter shades of the same colors reflect more light than darker ones. The auto system is therefore forced to 'hunt' for the right exposure for one particular set of circumstances but no sooner has it done this than different circumstances occur and the hunt starts again.

Sometimes these new circumstances call for no more than a minor alteration to the aperture and make

little overall difference to the scene's colors and exposure. Others create such a difference that all the colors in the frame fluctuate; they lighten or darken in an unrealistic manner. To illustrate this a couple of extreme examples should suffice:

(1) We frame an average scene and start shooting. A man in a black shirt passes close to the lens so the aperture opens wider to compensate which turns the black shirt gray. In other parts of the scene, what we originally saw as red goes light pink and what was almost purple changes to pale blue.
(2) As this person passes out of frame the colors change back to normal but then another person – wearing a white shirt – enters. As the aperture stops down, the white shirt turns gray, red turns to dark maroon and the purple becomes almost black.

A fluctuating exposure also occurs when the camcorder itself is moved. When, for instance, panning across scenes of different reflective properties or when the camcorder moves from a bright sunlit shot to a scene that is in deep shadow.

Manual controls

Overcoming all the above visual nasties depends on being able to have a manual means of controlling the aperture settings. The most commonly available control is a small thumb-wheel which can be turned to darken or lighten the image as seen in the viewfinder. Alternatively, a push-button with plus (+) and minus (−) markings does the same job. Therefore, the aperture that closed down a few stops on that snowcapped mountain and created gray snow and a very dark picture in the viewfinder, can be opened up until it gives correct overall brightness.

However, such a control merely sets a limit to the range of f-stops that can be used by the auto system. It does not cancel the auto-function so it continues to hunt and flutter within this new limit.

The best system is one which allows the auto system to set a reading which can be locked – the aperture is not allowed to open or close

any further while in the locked mode. Thus, that disturbing color and brightness fluctuation described above cannot occur because the auto system no longer hunts – it is locked in a fixed position.

It means, though, that the initial reading has to be a correct one and here some experience and practise is required. In simple terms a good reading is one which correctly reproduces the image in such a way that everything in the shot appears in its natural color and degree of brightness. But, owing to the varying reflective properties of colors and substances, merely pointing the lens at any scene indiscriminately isn't necessarily going to produce the correct reading.

As a rule of thumb the following method is very effective:

(1) Set the camcorder at wideangle. This ensures that the scene reflects the greatest mix of colors and light and shadow, and that the light sensor reads the best average of them all.
(2) Turn your back to the direction of the sun in order to avoid direct light entering the lens and fooling the meter.
(3) Frame a scene that contains an average mix of colors and shadow and ensure that the sky occupies no more than the top 1/10th of the frame.
(4) Aperture-lock this reading.

In theory, then, this exposure setting should be close to an incident-light reading and should be correct for any focal length subsequently selected and any shot made while the same lighting conditions exist. This applies even when the camera is panned in a full circle or pointed against the direction of the light. The only exception is where the subject to be videoed is entirely in shadow; opening the aperture half a stop may be all that is necessary to show its details, or take a separate reading for that subject specifically.

The gray card system
There is, however, an even more accurate method. It is based on the principle that one particular shade of gray – which is known as 18 percent

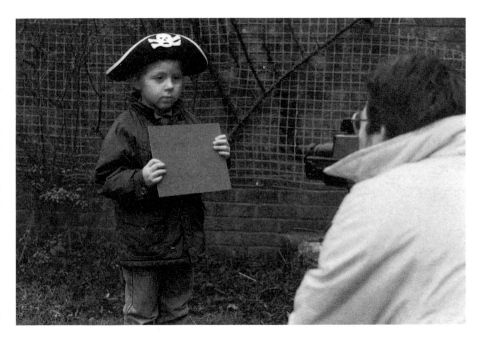

The Kodak 18% gray card.

gray and is similar to a dark battleship gray – reflects a neutral amount of light. And, if a reading is taken and locked at the amount of light it reflects, all other colors will also be correctly exposed.

Kodak, the giant film company, make 10″ × 8″ grey cards for film users and most photographic shops sell them. Outdoors, a reading is made by placing the card to face the source of light then zooming in so that the card fills the frame. The aperture is locked at that setting. It is, then, the closest thing to an incident-light reading. The back of the card is 90 percent pure white, which means it is perfect for providing manual white balance settings.

Contrast
Even when an average scene or gray card reading is taken it is sometimes necessary to make slight adjustments to the aperture where the scene or image framed contains high contrast. Unlike film, which copes with a contrast ratio of 100:1, video can only cope with a ratio of 25:1 so in high-contrast lighting situations, decisions have to be made about what part of a scene should be given priority for correct exposure.

Imagine, for example, a shot in which a man's face is in bright sun-

light while the rest of him is in deep shadow. The chances are his face will record as an overexposed bright highlight – possibly even bleached out. The only general rule here is to expose correctly for the highlights or brightest parts of the image and let the shadows block out to black. This is usually more acceptable than bleached highlights.

If, on the other hand, the detail in the shadow is the priority then zoom into the shadow area, lock the reading then pull back to frame and make the shot.

Backlight
Similarly, if a person is standing with his back to the light (backlit) his face and front will be in shadow. If we want to shoot a perfectly exposed close-up of his face and shoulders, we zoom in to fill the frame with his face, adjust a manual iris override – or lock the aperture – then zoom back to frame the shot.

Without aperture-lock or iris manual override facility, shooting against the light – or in any backlit situation such as an interior scene where the backlight is a window – will always produce severe underexposure of the subject standing in front of that window or light source. Some auto-only camcorders try to overcome this by fitting a BLC (backlight compensation) button. Its effect is to open the aperture by one or two

For all normal videography, where the object of the exercise is to show images moving in a natural manner, the standard shutter speed of 1/50th (1/60th NTSC) of a second is considered to be the one to use because faster shutter speeds can produce some abnormal effects. This fact often confuses the newcomer who has SLR stills photography experience – he is inclined to believe that fast shutter speeds create sharper pictures. In fact, they only produce *blur-free* images which has nothing to do with sharpness in the sense of being properly focused. Some explanation, then, is required.

If a stills camera set at 1/50th snaps a fast moving object the result

Deep shadows and bright sun create huge contrast; set the exposure for the sunlit highlight.

stops. It's better than nothing but a bit hit-and-miss since the number of stops opened is often fixed regardless of the strength of the backlight. But, the BLC button should not just be thought of as being useful for shooting against the light. It could, for instance, be used to open up a couple of stops while filming on that snow-capped mountain.

Neutral density filter
When using auto-only there may be times (sunlit snow, beaches, etc.) when the reflected light is too strong for the AE-only systems. In these conditions there are two answers: use a faster shutter speed to force a wider aperture, or fit a neutral density filter.

The term 'filter' is not strictly accurate here since these filters do not actually filter light – they absorb it. The better quality ones do this in a neutral way without having any effect on colors. Nevertheless the term is commonplace since it describes an optical accessory that screws to the filter thread of the zoom.

Neutral density filters are gray and are available in strengths denoted by factors. A 2x will cause

A reflector can be used to throw light back on the subjects to lighten shadows. (Photo: Terry Mendoza)

the aperture to open by one f-stop, a 4x by two stops and an 8x by three stops. The 8x, then, is the most effective general-purpose one for preventing underexposure and, in such circumstances, is a better option than using faster shutter speeds.

Apart from absorbing excess light entering the lens, the fact that they cause apertures to open wider also means they can be used to decrease depth of field. This is discussed later.

is likely to be a blurred picture. The picture is not necessarily unsharp – it may be perfectly focused – but the blurriness gives the impression that it is. If, though, a fast shutter speed, say, 1,000th of a second is used it 'freezes' fast action and therefore produces a blur-free image.

What must be born in mind, though, is that this one snapshot is a single moment frozen in time – an isolated event on a single snapshot that may be viewed for as long as the viewer wishes.

With *moving* pictures – which most of us use our camcorders for – fast shutters create a somewhat jerky or stroboscopic and animated

appearance. The faster the shutter speed the greater the strobe effect. Up to 1/250th it's not that drastic but you can tell it's not right.

It happens because all moving pictures, whether shot on film or tape, are an *illusion*. The illusion is created by showing a series of slightly blurred *still* pictures in quick succession, which interact with the human eye and brain.

For the brain to accept this series of individual pictures as continuous movement the human eye now plays its part. When the eye's retina sees each individual frame flash past on screen the brain retains each picture in memory for a split-second. Before the memory has faded the cycle is repeated as each new frame appears. This is known as the persistence of vision.

When shooting, the tape runs past at the effective speed of 25 frames per second (fps) or 30 fps for NTSC. If each individual frame of movement is 'frozen' short of its 'natural' lens appearance-time and contains no blur the illusion is less successful because, regardless of which shutter *speed* is selected, 25 or 30 fps will still be shot. Put another way: if a shutter speed of 1/1000th is selected 25 or 30 frames per second will still pass through the camcorder but each frame will only contain $1 \times 1/1000$th of a second of the action or movement.

Now we must look at what happens when these images are played back. Normal playback speed is also 25 fps (30th NTSC). And, as the pictures are played back each frame is scanned twice: once for the even numbered lines and once again for odd numbers.

For simplicity I shall only refer below to shutter speeds for the PAL system but the same general principal is also applicable to NTSC.

Each scan takes 1/50th of a second. Therefore, the two scans, added together, make up the 1/25th of a second frame running time.

So, if only 1/1000th of a second of each frame's image has been recorded it means that only 25/1000ths of any one second has been shot which leaves a huge chunk of it missing – 975/1000ths of it. Put simply, for every one second of screen

running time more than 90 percent of the image has *not* been shot.

At normal speed playback the eye/brain combination notices this missing bit which registers it as a 'hiccup' – a bit like blinking. It's this 'now you see it, now you don't' gap in the movement between frames which produces the 'jerkiness' associated with fast shutter speeds when the tape is played back at normal speed. This jerkiness is not apparent at the standard shutter speed because the slight blur helps carry the memory from one frame to the next. Therefore, this slight blur is absolutely vital to produce the illusion of natural movement on a tape played back at normal speed. It is therefore, advisable to use the standard speed wherever possible regardless of the speed of the filmed action.

Fast shutter speeds, though, can be used for filming static objects provided the camera is not moved as in panning.

The main reason for using faster shutters is for shooting fast action where the intention is to play it back

in slow motion for blur-free frame-by-frame analysis on a mains-deck equipped with a *noise* and 'jitter-free' 'pause' or 'still-frame' facility.

It must be remembered, though, that increasing the shutter speed to 1/1000th opens the aperture by over 4 f-stops more than using 1/50th so it can only be used in brightly lit conditions – where, say, the 1/50th speed sets an aperture of f/8 or smaller. And if a speed of 1/10,000th is used the aperture will open seven-and-a-half stops wider which means it cannot be used unless the standard reading sets an aperture as small or smaller than f/16. Even where this is possible, what you gain in apparent sharpness with a blur-free image might be lost in poor focus because of a huge decrease in depth of field.

Each individual frame of fast-moving subjects will blur when shot at the standard shutter speed (1/50 PAL, 1/60 NTSC), but when the tape is played back at normal speed, the blur helps create the illusion of natural movement.

4

FOCUSING AND DEPTH OF FIELD

Standard 15 system;

Focus;

Focusing the zoom;

Differential focus;

Zooming;

Converter lenses:

Wide-angle converters;

Using wide-angle;

Teleconverters

When a lens is focused on a specific point, a distance in front of and behind that point will also be in *acceptable* focus. That acceptable distance from front to back is known as the depth of field. One third of it lies in front of the point the lens is actually focused on and two thirds of it is behind the point.

It is, of course, possible to see this depth in the viewfinder but a little understanding of the theory will ensure that you understand how to use it or vary it for your own purposes.

How much depth of field depends on:

(a) the distance the lens is focused at;
(b) the selected focal length; and
(c) the aperture (f-stop).

For any given focused distance the depth of field is greatest with: (1) the shortest focal length and (2) the smallest aperture.

Depth of field *decreases* as the focal length is increased. Therefore, when zooming in, the depth of field decreases. It also decreases if the size of the aperture is made wider. We can therefore state that for any given distance, setting the zoom to the wide-angle end and using the smallest possible aperture will always give the greatest depth of field – the amount of acceptable focus in front and behind the object actually focused on.

The focused distance also plays a part. The closer the focused distance the less the amount of depth of field. To illustrate this, and all the above variables, two examples should suffice. Note that I have referred to distances in feet and inches. For readers more familiar with metric measurements one meter is equal to 3.25 feet. One foot is approximately 30 centimeters and one inch approximately equals 2.5 centimeters:

(1) If the lens is set to 6x telephoto and the focused distance is set at 4ft at an aperture of f/5.6 the amount of depth of field will be less than 6 inches.

Change the focused distance to 15ft and the amount of the depth of field increases to approx 6ft (13ft to 19ft)

Depth of field tables.

Approximate depth of field for aperture used and distances focused at the wideangle end of a typical domestic camcorder

Distance Focused On (in feet)		f/2.7		f/4		f/5.6		f/8		f/11		f/16	
		ft.	in.	ft.	in.	ft.	in.	ft.	in.	ft.	in.	ft.	in.
∞ (INF)	NEAR	5	11⅜	4	¼	2	10⅜	2	⅛	1	5½	1	0
	FAR	∞		∞		∞		∞		∞		∞	
25	NEAR	4	9¾	3	5⅝	2	6⅞	1	10¼	1	4½	0	11½
	FAR	∞		∞		∞		∞		∞		∞	
15	NEAR	4	3¼	3	2⅛	2	4⅞	1	9¼	1	4	0	11¼
	FAR	∞		∞		∞		∞		∞		∞	
10	NEAR	3	8⅞	2	10½	2	2¾	1	8⅛	1	3¼	0	10⅞
	FAR	∞		∞		∞		∞		∞		∞	
6	NEAR	2	11⅞	2	4⅞	1	11⅜	1	6⅛	1	2⅛	0	10⅜
	FAR	∞		∞		∞		∞		∞		∞	
4	NEAR	2	4¾	2	⅛	1	8⅛	1	4⅛	1	⅞	0	9⅝
	FAR	11	11⅝	∞		∞		∞		∞		∞	

For focal length equal to five times zoom.

Distance Focused On (in feet)		f/2.7		f/4		f/5.6		f/8		f/11		f/16	
		ft.	in.	ft.	in.	ft.	in.	ft.	in.	ft.	in.	ft.	in.
∞ (INF)	NEAR	146	10⅛	99	7⅛	71	4⅛	50	½	36	5⅜	25	1
	FAR	∞		∞		∞		∞		∞		∞	
25	NEAR	21	5	20	½	18	6⅞	16	8¾	14	10⅝	12	6⅞
	FAR	30	0	33	2⅜	38	2½	49	4⅞	77	11½	∞	
15	NEAR	13	7⅝	13	¾	12	5⅛	11	6⅞	10	8	9	5⅛
	FAR	16	7⅞	17	7⅛	18	10⅞	21	3⅜	25	3	36	7½
10	NEAR	9	4½	9	1¼	8	9½	8	4¼	7	10½	7	2⅛
	FAR	10	8⅜	11	1	11	7	12	5⅛	13	8⅛	16	5¼
6	NEAR	5	9¼	5	8	5	6½	5	4⅜	5	2	4	10⅜
	FAR	6	2⅞	6	4⅜	6	6⅜	6	9⅜	7	1⅝	7	9¾
4	NEAR	3	10¾	3	10⅛	3	9½	3	8½	3	7⅞	3	5⅛
	FAR	4	1¼	4	1⅞	4	2⅝	4	3⅞	4	5⅝	4	8½

If the aperture is now narrowed to f/11 at 15ft the depth leaps to nearly 16ft.

(2) At the wide-angle end, if the focused distance is 15ft at an aperture of f/5.6 – or smaller – the depth of field extends from less than 3ft all the way to infinity.

Standard 15 system

Look again at the second example: I have named this the Standard 15 system. It means if, on an average day, the camcorder is manually set at wide-angle and focused at 15ft, nearly every shot will be in focus without the need to rely on autofocus or make manual adjustments. And a limited amount of zooming – up to a focal length of 1.5 × standard – will not make too much difference. It's the perfect setting for surprise situations where fiddling around focusing or waiting for autofocus to stop hunting means missing the shot.

Focus

Nearly every camcorder has some means of automatically focusing an image. Different systems exist: there are those which send out infra-red signals and measure the distance between the camcorder and what they strike and other systems which measure areas of contrast or vertical objects. Some systems work internally through the lens (TTL) while some have external sensors. No system is perfect and, like auto-exposure or any type of auto system, it can be fooled.

Typical failures to achieve good autofocus occur where the system gets confused about what its target is: reflected images are likely to do this as is vertical information in front of the target – the latter leading to the old cliché of focusing on the bars of a cage but not the gorilla inside it. And every user must be familiar with that annoying tendency of the system going in and out of focus as it hunts desperately for a target to lock onto.

It does, however, come into its own when it locks onto a subject that is moving towards or away from camera – especially where mid-range or long focal lengths are used and the depth of field is very small.

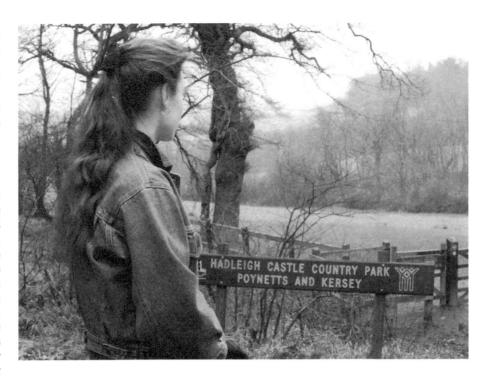

Focus set at 15ft, aperture f/5.6 produces a huge depth of field.

Focusing the zoom

Manual focusing means the auto system is relieved of the responsibility of deciding the target so any errors are down to the operator. Manual errors, though, are rare provided the operator remembers that critical focusing is best done using the smallest depth of field. The focus is set by turning the ring on the lens barrel (if you have this facility); the one that is marked with a scale in feet and meters. The usual range extends from a minimum focus distance (MFD) of four feet to infinity.

Zoom lenses, then, should always be focused on the subject at telephoto – their longest focal length – where depth of field is small.

Having set this focus the lens can now be manually zoomed back to frame the shot in the certain knowledge that, as the depth of field can only increase, sharp focus is guaranteed.

Conversely, since depth of field is greater at the wide-angle end, setting focusing is less precise and any error will be masked. If the lens is then zoomed in from this position to a longer focal length it can throw the subject completely out of focus.

Differential focus

Some camcorders have a so-called 'portrait' mode; where a close-up of some object or a person's face is sharply focused but the background is blurred. There is nothing magic here. The camcorder is set at a short focal length, and a faster shutter is selected to force a large aperture. In other words, it is using the principles of exposure and depth of field to produce differential focus.

However, because of the foibles of fast shutter speeds it is usually far better to produce the effect manually – use a long focal length, standard shutter speed, and open the aperture by fitting ND filters.

Zooming

Finally, let me make the most important point about a zoom lens: its main function is to provide a variety of focal lengths with which to frame or compose the shot and exploit depth of field. It is not simply a device for zooming.

Since eyes do not zoom, zooming in or out is an unnatural mechanical function that draws attention to itself and therefore draws a viewer's attention away from the scene being filmed.

If you really cannot resist zooming make sure you have a really good reason – such as showing the

Focus set at 4ft and an 8x ND filter widens the aperture by three stops, thus blurring the background.

Watch out, too, that auto focus is not disabled since not all converters are auto compatible.

Wide-angle converters

Wide-angle converters decrease the MFD and focal length and therefore increase the angle of view and widen the perceived perspective. How much it does all depends on the converter's rating.

A rating of 0.7 means the zoom's focal length is multiplied by 0.7. 9mm × 0.7 reduces to 6.3mm which provides a 30 per cent wider angle of view and a much greater depth of field.

Other ratings might be 0.6, 0.5 and 0.4 – the smaller the rating the shorter the focal length and wider the angle. And, because the angle is wider than standard, normal perspective changes also; everything

relationship of one subject to another. An example might be where a close-up of a man walking zooms out to show he is in a valley surrounded by the vast panorama of a mountain range.

Indiscriminate zooming is nicknamed 'tromboning'. In short, zooming is a special effect and should therefore be used sparingly.

Converter lenses

Supplementary lenses are available that screw onto the front of the zoom lens and change its focal length. Converters also alter the MFD (minimum focus distance) and the focusing scale inscribed on the camcorder's own lens barrel. Sometimes, converters have a focusing scale of their own but it is only accurate when the camcorder's lens is set to infinity. Where no focusing scale is available on the converter, focusing must be done visually through the viewfinder.

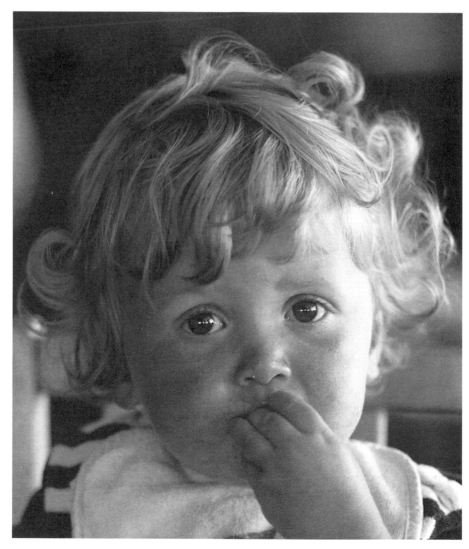

Portrait modes use the principles of depth of field to blur the background. (Photo: Terry Mendoza)

Sigma converter lenses. (Photo: *CZ Scientific Instruments Ltd.*)

looks farther apart from its neighbor than it really is and objects therefore appear to travel at a faster speed than normal.

Converters with ratings below 0.6 will give a progressively more fish-eyed view – uprights will curve inwards and the whole view appears somewhat circular as though it was shot from inside a gold-fish bowl.

Using wide-angle

In my opinion, the 0.7 or 0.6 converters are the most useful for 'normal' shooting and one or the other should be everyone's first add-on lens. The depth of field – even in less than average light – is so huge that focusing is rarely necessary even when the camcorder is within a foot or so of the

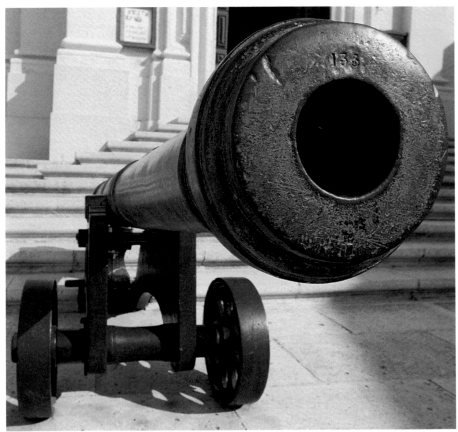

0.5 wide-angle converter increases apparent depth of perspective. (Photo: Terry Mendoza)

subject. And, since camera shake is de-magnified it is ideal for hand-held work such as when walking with the camcorder or getting in really close for head-to-head interviews.

Tele-converters

Telephoto converters are rated from 1.5 to 5x. Unless you really need such huge magnification treat anything greater than 1.5 with caution. Apart from obvious factors such as a greatly reduced depth of field and an increased MFD, the greater the magnification the more every tiny movement transmits as a shake and wobble shot. Very sturdy rock-solid tripods are therefore essential.

Picture quality is not usually that good because some light is lost which means even wider apertures. And every tiny flaw in the optics is also magnified.

Other types of conversion can be

made with interchangeable lenses if the camcorder is fitted with the correct mount such as the VL system.

Wide-angle converters decrease the M.F.D. while increasing the depth of field.

The first Canon camcorder with the VL mount interchangeable lens system. (Photo: *Canon UK*)

5

MACRO AND CLOSE-UP LENSES

Using macro;

Tele-macro;

Plus diopter add-on-lenses;

Focusing and depth of field;

Flying insects

According to the dictionary, the word 'macro' means *long, large* or *large-scale*. To the videographer, a macro-shot is one which magnifies something really small, say, an ant, bee, or butterfly into a larger-than-life, screen-filling image.

To the viewer, such a shot often produces a reaction of awe and excitement. It's not that they haven't seen this type of shot before – they have. But usually, they associate them with specialist 'wildlife' programmes or believe they can only be produced using highly complicated equipment.

So when a mere amateur, using a domestic camcorder, does it too, the audience is inclined to believe that this is no ordinary amateur. Surely, they reason, he is exceptionally talented and undoubtedly an expert.

There is some truth in this because the world of macro is not as simple as normal photography but, apart from a steady tripod – which is absolutely essential – and a couple of plus-diopter add-on lenses, very little extra equipment is needed to produce

In real life the human eye is one-and-a-quarter inches wide but a macro shot can fill the screen.

a very professional end product.

Mastering the techniques is worthwhile because, apart from 'wildlife' applications, practically every film you ever make can benefit in some way from such extreme close-ups.

For instance, the holiday film might contain close-ups of a picture postcard followed by further shots of tiny areas from within it. Birthday party and wedding programs might show shots of individual greeting cards, then cut to extreme close-ups of the words on them, plus more close-ups of individual signatures or particular motifs on each card.

Documentaries might need to show the wording on documents or newspapers, or pick out an individual face from an old photograph.

In fiction dramas, the protagonist might lay something small on a table and the next shot is an extreme close-up of the object: ring, coin, poison pill, key or whatever. Then there's the classic drama shot: a man looks through a keyhole, and the next shot is that of a screen-filling, red-veined eye, blinking, watering, opening and closing its iris, apparently staring back at the man. Not a pretty sight but certain to create audience reaction.

The +2 dioptre is better than macro in contrasty lighting.

Using macro

Nearly every camcorder has a macro mode. On most of them this is entered by manually moving the zoom lever to the end of its travel, then pulling the lever up past a 'locking' point and into the macro scale. On other models a secondary button might need to be pressed simultaneously before the zoom lever enters the macro mode. In this position the zoom lever is used for focusing not zooming.

Some cameras have the macro scale at the tele end of the zoom but with most makes it is at the normal (wide-angle) end. Only a few cameras focus right up to the front of the lens without the need of special macro-switching.

The advantage of wide-angle macro is that the camcorder's lens can be positioned to within a few millimeters of the subject, say, a flower, and the depth of field (the distance in front and behind the subject in *acceptable* focus) is sometimes as great as from the front of the lens to infinity.

The closer the lens to the subject the larger the image but, because of the huge depth of field, absolute positioning is not essential for critical focus. Its disadvantage is that positioning the camcorder so close to the subject can block the light.

Tele-macro

An advantage of macro on the tele end of the zoom is that the magnification of the subject is far greater. But so also is every tiny movement such as camera shake or pressing the 'shoot' button without a 'fairy' touch. It's therefore better if the camcorder can be operated by remote control.

Tele-macro's greatest disadvantage is that, in order to focus and frame the subject, great care must be taken to ensure that the camcorder is placed at the correct distance (usually only a few inches) from the subject, and the depth of field is very small.

Both types suffer the disadvantage that, because the zoom lever is now 'locked off,' it cannot be used to frame the shot; framing and focusing relies heavily on positioning the camcorder. And doing this – when trying to position a tripod, not block the light, and keep shadows of oneself out of the shot – can be somewhat tricky.

'Plus' diopter add-on lenses

Another, arguably the best, method of achieving such images is to use one or more supplementary lenses known as 'plus' diopters. They are available in varying amounts of magnifying power and are labelled +2, +3, +4, etc.

The higher the '+' figure the greater the magnification. And, when two such lenses are screwed together their magnification factors are added. For example, fitting a +2 to a +4 is the same as using just the one lens rated +6.

My own preference is for two such lenses: a +2 which magnifies a large coin to fill the screen, and a +3 which does the same thing for a small coin. And using the two screwed together makes a rhinoceros out of a ladybird.

The half-inch snail shot at the tele end with a +3 dioptre close-up lens.

+2 dioptre on wide-angle to shoot the whole postcard.

+3 dioptre with zoom to magnify a portion of the postcard.

Focusing and depth of field

Some people may argue that adding an extra piece of 'glass' to a camcorder's lens cuts down on the incoming light and reduces the quality of the picture. They're right, but in both cases the amount lost is insignificant. Nevertheless, all tele-macro and +diopter shots require either bright (but not too contrasty) daylight or supplementary indoor lighting if the maximum clarity and greatest depth of field is to be obtained.

Plus diopters do have a major advantage over any type of macro; they screw onto the filter-thread of

Hoya close-up lenses. Buy them to fit the filter thread size of your camcorder.

the camcorder's lens. This means that the zoom lever is not 'locked off' so varying focal lengths of the zoom can be used to frame the shot precisely or vary the image size.

This though should be done with care because the greater the focal length (increasing the zoom) the less the depth of field. So even in good light the trick is to frame the shot as close as possible to the wide-angle end.

Even so, for pin-sharp focus, the distance from the front of the +diopter lens to its subject should be measured, and this measurement varies with the +factor.

At full wide-angle, and using manual focusing with the lens-barrel set to infinity, a simple calculation can be made to find the optimum

focusing distance from the subject. The +factor is simply divided into one meter (39 inches). Thus, the focusing distance of a +2 lens = 1/2 meter (19½ in); a +3 = 1/3rd of a meter (13 in); a +4 = 1/4th of a meter; and so on.

After measuring (or accurately estimating) this distance, zoom in to make critical adjustments to the focus through the viewfinder, then manually zoom back to frame the subject. And, wherever possible use a monitor – especially indoors.

Autofocus works well on some models and not so well on others due to the way a particular auto system works and whether, at this degree of magnification and closeness to the subject, the image provides 'auto-readable' information.

Flying insects

Videoing a flying insect, such as a butterfly settling on a flower, seems to viewers and the uninitiated a remarkable achievement. But an old professional trick is to catch the insect and put it in a small container drilled with 'breathing' holes, then put the container in a refrigerator (not freezer) for 15 minutes.

This fools the insect into thinking that it is winter so it starts to hibernate. While this is happening, set the camcorder on a tripod, and frame and focus a suitable flower. Tip the insect on the flower and start filming because, after a few seconds, as the insect 'wakes' up, it will move and fly away.

Such shots, mixed with 'normal' ones, can build into proper 'macro-life' documentaries. And, if the right commentary is post-dubbed it can even become a comedy. For instance, a six-minute short about a day in the life of 'Bert the worker-bee.'

One word of warning: watching raw macro-nature is not every viewer's cup of tea. The sight of a 12" wide house-spider gorging itself on an 8" wide fly can make *Frankenstein* seem as frightening as a goldfish.

For indoor shooting: table-top material, aquariums, title cards, news-papers or Christmas cards – and regardless of whether macro or + diopters are used – supplementary lighting provides the best and most sparkling results. Flat material, such as cards, must be set up on something rigid or simply pinned to a wall. Two photofloods can then be set up either side and slightly behind the tripod-mounted camcorder but, to avoid reflections, lamps need to be angled at 45° to the card.

Wideangle macro. (Photo: Terry Mendoza)

6

FILTER EFFECTS

Skylight filter;

Neutral density filter;

Polarizers;

Graduated filter;

Correcting color;

Star effects;

Multiple images;

Diffraction filters;

Centre Spots;

Masks;

Lens hood

Practically every photographic dealer stocks a wide range of filters and has an illustrated catalog showing prices, styles and sizes.

Two types of filters are available: round ones, such as the Hoya brand, which screw to the thread on the front of the lens, and square ones (Cokin) that slide into a purpose-built universal holder attached to the lens by an adaptor. Both systems allow more than one filter to be used and each filter can be rotated. The square ones also allow filters to be moved up and down.

The universal holder is the most popular system but check before buying that the holder doesn't obstruct auto focus. And, if your auto-focus won't work with converter lenses it won't with filters either. White-balance sensors, though, are un-affected.

Some of them are very subtle whereas others can be a bit arty-farty and flashy. Therefore, I am only going to list those which have been most useful to me.

Skylight filter

Irrespective of which system, a screw-on round *Skylight* filter is absolutely vital. This apparently clear piece of glass cuts down on haze but, more importantly, protects the camcorder's lens against dust, grit, finger marks and damage. Since the camcorder's lens, if damaged, is very expensive to replace, I advise that you buy a skylight filter immediately and fit it permanently.

Neutral density filters

Neutral density (ND) filters were mentioned in a previous chapter and are the next priority. Depending on their designated factor (2x, 4x, 8x) they cut down the light by one to three f-stops and are therefore useful for reducing depth of field or for preventing underexposure in very bright conditions – such as where sunlit snow would otherwise swamp the exposure-system.

In such circumstances an ND filter is better than using faster shutter speeds to do a similar job since it avoids the jerky moving images that fast shutters create. The 8x is perhaps the one for that initial purchase.

Polarizers

Polarizers are used for eliminating reflections such as those from glass or water. The filter is rotated to a position where the reflections apparently vanish. This can be quite stunning on still waters; boats and objects, minus their reflections, appear to be floating in thin air. Polarizers also slightly darken the sky – making it appear bluer to what it is in reality.

Graduated filters

These are transparent at the bottom and gradually change to a see-through pastel color at the top. If the camcorder is mounted on a tripod and a graduated blue is carefully positioned so the 'join' overlaps a horizon, a grotty gray sky becomes as blue as the filter while colors below the horizon are unaffected. Try *amber* or *tobacco* for improving or faking sunsets.

Correcting color

Color-correction filters change the overall hue of the whole frame; orange adds warmth and produces a similar cast to sunrise or sunset where it would otherwise be rendered 'normal' by the AWB. Sepia creates an old-fashioned Victorian or Edwardian look while blue, coupled with manually under-exposing (say) two stops, simulates moonlit night.

Star filters

Star filters convert points of light such as photofloods, car headlights, or points of sunlight reflected on water, into star shapes. Such filters are frequently used on pop-music shows. For starters, a six-point star is most popular.

Multiple images

Multi-image filters produce multiple images of the subject in frame. Coupled with zooming and rotating the filter some very exciting title backgrounds or nightmare/dream sequences can be created. You can really go to town with these!

Diffraction filters

These filters are etched with tiny lines which turn highlights, and such things as shafts of sunlight through

trees, into prism style rainbow-colored rays without otherwise altering the image. Arty if not over used.

Center spots

These allow a clear centre image which is surrounded by a soft, almost blurry, outer border in a choice of colors: clear, white, gray, violet, orange, etc. Very good for those romantic wedding shots or baby christening photos.

Masks

Pre-shaped masks produce vignetted shapes such as binocular, heart, keyhole, circle etc. These are only suitable if the camcorder has manual-iris or aperture-lock because auto exposure will read from the black mask and open the iris causing the subject to be overexposed.

Finally, many filters suitable for stills photography do not always produce satisfactory *moving* images. Before buying, check its catalog picture. If you think it will confuse *movement* – other than for effect – forget it.

Lens hood

Always screw the lens hood to the thread on the front of the filter. Not only does it protect the lens from mechanical damage, it also prevents light from striking it from a very oblique angle. Light that enters obliquely reaches the CCD in a diffuse way causing blacks to appear grayish. The result is an apparent loss of sharpness.

No filter. Note reflections in window

Polarizing filter reduces reflection

Sunset

Cokin filter holder

Centre-spot filter

Diffractor filter

Sepia filter

Multiple image

8-star highlighting the sun

Blue filter

Binocular mask

Star and filter

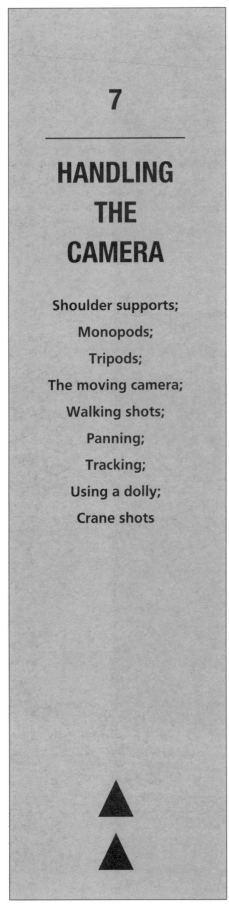

7

HANDLING THE CAMERA

Shoulder supports;

Monopods;

Tripods;

The moving camera;

Walking shots;

Panning;

Tracking;

Using a dolly;

Crane shots

The hallmark of the average 'point 'n' shoot' snapshotter's camerawork is hand-held jerky and wobbly shots, long wobbly pans and indiscriminate jerky zooms. It needn't be so, and practising the techniques described below will help you discard amateurishness for ever.

Let's start by making one simple statement: For any sequence of moving pictures to be acceptable to a viewer for any length of time they must be absolutely rock steady – especially long-shots and medium-shots where the background is scenery or buildings of some kind. Movement of any kind should only be seen if it is done deliberately for effect.

This means that, while shooting, the camera must be kept still. And, because your body is the camcorder's only support when you are hand-holding it, the body must also 'freeze' while making the shot.

Use two hands and tuck the elbows firmly into the sides of the body. Use the wide-angle end of the lens and try to avoid fiddling with the zoom and other buttons, and breathe gently and only when you have to. If you need a larger image-size don't rely on the zoom to provide it since magnifying the image this way will also magnify camera shake. Enlarge the image by moving yourself and the camcorder in closer.

Look also, for anything that further helps to support the body: trees, walls, cars, etc. Anything that you might lean against or prop your elbows on in order to provide greater stability and support.

Put it this way: you may be an amateur using amateur equipment but you don't have to make a 'shake 'n' wobble' shot – that's amateur*ish*.

Shoulder supports
Shoulder braces, chest-pods and body harnesses are popular, cheap methods of providing extra support to hand-held camerawork. Their main benefit is that they allow the camcorder to be operated with one hand and support the camcorder hands-free between shooting.

Designs vary considerably, so what suits one camcorder and a particular user is no guarantee that it will suit you and your camcorder.

Find a store that will let you try several different types and do not buy one until you have tested that it works for you in the way you expect it to. Do not, though, expect it to be anything other than a convenient aid for balancing the camcorder.

Monopods
The best monopods are made from light, aluminum, retractable sections which can be lengthened or shortened with quick action snap-fittings. They are really useful for getting in and out of small or crowded places where full-size tripods would occupy too much space or take too long to set up. Ideal when travelling light – such as a touring holiday.

Again, it pays to try before you buy. Avoid any which are so fragile that when fully extended, they create a whip effect when loaded with the camcorder under firm hand pressure. Rigidity is all. And check that, when extended, it is tall enough to reach your eyeline.

Tripods
Any shot made with the camcorder on a tripod should be absolutely rock-steady – that's the theory. But unless that tripod is purpose-built for camcorders and video cameras – beware! So many of them are really only suitable for stills cameras even though they might come with a pan and tilt head.

Again, rigidity is all – especially when fully extended. Ideally, the three legs need the additional support of cross bracing and the feet need non-slip rubber 'shoes' that screw away to reveal spikes for anchoring to grassy slopes or outdoor terrain.

When setting up, it is important that the head – which acts as a platform for the camcorder – is kept level while panning. If it's not level, pans containing vertical lines or level horizons at the start will end with the horizons and verticals tilting sideways. The best tripods are provided with a small circular spirit-level fitted to the head or top of the centre column. Such spirit-bubbles can also be purchased separately.

Panning is the process of moving the head (and camcorder) in a sideways horizontal arc. Tilting is the name given to vertical panning.

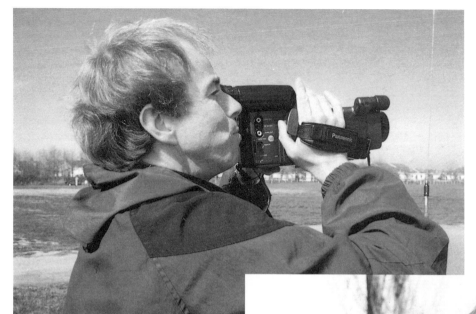

Propping your elbows on something turns your body into a tripod.

Look for trees, walls and firm surfaces to support your back.

Shoulder/neck braces for places where tripods can't go.

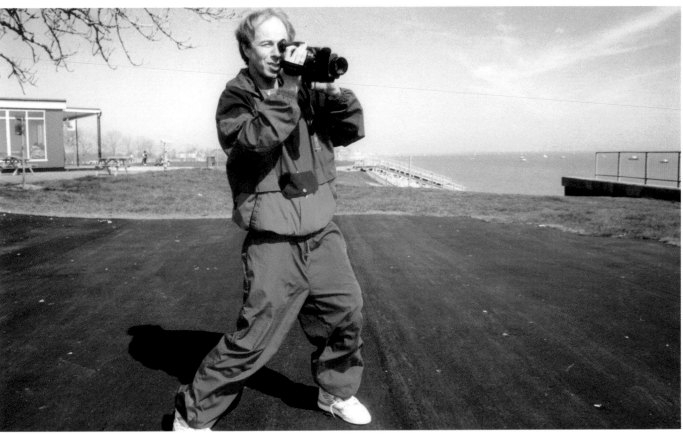

Face where the pan should end, then
twist your torso to face the start then gradually unwind . . .

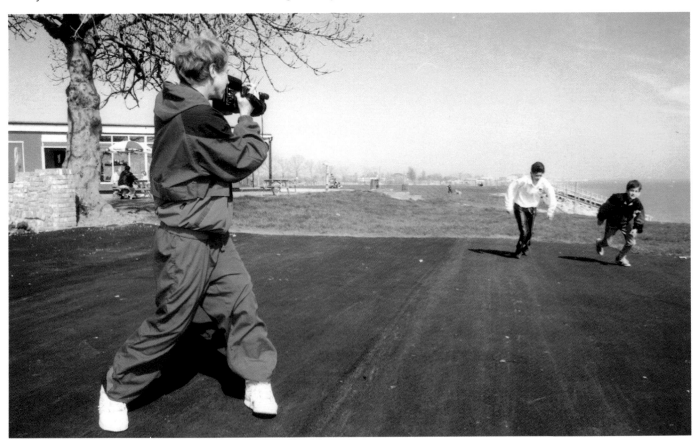

In general, pan and tilt heads come in two types: friction heads and fluid damped. The speed and smoothness of the movement of the heads is adjustable. Friction heads have a knob which tightens to increase the pressure on two friction plates and therefore slows the speed of the movement. The problem with these is that it is virtually impossible to pan with a smooth start and finish. In my experience, it is better to loosen off the friction entirely and rehearse the pan before making the shot.

The moving parts of genuine fluid-damped heads float in a bath of high viscosity oil, so silky smooth pans – including starts and finishes – are extremely easy. They are, however, more expensive than friction types but can be bought separately and fitted to a variety of different leg configurations. Indeed, one manufacturer, Manfrotto, supplies legs of different strengths, weights, heights and designs – including some with detachable wheels – for different pur-

. . . to follow the action.

poses. And different designs of fluid-heads can be purchased separately.

The importance of tripods cannot be overstated. They are the only real means of providing a controllable stable platform for rock-steady long focal length shots and smooth panning and zooming. After the camcorder, a tripod should be everyone's priority purchase. And, since little can go wrong with them a good second-hand one will do nicely.

The moving camera

In earlier times of cinematic movies, cameras were heavy bulky objects and difficult to move without some kind of mechanical supporting apparatus. Partly because of this, the cameraman's golden rule was: 'Keep the camera still and let the action do the moving.'

Audiences became conditioned to this and, for many years, a hand-held movie-camera was the hallmark of the inexperienced home movie-maker.

Gradually, with the development of the lighter, shoulder-mounted

cameras – especially ENG (Electronic News Gathering) video cameras – some movement became tolerable as viewers understood the on-the-hoof nature of such reportage.

Later still, the moving camera gave fly-on-the-wall documentaries and live interviews a kind of authenticity; viewers accepted the presence of the camera, and therefore its movement, as signifying unrehearsed, unedited honesty and truth. This, despite the fact that such material is usually more heavily edited than any other genre.

However, this does not mean that the camerawork is jerky or wobbly. On the contrary, such movements are only done where it is possible to make really smooth, flowing movements, and where the camera is moved for some real purpose such as following the action or where the movement in the action disguises the movement of the camera itself.

Two things contribute to this smoothness: the design of the camera and the skill of its operator.

Professional camcorders weigh 4–6kg and have shoulder-shaped cut-

A crane shot starting from a crouched
position . . .

. . . and very slowly . . .

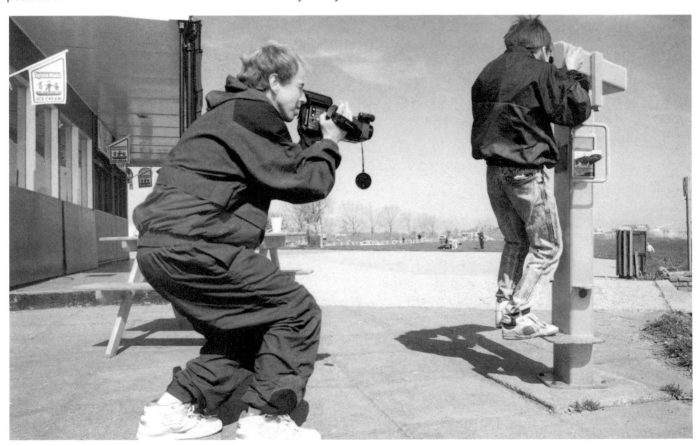

Add wheels to a tripod for tracking on smooth surfaces.

outs for comfortable easy positioning and balance. This combination of weight, shape and balance turns the trained cameraman into a mobile support – as though he and the camcorder were one giant piece of equipment.

Walking shots

When walking (or running) with it he will use a special walk – the Indian-Marx walk. His whole body becomes a shock-absorber; he bends his knees slightly and crouches like Groucho Marx then walks like a Red Indian – placing one foot in front of the other to prevent the camcorder swinging from side to side. He also tries to breathe smoothly – even holding his breath entirely when making a static shot. He's learned that breathing in moves the camcorder upwards and breathing out lowers it.

Amateur camcorders are much lighter, typically 1–3kg, and few are

. . . straighten up.

designed for shoulder mounting. Therefore, jerk-free hand-held shooting is extremely difficult.

Nevertheless, smooth, hand-held walkabout shots are possible with practise. But only when using the camcorder on its wide-angle setting – or better still, with a 0.6 or 0.7 converter – together with the Indian-Marx walk.

Panning

Hand-held pans across scenery or static objects are extremely difficult to do smoothly. The best method is to first work out where you want the pan to end and face this point with the body square onto it, anchoring your feet firmly. Bend the knees slightly, and twist from the waist until the camcorder faces the point at which you have chosen to begin panning. Start shooting and slowly (very slowly) unwind the torso until you again face the end point. It usually pays to rehearse this movement before making the shot.

Anything with wheels makes a useful dolly.

Tracking

When a camera is moving parallel to, or stays at the same distance from the moving action it is said to be making a tracking shot. Such shots are common in fiction films and TV dramas. For example, one police-type drama often contains the type of hand-held shot that follows a character down a flight of stairs, past a landing, along a hall, out of a door, across a yard and into a car, and all in one continuous shot.

Another common type is where the camera is positioned in a car and films another car driving alongside. Or, the camera car positions itself in front or behind the object car to make 'head-on' or 'tail-on' tracking shots.

When filming from inside a car do not use a tripod because road vibrations will transmit to the camcorder. Provide yourself with some extra foam cushions and wedge yourself in, keeping the camcorder hand-held on its wide-angle end. A shoulder brace or body harness is useful here provided no part of it is in contact with the car.

Another type of tracking shot is known as the subjective track; it

gives the point of view of the subject. To illustrate this, imagine the shot of a man walking through woods. What he (the subject) sees can be simulated by the camera if it is hand-held and placed in his position. If he stops so does the camera, if he looks left the camera pans left and so on. In other words, the camera sees what the man's eyes see and in the way that he sees. In this instance, some deliberate jerk and wobble is introduced to simulate the jerkiness of natural walking.

Using a dolly

In professional use, dollies are custom-built vehicles which may be pushed along a plastic or metal 'railway' track. This method is probably where the name 'tracking' originated.

'Dolly' is also the name given to any wheeled platform upon which the camera and its operator are positioned. In this sense, any type of mobile platform: cars, wheelchairs, supermarket trolleys, wheeled tripods, etc., can be pressed into service.

Their main use is for providing smooth tracking shots of moving sub-

A sturdy tripod is an essential first buy for rocksteady shots.

Monopods: easy, cheap, and convenient for go-anywhere shooting. (Photo: courtesy *Jessops UK*)

jects but they can also be used for filming static objects such as statues, ornate fountains and so on. In this case, the camera-mounted dolly tracks in a circle round the subject giving an all round (almost three-dimensional) view that separate static shots cannot provide.

Crane shots

When a camera tracks vertically up or down it is making a crane shot. Professionals use hydraulically operated apparatus that is outside the amateur's budget, but a limited amount of craning can be done, hand-held, by bending the knees and crouching down as slowly and as smoothly as possible.

Craning upwards means starting from the crouched position and slowly straightening up.

Of course, if you have access to, or can hire, a forklift truck or one of your council's street-lamp repair vehicles, really imaginative craning is no problem.

8

COMPOSITION, CAMERA ANGLES AND IMAGE SIZE

The point-of-view shot;

Tilting the camera;

The Dutch tilt;

Buildings;

Picture composition;

Portraits;

Landscapes and sky

If you sit in a theater watching a stage play you are anchored to viewing it from one position. And, since eyes have only one focal length and cannot zoom, it is impossible to view objects and actors' faces in great detail.

Newcomers to videography often produce similar 'stagey' images; every shot a long-shot and all made from the standing head-high position.

'Changing the camera angle' is an expression used frequently in all kinds of movie-making. It simply means moving the camera to a different position so that it gives a different view to the one it gave before. This is part of the magic of movies which, coupled with the ability to change the image size, provides a much more life-like interpretation of the action.

However, the creative cameraman does not restrict changing angles to fiction dramas. On the contrary, he tries to represent real life in the way that we, as viewers, might see it if we were actually there and able to move around freely.

Imagine, for example, we are at a small town sports event. If the camera were fixed in one position it would make a very dull movie. But, if

Shooting from a high building for an overall view is an effective establishing shot.

the camera changes positions it can show the point of view of the spectators, the players, the umpires, and draw our attention to interesting detail by producing close-ups of faces, scoreboards and related goings on; or the camera can be placed at ground level to give a worm's eye view or it can look down on the overall scene from a very high building. Putting such shots next to one another (juxtaposing) means that the camera can provide more than simple pictures – it can provide atmosphere and flavor.

The point-of-view shot

In fiction movies the camera might show the baddy and the goody squaring up to each other. But rarely will we see this in one shot showing one image size. As like as not we'll see them first in a medium-shot showing the two facing each other – the spectator's point of view. Next the camera positions itself in the goody's position and we see a close-up of the baddy from the goody's point of view (POV). And, naturally, at some point we'll see it from the baddy's POV.

But everything has a point of view – not just humans. If we show a shot of the town square from ground level it can be followed by the downward view from one of its buildings. If we show a shot of a lady walking a dog we might next get the camera at dog height and shoot a close-up of it. Then follow this by a hand-held sub-

With lens at wide-angle, head-high
shots show normal human perspective.

Shooting downwards for a bird's eye
view.

Shoot buildings corner-on for that
three-dimensional look.

jective tracking shot at low level to
simulate the dog's POV – not forget-
ting to stop at the odd lamp post.

Children too, are best videoed by
getting down to their height. If baby
is crawling on the floor, that's where
the camcorder should be.

So when changing angles it should
be remembered that the camcorder
can be moved vertically as well as
horizontally, constantly ringing the
changes – looking for different points
of view.

Tilting the camera

Another important consideration is
the effect created when the camera is

When videoing children, get the
camera down to their height.

A wide-angle worm's eye view adds depth and drama.

positioned low but pointed in an upwards direction or vice versa.

Let's go back to our goody–baddy confrontation for a moment. If the camera is positioned at the baddy's knee height but pointed upwards, so that his entire body fills the frame, the image produced will give the impression that he is very tall, powerful and menacing. If, on the other hand, the camera is positioned slightly above his head and pointing downwards, he will appear much smaller and less significant. Watch for this camera-angle effect at the cinema – the huge, menacing figure of the baddy and the small, helpless, innocent victim.

Buildings

Buildings, statues and other objects, too, can be given the upward/downward angle treatment. A building will always look taller when shot from a low upward angle. But there's a further point to be considered here – the three-dimensional effect.

If the building is videoed from its front-on position it will produce a very flat two-dimensional image –

there will be no impression of depth. If, though, the camera is positioned corner-on to it so that, as well as the building's front, some part of one side is also in shot, a three-dimensional impression and a greater sense of perspective is created.

The Dutch tilt

Experiment, too, with a sideways tilt – often referred to as the 'Dutch' tilt. Used with care, this can often be an unusual effect and not just for buildings. A car travelling along a road

towards the camera, if shot from a low angle combined with a Dutch tilt, can be quite dramatic. The angle of tilt should, however, be seen to be deliberate and chosen with care – around 30 degrees from horizontal. The tilted angle should not be so small that the viewer gets the impression that it is simply bad camera-work.

The Dutch Tilt adds to the impression of speed.

Tilt upwards from a low angle to give an air of menace.

Before shooting from inside a car, set exposure to outside lighting conditions.

Picture composition

All of the above contributes to the composition of a picture which many newcomers with some experience of 35mm stills photography *think* they know all about. They'll have been brought up on a diet of composition rules: the rule of thirds, don't place a scenic horizon midway in the frame, when shooting portraits throw the background out of focus, and so on. I understand their problem because I've been shooting stills since I was twelve years old and it took me many years before I realised that shooting *moving* images requires an entirely different approach.

This does not mean that all such rules should be ignored – especially when shooting landscapes and static material. Indeed, the videographer can gain much from popping down to the local library and studying half a dozen books on the subject.

However, when an object moves or a scene contains plenty of action, the movement itself becomes part of the composition, and keeping it in the frame must take priority over any so-called rules and regulations.

Portraits

To make this clear, let's examine the two attitudes to portraits.

The stills photographer frames the subject's face – possibly from the shoulders up – just off-set from the centre of the frame and with just the right amount of headroom. Then, using large apertures and a longish focal length to decrease the depth of field, he'll ensure that any 'busy' background is out of focus.

He does this because that photograph will be one split second frozen in time – the entire object of the exercise. Since it will be viewed or studied at leisure, the overall framing and balance must be pleasing to the eye and the blurry background concentrates the viewer's attention on the subject's face.

The videographer might start by setting up the shot in the same way – framing it off-centre and allowing headroom, only to find the subject moves in and out of frame. The head might be thrown back as the subject laughs; it might turn from left to right; the eyes will move and blink and the lips will move as the subject speaks. Hair, too, is a moving hazard: strands fall across the face, or it sticks out in strange ways. What price preset framing now?

Then there's the busy background. Let's suppose it is a beach scene with several figures moving about. If this is out of focus it will not freeze the movement – it will simply be blurry movement. To the viewer, used to seeing everything pin-sharp on professional TV programs, this will be somewhat weird – even irritating. They'll be so busy trying to work out what these blurry images are they'll be distracted from the subject – the opposite of what was intended.

Ninety percent of video pictures, then, must always use the maximum depth of field and be framed to anticipate the movement because it's the movement that captures the viewer's attention. Blurry backgrounds should be restricted to special effects, but careful framing should always take priority with static subjects.

Classic composition: use some object here, (the tree) to frame the shot and a human figure indicates scale and the point of interest.

Where sky has no significant interest, restrict it to the top one-tenth of the frame.

Landscapes and sky

In nearly every book on composition, a great deal is written about shots containing sky. Generally, they quote the 'rule of thirds' and advise that the sky should occupy either the top one third of the frame or the top two-thirds – the skyline should never be centre frame. Again, this is fine for stills photography or where the sky has pretty or interesting cloud formations. But even one-third of the frame is a huge area of precious picture-space wasted if that sky is a bland blue, gray or white without any interesting features.

Too much sky can also fool auto-exposure to underexpose the land below, while opening the aperture to correctly expose the land causes the sky to be overexposed.

What you need to decide as a priority is whether the sky has any interest at all. After all, sky is sky; it looks pretty similar the world over. But every patch of land is unique whether it be the cornfields and windmills of Holland, the canals of Venice or the Grand Canyon.

My advice, then, is to restrict the sky to the top fifth of the frame and concentrate on the land features. Not forgetting that scenic shots showing long distances need something in the foreground, say, a person – preferably without distracting movement – to give the viewer some idea of its perspective and scale. This 'something' though, *should* follow the rule of thirds; it should be positioned either in the left or right vertical third of the frame – not in the centre.

Composing video shots is not so much to do with rules; it's more a matter of common sense and targeting interest by changing angles and selecting the image size. But at the heart of true moviemaking is the craft, art and skill of juxtaposing shots in sequences that show the action or scene in a logical and coherent manner. Achieving this, perhaps the most vitally important element of video movie-making, is discussed in the chapters on movie grammar.

9

LOCATION SOUND AND MICROPHONES

Many camcorder users experience severe disappointment recording sound. A typical newcomer's reaction is: 'The sound was dreadful. Continuous roar of traffic, chattering people, and all sorts of background noise which drowned out the natural sounds of what I was filming. About 80 percent of the track was affected so the microphone must be faulty.'

This situation often arises because, whereas most people are quite prepared to accept that taking good pictures requires some basic knowledge of the physics of light and the skill to manipulate cameras, they often fail to recognize that sound-recording also requires study. But only by knowing precisely what sound is and how it works, only by knowing how *machines* (microphone, amplifier, recorder, etc.) reproduce it, can a good recording be accomplished.

So let's start by saying that sound is a form of *energy* which, depending on its loudness, tone and concentration can have tremendous power. It can start an avalanche, shatter glass, shake buildings, and cripple human eardrums. This is because sound *energy* literally moves air, in wave-shaped patterns, which creates *pressure* on any surface it strikes.

Rycote professional windbasket. Note the mike is suspended in a shock mount. (Photo: *Rycote Ltd*)

Low-pitched sound such as the QE2's foghorn, can produce waves of air 10 yards long, whilst the high-pitched treble sound of a dog-whistle produces tiny waves less than a quarter-inch long.

These waves – and therefore the pitch or tone – can be accurately measured. By using a *machine* to convert the *pressure* created by the waves into electrical voltages, the resultant signal can show these wave patterns graphically on a screen. (See Figure 1)

When one full wave takes a full second to complete its wave shape it is known as one *hertz* and is written 1Hz. And when a tone or sound makes 1,000 waves per second it is known as one *kilohertz*, – written 1kHz. The greater the number (frequency) of waves per second the higher the sound's pitch or tone. For example: the deep bass note on the extreme left of an eight-octave piano keyboard has a fundamental *frequency* of 27.5 Hz; middle C is 261 Hz; and the highest note on the right is over 8kHz.

Note here that we're discussing *fundamental* frequencies only because most sounds have several frequencies including *harmonics* which allow the ear to determine the *timbre* of the tone and know the difference between say, a piano and a trumpet even when they are playing the same note.

Top diagram: One sound-wave per second is 1Hz, one thousand per second is 1kHz.

Lower diagram: microphone frequency-response graph.

Loudness, ears and mikes

Loudness is measured in a logarithmic scale of *decibels*, written as dBs. Every +6dB doubles the loudness and every −6dB halves it. One dB is the smallest difference in loudness that a *trained* human ear can detect whilst the *average* ear can only detect a difference of 3dBs. An idea of decibel differences is in the following:

- A jumbo-jet taking off: 135dB
- Average conversation (two people): 60dB
- Interior library reading room: 40dB

Sound also travels through the ground, buildings and structures by creating vibration waves – hence the old saying: 'Keep your ear to the ground.' The deeper the tone, say 20 Hz, the longer the wave-pattern vibrations and therefore the greater the distance travelled.

When sound pressure strikes the ear's diaphragm (eardrum) vibrations are set up which produce nerve signal-pulses to the brain. The brain sorts them into tones, degrees of loudness and directionality. It can also recognize which sounds it wants to concentrate on, isolate them for 'amplification', and filter out the sounds it has no use for.

Microphones also have some form of diaphragm which – when struck by pressure waves – generate tiny electrical voltages. In other words, mikes convert sounds into a *signal*. The better the mike's quality the better it is at this conversion process and therefore a purer and more faithful reproduction of the original sound will result.

Frequency response

Ears and mikes vary in how many tones or *frequencies* (Hz) they can hear clearly. Some people, for instance, cannot hear every tone (frequency) with complete clarity while others may not hear a specific frequency at its true value (dBs) of loudness – hence such expressions as *tone deaf*. The young and perfect ear recognizes (or responds to) frequencies from around 50Hz – 16kHz but, by middle age, the upper limit drops to around 12kHz.

Microphones also 'hear' or respond differently to different frequencies, and figures are usually given by

Additional "gags" are needed in strong winds. (Photo: *Rycote Ltd*)

microphone manufacturers to show the range of frequencies the mike responds to, say, 50Hz – 17kHz. These figures determine the mike's *frequency response* and a graph or diagram, known as the mike's frequency response curve, might show that the mike responds differently to certain frequencies by recording them at a lower or higher level of dBs. In other words, mikes can also be partially deaf to some tones (see Figure 2).

Some manufacturers do, by deliberately cutting or boosting some frequencies, produce a mike custom made for specific recording situations. For example: the calls of wild birds are mostly in the middle to upper sections of the frequency range between 1kHz and 16kHz. Therefore a wildlife recordist might choose a mike which boosts or amplifies the signal in this range by +6dB and gradually 'rolls off' or *attenuates* the lower frequencies which otherwise might drown, muffle or interfere with the 'target' sound.

Built-in mikes

The frequency response and 'conversion' quality of the comparatively cheap in-built mikes on camcorders is severely limited. But, it does the job it was designed for: to record a limited range of general background sound.

Unlike ears, no mike is connected to a brain. It cannot determine which sounds the recordist *wants* and exclude all the others; it does not know which sound is wind, and which is traffic rumble. Neither does it know which sounds are generated by zoom and other servo motors. It therefore treats all sounds as if they had equal priority.

Manufacturers *can* identify the exact frequencies of zoom and servo motors and produce mikes which exclude these frequencies. But, if they did, the mike would fail to record all the other sounds containing these same frequencies.

Similarly, mikes with 'wind-roar' or 'bass-cut' switches, can only achieve *partial* wind roar elimination by cutting low frequencies, below say 250Hz, by several dBs. However, if they are cut too severely, voices sound very thin – almost telephonic. So at best it's a compromise. The only real solution is to buy one or more separate 'designer' mikes and know how to use them.

But – and this is vitally important – the only way to know precisely what sounds any mike is (or isn't) picking up is to *monitor* the mike's sound through *headphones* of the closed-back type which *fully* enclose the ears.

'Walkman' types and 'earpieces' are better than nothing but, since they are open-back, they allow off-mike sounds to infiltrate which fools the user's ear/brain function. So first steps to quality sound-recording must include the provision of adequate headphones.

Sennheiser camera-mounted supercardioid mike. (Photo: *Sennheiser*)

Types of mike

There are hundreds of different mikes available, from 'close-ups' with in-built echo for vocalists to radio/transmitter types housed in huge, highly directional, parabolic reflectors, for pinpointing wildlife or the crack of ball on baseball bat.

Because no camcorder's built-in 'squeaker' can record any more than general background sound – which often includes a lot of out-of-shot and unwanted material – additional 'specialized' mikes are often essential.

To help you decide which ones you need, described below are the more ordinary types which fall within the average amateur/semi-pro bracket in terms of usefulness and price.

Dynamic mikes require no battery. A coil attached to its dia-

phragm is moved by sound waves and vibrates between the poles of a magnet to produce an electronic signal. These are ideal in quiet locations for 'interview' and 'voice-over' because good ones have a high *signal-to-noise* ratio. This means that the mike itself produces very little noise (a kind of mushy hiss and hum in every electrical circuit) to interfere with the sound being recorded. Another advantage is that it's virtually impossible to overload and damage them even with extremely high and loud sound-pressures.

Electret mikes require a battery to power a built-in pre-amplifier which boosts the signal. Because of this they are usually more powerful, or more *sensitive*, than dynamic types. Their disadvantages are: (a) very loud sounds (above 100dB) can overload and possibly damage them; (b) they must be protected from rain, damp, humid, and cold environ-

ments; and (c) they produce 'noise' – about 20dBs worth – and usually have a poorer *signal-to-noise* ratio than dynamic mikes. It is, though, only really obtrusive when recording quiet sounds in a quiet indoor environment.

Pick-up patterns

Mikes, whether dynamic or electret, may have different *polar* or pick-up patterns (see Figure 1) which show the mike's *angle of* sound *acceptance*. This angle can be:

Omnidirectional – picking up sound equally from all directions

Cardioid – (often referred to as *unidirectional*), means the mike picks up sound from the direction it's aimed at in a heart shaped *polar-pattern*, while considerably attenuating sounds from its rear. And because this slightly increases the mike's frontal sensitivity, it can be used 1.73 times

THE CAMCORDER USER'S VIDEO HANDBOOK

Three dimensional polar patterns:

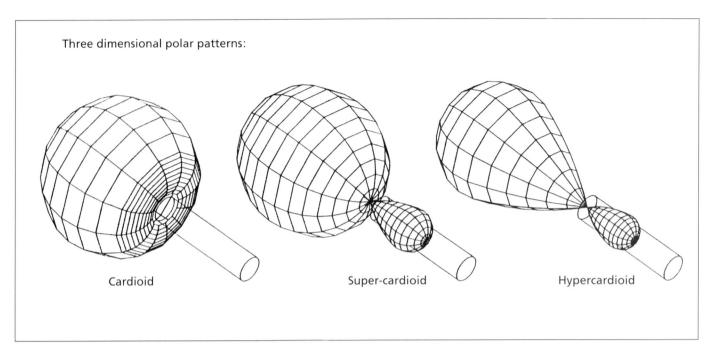

Cardioid Super-cardioid Hypercardioid

farther away from the sound source than an *omni*.

Super-cardioid, Hypercardioid and **Lobar** imply a greater and more progressive degree of directionality than cardioid, and a greater degree of attenuation of the sounds coming from the sides. It is, then, incorrect to say that they pick up sound only from the front but, depending on their design, they reject most sounds from the rear and sides.

When they are fitted into a tube, which has specially milled slots and baffles in it – to further cancel out sounds coming from the sides – they are called *shotgun* mikes. Just *how* directional a shotgun is depends on its polar-pattern. *Lobars* have a narrow angle of acceptance – a mere 60 degrees around the target – and may be too directional for the inexperienced or lone cameraman, whereas hyper and supercardioids 'fan out' to 110 degrees.

Shotguns can be used up to four times further from a sound source than an *omni*. This does not mean, as is sometimes supposed, that they can

Sennheiser K30AV with directional module, attached to telescopic mini-boom. (Photo: *Sennheiser*)

be used to 'magnify' or pull in sounds from great distances. For instance, the normal *omni* distance, for fully modulating the voice of one speaker, and minimizing 'background', is between one to one-and-a-half feet. Therefore, a *shotgun* should not be positioned more than four to six feet away to produce the same effect.

The only way to fully modulate a sound and cut out unwanted background – so that the wanted sound 'marries' to the camcorder's viewfinder image – is to use a *cardioid* or *shotgun* on an extension cable, and position the mike as close as is necessary (judged by monitoring) to the sound source.

Polar pattern plan view showing how pattern varies according to frequencies.

Balanced and unbalanced
Microphones may be balanced or unbalanced. In layman's terms the balanced mikes are more professional since they contain two thin conductor wires in the cable: one marked + (plus) to carry the sound's voltage, a second marked − (negative) to return it and carry away stray signals and hum. A third braided wire 'earths' the circuit. Balanced mikes need balanced inputs (the socket the mike plugs into) and require three-pin connectors.

Unbalanced mikes have only one conductor wire to carry the voltage and a braided 'earth' which doubles as the negative conductor. These require unbalanced input sockets and are the type used by practically every domestic camcorder using the mini-jack plug.

Balanced mikes may be converted to unbalanced by soldering together one of the conductor wires to the earth braid and fitting the appropriate two-connection mini-jack.

Impedance
In broad terms, impedance is an electrical resistance which is measured in ohms. This need not concern us greatly since mikes are usually either high or low impedance. Low impedance is between 200 ohms and 1000 ohms whereas high impedance is 47,000 ohms or more.

What is important is that you choose a mike of the impedance rating that matches the one given in the camcorder's instruction book. Almost invariably domestic camcorders have low impedance unbalanced sockets.

Examples of Polar Diagrams

CARDIOID

1 KHZ ———
10 KHZ — — —

SUPER–CARDIOID

1 KHZ ———
4 KHZ — — —

Stereo

Many camcorders have stereo recording capability and therefore have left and right mike input sockets. This implies two microphones or a one-point stereo mike – one mike with two recording modules. There are, though, many times, perhaps the majority, where true stereo imaging is not required or only one mono mike

A boom-mounted (out of shot) mike allows greater control. (Photo: Terry Mendoza)

is available. Nevertheless, mono recordings always sound better if they are recorded on both channels. So even when using one mono mike connect it via a 'Y-shaped' connector to both sockets.

Which mike

The amateur, shooting real life in real time as it passes the lens, and on a limited budget, often works alone. And for him, with only one pair of hands, often, the only choice is to use a budget-priced, camera-mounted, multi-purpose mike; an electret one

which is switchable between 'wide-angle' (cardioid or unidirectional), and 'telephoto' (supercardioid or superdirectional) and position the camcorder, and therefore its mike, as close to the target as possible.

When the mike is switched to 'tele' or supercardioid, the amount of amplification is increased by up to four times more than 'wide-angle'. However, this increase in amplification does not come without penalty: the 'noise' – a mushy hiss made by random signals produced by the electronic components in the mike – in-

The Sennheiser K30AV/ME88 long shotgun. (Photo: Terry Mendoza)

creases also. It's a bit like the 'mushy' background sound on medium-wave radio, and sometimes, when recording a quiet target, this 'noise' can be louder than the target itself.

In general, when the target is outdoors and is a single speaking voice against a fairly quiet background sound, the mike, using 'normal' cardioid, should not be further than 6–10 feet away, and no more than 11–25 feet on its 'tele' setting. Indoors, the 'tele' or supercardioid setting is likely to be too 'noisy'.

Tie-clip mike

Perhaps the one mike which should be in everyone's collection is the electret omnidirectional tie-clip. It's usually no more than one-inch long and comes with a miniature crocodile clip. Its small size therefore makes it very easy to conceal.

Apart from the obvious use of fitting it to an interviewee's clothing, it can also be connected to an extension cable and fitted to things: fences, hedges, wires, etc.

Indoor recording

Because sound travels by creating vibrations in structures, and produces waves in the air, recording indoors can produce problems. To a microphone, even a supposedly quiet room will not be entirely silent. It will pick up the *acoustic ambience*.

The fridge, central heating, draughts, and other 'machines' in other rooms will transmit sounds through walls and floor to the mike, even though the human ear/brain might not notice them. To this will be added to the electronic 'noise' generated by the mike and the camcorder's amplifier.

Secondly, when sound waves strike the walls, ceiling, floor, and furniture – they bounce, bend and reflect, and some frequencies are distorted in the process. The harder and shinier the surfaces, the greater the bounce. This bouncing takes the sound waves on a journey around the room – which takes from milliseconds to seconds depending on the size of the room – then back into the mike – which, because it's receiving a *distorted* repeat of the original sound, records it as echo, mush or hollow boominess. As an exercize to test this, try recording in a fully tiled bathroom and compare it to a recording made in a carpeted and furnished lounge.

Indoors, use cardioids, tie-clip, or shotguns, for best results, but ensure they are not positioned so that they directly face walls or other 'bouncy' surfaces behind the 'target' sound source.

Monitor everything and make test recordings. If it's still too boomy, cover highly reflective hard surfaces like doors, wooden tables, and walls with sound *absorbing* material such as duvets, blankets, drapes, etc. – anything to absorb those bouncing waves. And keep the mike itself off hard surfaces or place it on a cushion, (or something similar) to absorb vibrations.

But I repeat, the *ONLY* way to

hear precisely what the mike hears in the *way that it 'hears'*, to know whether the mike is close enough, to hear whether it's collecting the sounds you want – or 'garbage', is to monitor through *proper* headphones which must also be of the correct impedance.

Outdoor recording

Traffic rumble, wind-roar, and other low frequency sounds from 20Hz to 250Hz, are the outdoor recordist's worst enemy. This is because low frequencies make larger air-waves and produce greater vibrations through the ground, buildings and structures and therefore travel farther than higher frequencies.

This in turn means that even though the listener is a good distance from the origin of the sound, the low frequencies tend to 'drown' out the higher frequencies. For example, from outside a disco (or a neighbour's party – always a source of great irritation!), the thump of the bass can be clearly heard while the mid-range vocals are barely distinguishable. Similarly, traffic rumble can infiltrate even from considerable distances.

Most professional mikes, like the Sennheiser K30AV series, have switches which electronically filter out, or roll off, selected lower frequencies (from say 250 Hz downwards) in stages, say, -5dB, -10dB, and -15dB.

As every -6dB means an approximate halving of the selected frequency sound loudness, this is a very useful facility. It means that a recording of someone (close miked) standing in the middle of a roundabout surrounded by traffic, doing a speech to camera, will not have his voice 'drowned' by traffic rumble because even the deepest voice has no useful frequencies below 150 Hz. So cutting frequencies below it does not affect voice recordings – it only reduces the traffic rumble.

For 'ordinary' mikes, one of my video club colleagues cuts bass frequencies by soldering an 'L' pad into the cable (see Figure 1). A 15nF capacitor is soldered into the thin conductor wire and a 40k ohm resistor is soldered from the 'bottom' leg of the capacitor to the 'earth' braid. This should roll off frequencies starting below 250Hz by 6dB. Changing the value of the resistor to say 30k or 50k changes the frequency, so maybe the best method is to make it up in a matchbox-size box with changeable plug-in resistors and a mike-input and output socket so that alternative mikes can use it.

Another colleague, prefers instead to cut frequencies starting down from 150Hz by 12dB. He uses two 'L' pads wired in series: each capacitor is one micro-Farad (1nF) and each transistor 1kohm (see Figure 2).

The components for both methods cost mere pennies from radio spares shops.

Wind roar

Wind roar (not to be confused with the *sound* of wind) is a low frequency sound caused when the wind strikes the mike. Even on a fine summer day the wind speed can average 10 mph and buffet the mike, so there is no better cure than preventing wind striking the mike in the first place.

Professionals use proper and expensive windbaskets in which the mike is held in an anti-shock mount suspended centrally in a free air-space in a porous basket. The basket can in turn be covered with additional *porous* gags or furry muffs.

The object is to prevent vibrationally transmitted sound reaching the mike, and to channel the wind through numerous perforations and baffles until its velocity, upon reaching the mike, is reduced to zero.

A simple windbasket can be made cheaply and effectively using layers of special *porous* open-cell plastic foam interleaved with porous shaggy nylon fabric – the type used for making cuddly toys. Ordinary foam, made for furniture, is closed cell, so it is not suitable since it is not porous.

Open-cell foam may be cut, glued, stitched or taped and even a couple of quarter-inch thicknesses taped round the mike will work wonders. Additional gags or muffs can be made from the shaggy fabric.

It is, though, important to cover all the mike – not just its recording end. Any part left exposed will simply transmit the wind roar through vibration.

Automatic recording control

Most domestic camcorder's sound is controlled by an automatic gain control (agc), and after wind noise and traffic rumble, it's probably the biggest single cause of poor quality recording because 'automatic' does not imply *perfect*.

Its function is to hunt for a sound, 'sample' it, then adjust the recording amplifier up or down (fast down, slow up) so that the loudest sound it 'hears' is recorded at full modulation.

Therefore, if the 'sample' is a quiet one (a whisper) the agc, thinking it's

"L" pads soldered into mike cable to cut bass frequencies.

Fig.1

40K 15nF

Fig.2

1K 1uF 1K 1uF

under-modulated, will pump it up to full level. But, if while recording this, it suddenly also hears a loud voice, the agc then thinks that it's over-modulated so it pumps the level down. Result? Loud voice gets reduced and whisper disappears out of earshot. This creates a see-saw effect – sometimes the recorded sounds are too loud, and sometimes too quiet.

With manual control, once it has been set to fully modulate the loudest sound, all quieter ones remain at their respective levels.

With agc some help is given if, before shooting, the camcorder is set to 'pause/record' because the agc is switched on and starts to pump. Our guy on the roundabout can then say a few words which supplies the agc with a sample with which it sets a recording-level. Then, the guy stops speaking and, immediately after, 'pause' is released. He must then start his proper speech within two to three seconds – before the agc has a chance to start 'pumping' again.

Also, a 25kohm log potentiometer soldered into the mike's lead can act as a means of reducing the signal strength (a mixer will do the same thing). Its knob can be turned up from zero, very slowly, until the loudest sound is fully modulated, then turned down slightly thus leaving quieter sounds 'unpumpable'.

Summary

- Put a tie-clip mike top of your requirements, then add a shotgun – preferably with bass roll-off switches – as the next priority.
- Make a windshield for each mike.
- Always position the mike as close as possible to the sound source.
- Always monitor through headphones.
- Beware of cheap radio mikes – they are a mixed blessing. Sometimes, even when transmitter and receiver are in direct line of sight they can pick up unwanted 'broadcasts', hum and 'fizz' from passing cabs and other sources. At other times they work fine – especially those operating on VHF – but the sound quality is usually better on cabled mikes.

Tie-clip mike with crocodile clip.

Recording glossary

Attenuation – the reduction in signal strength measured in dBs.

Decibel (dBs) – a measurement of loudness as a ratio.

Dynamic range – the difference (in dBs) between the quietest and loudest sounds being 'played' or recorded.

Frequency response – the range of frequencies or tones (Hertz) responded to or recordable by a recording device.

Flat response – when a mike/amplifier records all frequencies at the same level, i.e. without boosting some and cutting others.

Full modulation – when the signal being recorded is at its optimum level; such as when the loudest sound pushes a VU meter's needle to reach zero and no higher. Also known as nought (0) VU.

Gain – the amount of signal amplification. When 1dB input is amplified to output at 10dB the gain is said to be 10 times.

Hertz – the number of waves per second which identify a specific frequency or tone.

Noise – random high frequency signals self-generated by the components in microphones, amplifiers, tapes and electronic circuits.

Sensitivity – the number of millivolts (mVs) of signal (or −dBs of sound) required to provide acceptable sound quality. The lower the number the higher the sensitivity.

Signal – once sound has 'passed' through a mike or line-input it becomes electrical energy and is referred to as the signal.

Signal-to-noise ratio – the ratio of *wanted* signal to unwanted noise, (see **Noise**) measured in dBs. The higher the ratio the better.

VU (volume unit) meter – measures the loudness of sound in decibels. When a sound is fully modulated the meter reads 0 (nought). Too loud, and the meter goes 'into the red'.

10

USING ARTIFICIAL LIGHTING

Battery vs mains power;

Inverse square law;

Four lamps;

Lighting for action;

Mixing light;

Lighting for drama

Proper halogen video-lights produce roughly three times the light-output of equivalently rated domestic tungsten 'bulbs' and, with a correctly set camcorder white-balance, colors appear contrasty and natural with no obvious cast.

There will be many times – especially in winter – when they come into their own because even though your camera might be capable of recording a black bat in a black cave, there comes a time when more light is needed to produce acceptable picture quality. This is because a camcorder working at minimum light levels – say 10 lux – has its video amplifier pumping flat-out and its lens aperture wide open – a combination which brings a 'noisy', soft-focus, flat contrast image with virtually no color or depth of field.

Battery vs mains power

On the face of it, all that is required is a single battery-powered video-lamp attached to the top of the camera. Indeed, such a lamp brings advantages:

lightweight, no extra hands needed – a lot better than no light at all, and battery-power is safe having no trailing mains voltage cables. Just the ticket to record those excited toddlers when they get their parents out of bed at five o'clock on Christmas morning.

Its disadvantage is that its output is likely to be restricted to around 100 watts, which means moving to within a few feet of the subject to achieve reasonable illumination levels.

Mains-power camera-top models are brighter but usually restricted to 300 watts because, as the amount of watts/light is also the same amount of watts/heat, a higher wattage could produce too much heat close to the camcorder's plastic and electronics. And, although camera-mounted lights are invaluable for 'newsreel' material, their 'front-on' light pattern gives harsh shadows, reflects 'dazzle' back to the lens, produces an

Nicely lit but blue gels were not fitted over lamps and white balance was incorrectly set – hence orange cast.

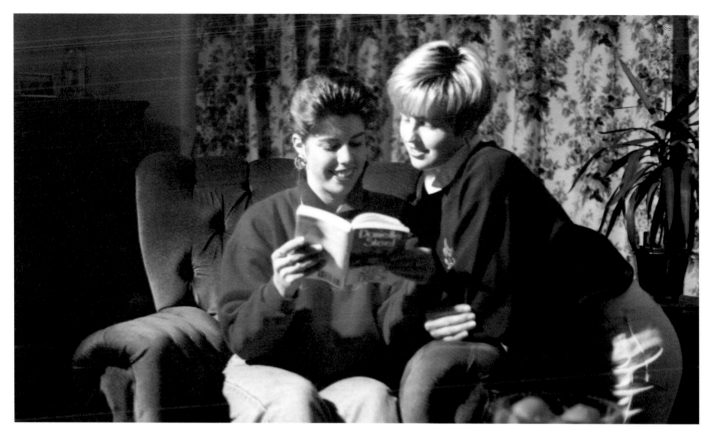

One single lit lamp produces too much glare and shadow.

Four lit lamps, but backlight and fill light not quite strong enough.

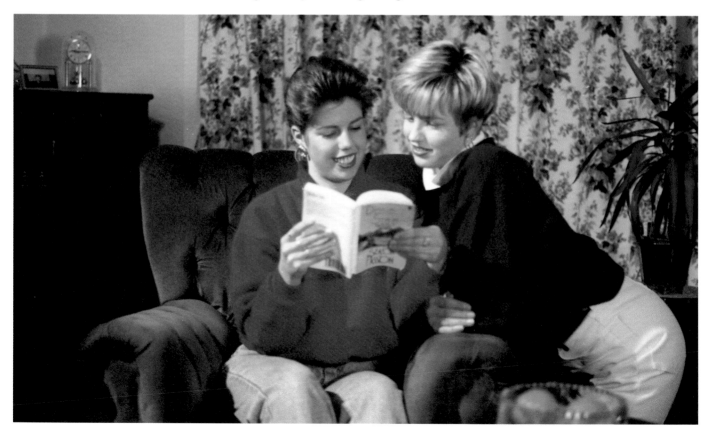

The inverse square law.

Doubling the distance reduces the light to one-quarter of its illumination.

2D

D

Four lamps: 1) Key-light 2) Fill-light
3) Background-light 4) Backlight

over-lit foreground, a very dark background and extremes of contrast.

Using one lamp in most situations, then, does produce images that *look* artificially lit. And, if a second subject is behind the one closest to the camera/light it may not receive enough illumination. This latter situation is caused because the strength of light falling on the subject varies according to how far the subject is from the light source.

Inverse square law

It's all due to the inverse square law which every videographer should print under his eyelids. It states: 'Relative illumination at any radial distance from a point source of light is inversely proportional to the square of the distance itself.' In practise this means:

Outdoor night shots – lamp is concealed behind shrub.

- **Doubling** the distance between the light and the subject reduces the illumination to *one quarter* of what it was.
- **Trebling** the distance reduces the illumination to one ninth of what it was.
- **Halving** the distance *increases* illuminations by *four times*.

However, dark backgrounds are brightened a little if the light source is spread by a large enough diffuser – the effect of the inverse law is less severe. Therefore, single lamps are always more effective, if say, they are 'bounced' off a white ceiling or shone through a photographic white umbrella.

Four lamps

In a controlled 'studio' atmosphere where natural daylight is excluded, a four-lamp set up – key-light, fill-light, background-light and back-light – is reckoned to be the minimum requirement to produce a

'natural' look on screen, even though it's anything but natural to the naked eye.

If, for example, we light two people (the subject) on a settee which is four feet away from a wall in an average lounge, we need to light the wall behind the people as well as the people themselves because the inverse law tells us that, if we don't, the shot will show two brightly lit people against a very dark wall. So a typical set up might be:

(1) Key-light 1,000 watts. This tries to take the place of nature's key-light – the sun – and is positioned as high up as possible, about 12 feet away from the subject, and slightly behind and to one side of the camera.

(2) Fill-light, probably only half the power or less, is placed lower, closer to the subject, and positioned so that it knocks out or reduces the shadows on the subject caused by the key-light.

Three-lamps: the background lamp is not used because the black background was important in this shot. Note the circular reflector has been used as a fill-light. (Photo: *Elizabethan Photographic*)

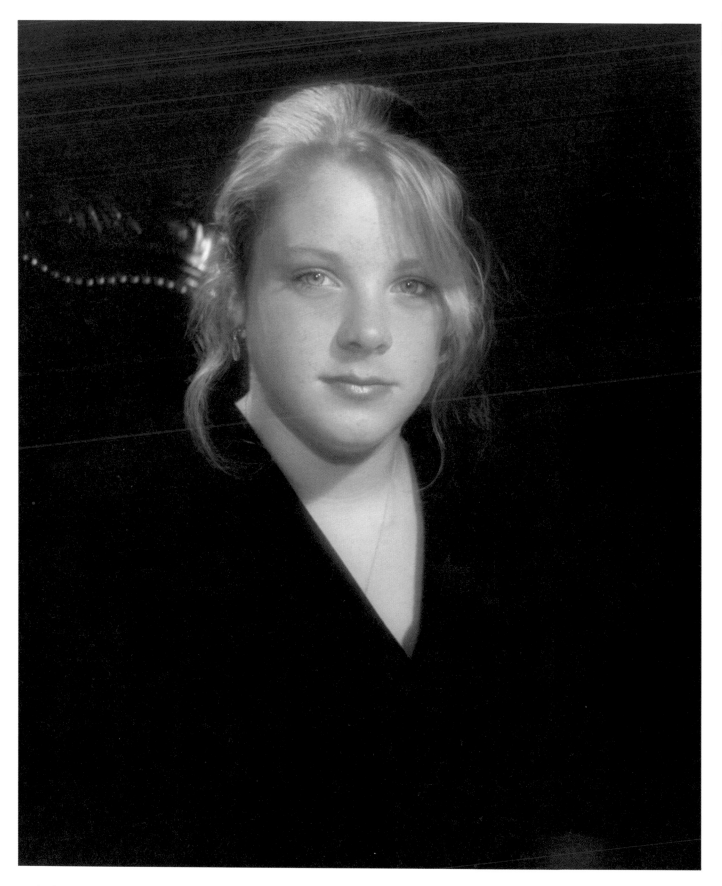

Typical three-lamp studio-style portrait.
(Photo: *Elizabethan Photographic*)

Four lamps correctly balanced.

(3) Background-light. Say 500 watts, this is placed to illuminate the area (lounge wall) behind the subject and is usually concealed (behind the couch) from being seen by camera: it takes away that two-dimensional 'flat' look by giving an illusion of depth.

With the above three lights in place, it's time to set white-balance, lens-iris, and lock the setting (where possible) for optimum results. If this facility is not available, set the next and final lamp.
(4) The backlight. Every good still-cameraman knows the importance of this one: positioned up high between the background (wall) and the subject, it points towards the camera position (but not in the lens) and 'rim' lights the subjects' hair, adding 'sparkle' and making them stand out against the background.

Auto-only controls can be used but, because we have a backlight, press the backlight-button when making the shot.

All of the above lights, except the backlight, give a more pleasing look if they are diffused in some way. Diffusing lowers high contrast, removes 'shiny' foreheads, masks unwanted reflections, and spreads the light more evenly, thus beating the inverse law. And of course, reflectors can always be used to soften shadows.

Lighting for action
The four-lamp set up is only used when subjects are fairly static as in the above example or some interview-type scene. It's no use backlighting where lots of spontaneous and separate actions are going on in a large area. Instead, set up 'bounced' or diffused light 'spread' as evenly as possible.

Large areas, such as community halls, need more lamps, possibly 2,000 watts each, and that's a lot of heat and electricity. It's therefore imperative to ensure the venue's wiring circuit can cope; that cables are kept out of the way and every lamp is fitted with the correct fuse.

Where, though, you have control of the action, say, in your home or a set of some kind, it may be possible to replace normal tungsten bulbs, which produce a yellowish color cast, with low wattage photoflood ones. Fitting them into a couple of strategically placed table or standard lamps will produce a natural look where they appear in shot.

Mixing light
Mixed light, such as daylight coming through a window into an artificially lit room can cause problems because all light is colored. Its *color-temperature* (hue or tone) is measured in 'Kelvins' – the higher the rating the bluer the color.

Our brains and eyes instantly

"Reflecta 8002" mains-powered studio lamp with barn doors. (Photo: *Cygnet Photographic Co*)

adapt to any 'temperature'. We *know* a white card is white whether it's lit by a low-Kelvin yellow or a high-Kelvin blue. A camcorder can't do this because the Kelvin range is too great for the white-balance circuitry to cope with. Therefore, if it has been set to 3,400K artificial light, average daylight coming through the window at 5,000K will appear deep blue and everything in its lighting path will have a bluish cast. If, on the other hand, the white balance has been set for daylight, artificially lit subjects will have an orange cast.

There are two solutions. The first, and most difficult, is to cover *all* the windows with transparent orange

Place Key light at least 45 degrees higher than the subject's eyeline.

45°

gel material. This cuts some of the light while simultaneously changing its color. It is available from specialist photographic shops and comes in rolls that look and handle like cellophane.

The second, cheapest and easiest solution is to make the artificial light as blue as the daylight. Photographic-lamp dealers supply heat-resistant blue gel correction-filters in sheets for cutting to size. They are fitted in wire frames which leave around a three-inch gap between lamp and gel to prevent them burning.

So light is not just about brightness, it's also about color. Therefore, if the camcorder's viewfinder is in black and white it pays to check all set-ups, with reference to how it looks, on a color monitor.

And please, always remember you

Hama camera-top lamps. (Photo: *Hama PVAC Ltd*)

are also dealing with heat and electricity. Never be tempted into buying cheapo 'iffy' lamps from dubious sources. Be safe! Don't use long cable runs. Don't fit table or ceiling lamps with photofloods of a wattage higher than they are designed for. And do ensure that all plugs are fitted with the correct fuses.

Lighting for drama

Dramatic fiction movies use lighting to influence mood. The haunted house scene, for example, will rely on lots of eerie shadows simulating broken moonlight through windows. In these circumstances, the video agc needs, where possible, to be switched off or it will be trying to lighten the shadows that you have so carefully created.

There really are no rules for dramatic action lighting. Indeed, rules here are best broken and experimentation is all.

Similarly, outdoor night shots have their own special needs. The

hours of darkness absorb huge amounts of light but even when huge amounts are used, if the lights are carefully placed, it will always appear to be night. One should aim to place lights so that the action or characters move from one pool of light to another.

In, say, a woodland scene, lamps may be placed behind trees or bushes to simulate moonlight; they should be positioned in such a way that they do not cast multiple shadows or the effect is unnatural. Similarly, street scenes need lamps positioned in such a way that the light appears to come from normal sources such as street-lamps, shop windows, houses or cars. In these circumstances, multiple shadows will not be unnatural.

In such areas where there is no question of using mains power such things as car headlamps, torches and battery lamps can be pressed into service. In all cases, sheets of white material or reflectors can be used to lighten shadows for the close-ups.

11

THE 'GRAMMAR' OF MOVING PICTURES

The camcorder user new to the hobby does not always recognize that he has in his grasp one of the most powerful tools of communication; a means of telling a story or putting a message across in a language understood worldwide – the language of moving pictures.

Every language, though, has its own grammar – a set of rules which govern how its words are used to communicate their meaning in a clear and unambiguous manner. So, even though a camcorder is a marvel of technology, without a literate and knowledgeable operator it is no more than a dumb non-thinking object; it cannot render any kind of judgment or 'write' anything anybody wants to 'read.'

Since this point cannot be emphasized enough let me make the comparison of the novice writer who has just bought himself another modern marvel, the wordprocessor. With it the writer is able to manipulate words in a way that no pen or typewriter ever could. Yet, if he wants to be understood, the writer still has to arrange the words in a logical order – *on the sat cat mat the* does not convey the same message as *the cat sat on the mat.*

In addition, commas, semi-colons, periods and other punctuation marks, are used to organize words into meaningful phrases and sentences, which are in turn grouped in paragraphs and chapters.

Similarly, if a camcorder's pictures are not shown in a 'grammatical' way, the viewer is presented with a garbled, confused and incomprehensible message.

Amazingly, some people *think* they know all about the 'grammar' of moving pictures without ever studying the subject or having any formal instruction whatsoever. This is partly due to the influence films and television have on all our lives. We watch them and become convinced that there really is nothing to it.

In reality, a TV documentary takes an army of highly skilled specialists several weeks or months of work before the end product hits the screen. And a two-hour fiction film can be years in production. The fact that it *looks* so easy is due to the art and skill of the makers. TV's slick professionalism disguises itself; it's an art that conceals art.

However, because *one picture is worth a thousand words*, learning movie 'grammar' is, in many respects, easier than written grammar provided its ABC is thoroughly understood. And whether shooting family records, weddings, documentaries or fiction dramas, learning the grammar brings a whole new pleasurable dimension to the hobby – and an appreciative audience.

The whole basis of it is continuity – the uninterrupted flow of sequences of moving pictures which communicate a message or tell a story.

Imitating eyes

The fundamental unit of continuity is the *sequence*, which may be defined as a series of *related* shots forming a 'sentence.' Its three basic ingredients are: the long-shot (LS), mid-shot (MS) and close-up (CU). Used in a correct and logical order, each shot becomes an 'imitation' of the viewer's own eyes; it shows what he sees in the *way* that he sees it.

For example: looking out of the window of his hotel on *Costa-packet* a holidaymaker looks down on the harbor and beach. The scene is new to him so he pauses a few seconds while his eyes flick about taking everything in: the sailing boats, the crowded beach, cars parked around the perimeter and so on. He's familiarizing himself with the surroundings; he's *establishing* his location.

Next, his eyes settle on a particular scene within that location, say, a section of the beach where three fishing boats are unloading. His full attention now focuses on them. The fishermen are, however, too far away to be precisely observed. So, he goes down to get a closer view.

If we want to imitate this natural eye function we must shoot the pictures in such a way that they bear a close approximation to the way the human eye works. This is the basis of all movie grammar.

Let's start by videoing the above scenes from this holidaymaker's viewpoint.

The long-shot (LS)

The camera (on a tripod) with its lens

at the wide-angle end of the zoom is set up in the window, and two or three rocksteady long shots are made *without panning* to cover the location. Each shot's running time is long enough for the viewer to study its inner details and get a 'feel' of the atmosphere. The function of these long-shots is for the viewer to establish his geographical location just as the holidaymaker's eyes did.

The novice cameraman would be tempted to shoot these shots as one continuous pan. But, in these circumstances, a pan would be inappropriate since eyes do *not* pan – they dart about each section of the scene in a way which no camcorder can match. Pans have their place – mainly to follow a *moving object* – and we'll look at panning later.

The mid-shot (MS)
Next we select one scene from the last shot (the three boats) for closer scrutiny – the MS. Here we must go out of the hotel – as the holidaymaker did – and the camera is moved much much closer, but still on wide-angle, and framed so that only the three boats and their immediate surroundings are shown. Again this has imitated what the holidaymaker's eyes did. Now we can see more detail but we can't see the faces of the boats' crew clearly or exactly what they are doing.

This leads us to get even closer – to frame just one of the boats and shoot this for six or so seconds. This has the on-screen effect of leading the viewer logically and progressively to concentrate on the next, even closer, detail of the activity.

Close-ups
We move position once more (change angle) and use the zoom lever to frame close-ups of faces, hands, baskets of fish and so on.

Again, the beginner is not likely to recognize the importance of the

There is no rule to say how wide a view a long-shot (LS) should be, or how close a close-up (CU) should be. What is important is that you should establish enough of the geographical location before moving in for MS and CUs. (Photos: Terry Mendoza)

'grammar' of these shots. As like as not, after his initial pan, he'll *zoom* straight in to the subject. But eyes do not zoom. Indeed, the presence of a zoom-shot breaks the continuity by calling attention to *itself* not the subject. Only the wide-angle end of the lens shows scenes in the same way as our eyes do; sizes of people or things look right, distances between them can be accurately judged as can the speed at which they move in relation to one another or their surroundings.

The closer the zoom gets to its telephoto end the more it distorts perspective, reduces the depth of field (the distance in acceptable focus), destroys the illusion of the third dimension, and screams out 'Amateur!' Therefore, the general rule is: *move the camcorder* to frame each shot at the wide-angle end of the zoom. Zooms have their place but 90 percent of the time zoom-controls are only used to make final adjustments to the composition of the shot before shooting.

To sum up, the basic sentence is:

(1) establish the location with one or more LSs.
(2) identify the specific scene with one or more MSs.
(3) shoot close-ups of the detail within the action.

But, before making any of the above shots, look for the best camera angles and points of view.

Variations

There aren't any rules about how close a close-up should be or how far away a long-shot should be shot from. It's a trial-and-error exercize governed by the size of the image in the viewfinder and what the camerman wants to show. A close-up of a baby's face might be shot from about 4 feet away; that of an elephant's from 20 feet.

There will be occasions, though, when the final action needs a mixture of mid-shots and close-ups. If, for example, you wanted to leave this one boat and show the action on one of the others, the three boats would need re-establishing with mid-shots before moving in for close-ups of it or the viewer will not know you've switched boats.

The simple scene

Even simple situations need this basic grammatical approach. A scene of one man repairing his car in the street might be covered thus:

(1) a long-shot showing him and the car in the street,
(2) a closer mid-shot,
(3) close-ups of his face and what he's actually doing.

Each new location (and one movie might contain many) must be treated with the establishing LS, MS, CU and re-establishing technique. What's important is that the viewer should be led progressively and logically from one or more establishing long- and mid-shots to close-ups of the final action. Alternatively, to create an air of mystery, do it the other way round – start with a giant close-up, then pull back to mid-shots to reveal the who, what and where.

Long-shot (LS) establishes the scene.

Mid-shot (MS) identifies the specific action within the scene.

More about composition and close-ups

Sooner or later the creative thinking novice begins to wonder why some of his shots are not as good as he'd hoped they would be; why so much of the main subject's image, which seemed to loom large in the viewfinder at the time of shooting, seems quite small and insignificant when seen on the television.

The reason is poor composition. But it's not quite as simple as that; it's also to do with the psychological adjustment needed when the human eye/brain is confronted by the rectangular shape of the viewfinder itself. It works like this:

We first see our subject in real life through our eyes but it's our brain that has told us what it is. It's the brain that has made the decision to concentrate our attention on this specific object while paying less attention to the surroundings. Ears are also feeding information simultaneously so while we are not paying full attention to the scenery and goings on surrounding the subject we are *aware* of them. In effect, the brain has 'framed' the subject.

This mental 'frame' still influences the novice as he puts his eye to the viewfinder; he forgets that, to the camcorder, the 'mental' frame does not exist. He therefore looks *through* the viewfinder, locates his subject, and as long as he can see it there somewhere he makes the shot.

The experienced videographer, however, never looks *through* the viewfinder at all – he looks *at* it. And before making the shot he recognises that the quality and quantity of the visual image, right up to the edges (or sides) of the rectangle, is just as important as the main subject *within* that rectangle.

In short, the viewfinder's rectangular image is the supreme commander of all that will be seen on the screen. And the camcorder user must train his eye/brain to look at the rectangle only, ignoring the mental 'world' outside it because, to the viewer, no other world exists.

Getting in close

It is particularly important to get to grips with this attitude when framing close-ups. Indeed, in any film, the quantity, quality and frequency of close-ups and the way they are composed within the rectangle can say a lot about the creative ability (or lack of) of the director/cameraman. This is because the effect of close-up shots, especially faces, cannot be overrated. They have such a magnificent visual impact that experienced amateurs and professional videographers seek to use them frequently and with unabashed delight whereas the novice cameraman seems to avoid them almost as a deliberate act.

Psychologists have an explanation for this too: it's based on what they call the invasion of 'intimate and defensive' space. The theory is that, when in the company of strangers, each individual tries to leave a 'just-in-case' self-defense zone of three to four feet between himself and the next person.

Creating this defensive zone goes back eons to when men kept a club's length apart from each other. And

A Close-up (CU) of the person involved . . .

. . . followed by CUs of what he's doing.

Inside the "defense" zone but on a 22"
TV set, faces would be less than one-
inch long.

CU from shoulders to the face,
although only six-inches long, is clearly
recognisable.

even today the vast majority of us are brought up to respect it without even thinking or consciously knowing about it. We just accept it as the polite thing to do.

However, when two strangers are introduced to each other, each allows the other to take a step just inside this defense zone and a handshake – which is supposed to declare a friendly and non-aggressive intention – takes place. Later, as the two become better acquainted, they may even permit each other to get inside the secondary inner zone known as the 'intimate space' area; an area where only trusted intruders are permitted.

Here then, is the novice videographer's dilemma: he knows that his camcorder, especially on its telephoto setting, can peer, voyeuristically, and with no defense-risk to himself, right inside a stranger's intimate space area without the stranger's knowledge or permission.

For viewers a big CU from hair to chin creates maximum interest.

But, when the novice cameraman looks in the viewfinder, he subconsciously feels that the camcorder has become an extension of his own eye, body and emotions so he asks: 'Dare I intrude like this?'

The answer lies in considering his viewer's reactions to the shot. Viewers aren't normally there at the time of shooting so they don't have to make this personal judgment of politeness and taste. Freed from this they develop an insatiable desire to peer into, and analyze, everything in the greatest detail – especially eyes, noses, mouths and facial expressions.

The cameraman, then, must mentally separate himself from the camcorder, overcome all reticence and inhibition, and shoot not only normal head-and-shoulder close-ups but include a great many giant 'intrusive' close-ups as well. I would go as far as to say that if a cameraman never shoots closer than waist to head he'd be better off with a 35mm SLR because he'll never become a good videographer.

There are also good technical reasons for creating screen-filling

images of a face. For example, a head-to-toe shot might be close enough for the face to be recognized on a large cinema screen. But the frame-size of a typical 22″ television is approximately 18″ × 12″ and, since a person's head is less than 1/12th of the length of his body, the face would end up on screen at less than one inch long.

Getting in closer, say, chest upwards, would make the face recognizable. But for the minimum acceptable definition, where changes of expression can be observed, it has to be framed from the top of the head to the beginning of the shoulder. Even then, with normal composition leaving a margin above the top of the head, the expression-making part of the face – from lower lip to eyebrows – is not likely to be longer than six screen inches.

How the shot is framed is also important. For example, although it is possible to frame this shot with the lens set towards the telephoto end of the zoom, it does have the disadvantage that the depth of field (the area in front and behind the subject

A giant CU allows the eyes and inner thoughts to be "read" by viewers.

which remains in acceptable focus) is very small. In addition, using telephoto makes the face appear 'flattened' – lacking roundness and depth – and the tiniest amount of camerashake becomes hugely exaggerated at extreme focal lengths.

The shot is usually more 'real' if it is made by physically moving the camcorder, on its wide-angle setting, as close to the subject as its minimum focusing distance will allow before adjusting the zoom lever to frame the shot. A long-telephoto close-up is best made if it is the *only* way the shot *can* be made and it should always be done on a tripod if camerashake is to be avoided.

The eyes have it

Part of a viewer's fascination with close-ups of the human face is that eyes 'talk' and can betray inner thoughts and emotions which can be clearly seen by the viewer. Actors (and some politicians) know that when they are tightly framed in giant close-up (from eyebrows to bottom lip), the only parts of their anatomy which they can move (inside the frame) are the mouth and eyes. And by thinking the right thoughts: sincerity, anger, sadness, hate, love, determination, etc., their eyes will display that thought or emotion for the viewer to 'read' irrespective of what words their lips might say. Hence such comments as 'a shifty-eyed politician' or, the fiction-film script directions 'a smile on her lips but murder in her eyes.'

Giant close-ups of facial/eye expressions are frequently used as 're-action' shots in fiction films. For example: two actors (in mid-shot) are facing each other, and the first says to the other: 'You're nothing but a drunken piece of garbage!' At this point the editor cuts to the giant warts-and-all reaction CU shot of the second actor and, according to the character being portrayed, his face and eyes will betray the way this insult affects him: deep shock, defiance, hurt or whatever.

Outside the fiction-movie in the world of the documentary, such giant close-ups should be used with discretion because, if for no other reason, they are larger than true life. But then again – isn't that what video can achieve better than any other medium?

Adding interest

Having made the basic LS, MS, CU statement it now needs a little filling out. The most usual method is to use cut-ins and cut-aways – names given to shots which, although they might still be in close-up or mid-shot, are used in a certain way to convey a particular meaning.

Cut-ins

The cut-in is used often. And, since it has several uses, its importance is worth grasping. At first sight it is merely another close-up but it's a close-up of some important *integral* part of the action that the director doesn't want viewers to miss.

Imagine, for example, a fiction movie in which we see the head-to-toe MS of a man who puts his hand in his pocket. This is followed by a cut-in – a CU of the pocket – which shows the man fingering the butt of a pistol. The director has cut in this CU to make the pistol perfectly obvious. He's making a point which he doesn't want the viewer to miss.

Another example: in MS, a car pulls up at traffic lights. The next shot cuts in the significant not-to-be-missed item which might be: a CU of the driver, a flat tire, the license plate, a smoking exhaust-pipe, or whatever. Having made the not-to-be-missed point, the next shot might be widened to a LS or MS showing the car driving off as the lights change.

And lastly: we're at a wedding. We show several LSs and MSs of the church thus establishing the scene. In between these we cut in a CU of the clock-face thus pointing out the significance of the exact time.

To sum up: cut-ins are a shot or several shots cut in to the main action to highlight a part of it.

Cut-aways

Cut-aways are probably the most important shots in a cameraman's and editor's armory. They differ from cut-ins in that they are not an integral part of the main action and can be in the form of a CU, MS or LS.

Although a cut-away is not part of the action it has to be related or *appear* to be related to it. Usually, cut-aways are selected from a part of the scene that was already estab-lished in an earlier LS.

Apart from being interesting shots in their own right, they – and cut-ins – may be used to expand or compress real time. An example of this might be in a scene which shows a man unloading several items from his car. If the entire section was recorded with one shot it would take several minutes of real time and much of the action would be repetitive and therefore boring.

So first an LS is shot to establish the man and his car in the location, then an MS showing unloading commencing.

At this point we *cut-away* for a few seconds to a shot (MS or CU) of someone watching. The watcher must *appear* to be related to the scene in some way – a neighbor maybe, or simply a passing Nosy Parker.

Next we cut back to the car and see that *apparently* during the time we've been watching the watcher, the man has unloaded several items. The cut-away has reduced the real time from minutes to seconds and cut out the boring repetitive action. Audiences readily accept this even though – if they thought about it – it's impossible for the driver to have unloaded so quickly.

Cut-aways and cut-ins, then, are an essential ingredient of every type of movie – even family records. Let's, for instance, examine how they might be used in a wedding video.

After showing an LS and MS of the stills-photographer setting up in front of the guests, we shoot a cut-in of his camera as he clicks the shutter. This we follow with a shot of what he is photographing – a mid-shot of groups of guests.

Next we shoot short cut-aways of onlookers, confetti on the ground, and anything (maybe a cat sitting on a wall) that appears related to the scene. All these cut-aways enrich the atmosphere and compress the real time that the photographer spends setting up the next group.

And what about those holidays. In between shots of 'Mum and the children' on the beach, cut-away to dogs, seagulls, crabs, sandcastles, pools of water, sailing boats, empty Coke cans and so on. These apparently incidental shots help bridge otherwise unconnected scenes and add 'flavor.'

Action–reaction

For every action there is usually a re-action: the footballer scores and punches the air in celebration. The joyful reactions of his team colleagues must follow, as must the glum reactions of the opposing team.

Whether such shots are LS, MS or CU, reaction shots are important – especially in fiction films. If, for instance, a character insults another, nine times out of ten the next shot will be a CU of the insulted character's facial reaction, and reaction cut-aways of onlookers may also follow.

Finally, if the production is intended to be edited, the rule is: shoot at least *twice* as many cut-aways as *thought* to be needed because even professional editors complain that they never have enough.

Linking sequences

Links and 'bridges' (sometimes called transition shots) allow one scene or location to change smoothly to the next.

There aren't any rules; sometimes a straight cut from sequence to sequence is the best method while other sequences benefit from an 'arty' approach. This is achieved by juxta-posing two shots containing similarly shaped visual patterns. For example: the shot of a man stretching his arms can cut to the shot of a bird stretching its wings; the shot of a fairground big-wheel cuts to the shot of a water wheel or car wheel; a football cuts to a beach ball; a wristwatch to a church clock – and so on.

After the second shot we pull out (or zoom out) to reveal the new location or piece of new action which starts the next sequence.

Fades and focus-pulls can also be used but the camcorder's in-built fader should be used with discretion. This is because such fade-outs usually take quite a long time and signify not merely a transition but a passage of time – the longer the fade the longer the time.

The focus-pull is similar but slightly more sophisticated and can only be done using manual focusing and is best using longer focal lengths. The trick is to blur the last part of the outgoing shot by turning the focusing ring. The next shot starts blurry then comes into focus.

LS of unloading commencing . . .

. . . followed by CU of driver.

The cut-in highlights a significant piece of the action – is this the booby-trapped box?

Cutaways of onlooker . . .

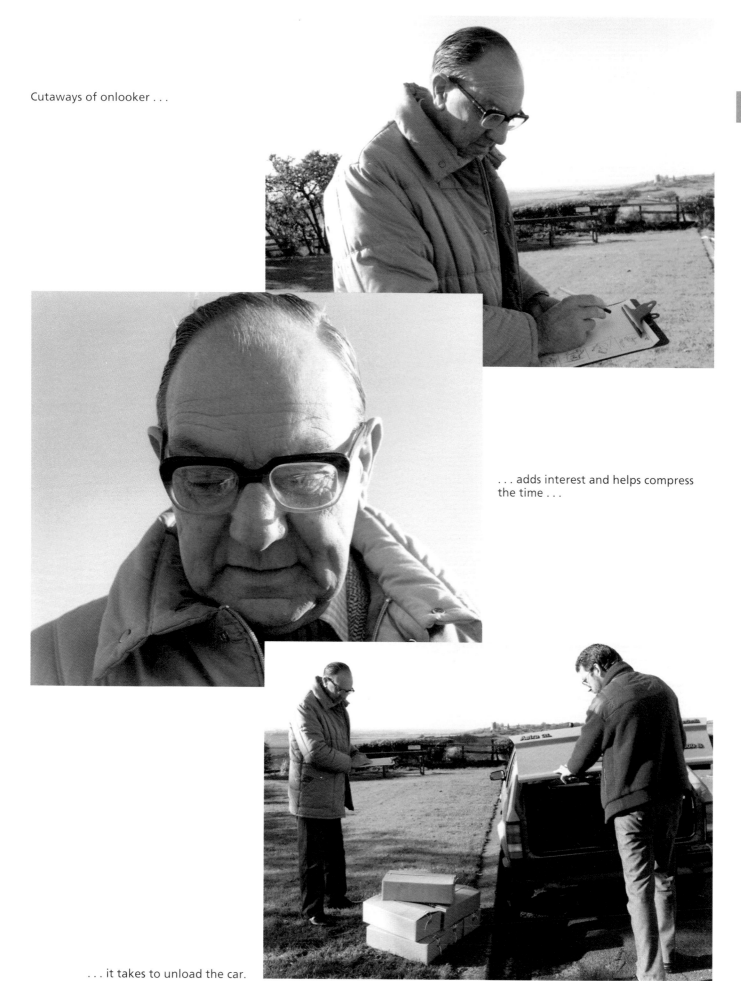

. . . adds interest and helps compress the time . . .

. . . it takes to unload the car.

Parallel action

When a movie shows sequences where the action in one location is taking place at the same time as another action in another location it is called parallel action.

This is used time and again in fiction films; the cowboy is shown leaving the ranch and entering the saloon. The next sequence cuts back to the ranch; it's saying, 'Meanwhile – back at the ranch . . .'

This 'meanwhile' technique can also be used in all types of movies provided the transition back and forth is perfectly clear. Imagine, for instance, a home movie showing father finishing his breakfast then kissing the wife and children goodbye. A cut-away of the clock shows 8.30. He strides out of the house, gets into the car, and drives off. Further shots show the car on route and from inside the car we see father glance at his wristwatch.

Fading to black when the lamp is switched off makes a "natural" transition to night.

This cuts to a shot of the kitchen clock showing 8.45 then cuts to a sequence of the mother loading the washing machine and making herself a cup of coffee. As she sits down to take her first sip we cut to the husband sitting down in his office. A clock on the office wall shows 9am.

Naturally, such techniques are usually only possible when the movie is intended to be edited and are commonplace in chase sequences where the shots or sequences alternate between chased and chasers, getting progressively shorter as the chase reaches its climax.

Avoiding grammatical errors

Most newcomers are not aware of proper grammar, and pan everything in sight in a misguided attempt to 'get it all in.' But indiscriminate panning is not how eyes work. Eyes see everything through an outer and inner circle of vision. The outer circle is somewhat blurred with only vague detail but the inner circle is focused precisely.

When scanning distant scenery, eyes pause only for a moment (sometimes only a split-second) – while the inner circle focuses on one part of the scene then darts along to the next. And no camera-pan can imitate this in the same way.

Because of this a camcorder's 'unnatural' mechanical pan-function disturbs the viewer by drawing more attention to itself than it does to the scene. And when the camera is, say, panned from left to right across a static scene the viewer sees something – which he knows should not move at all – travel across the screen from right to left.

In order for a 90-degree pan of, say, the New York skyline to work well it needs to start with (say) a three-second static shot of some meaningful point – to allow the viewer to establish what is happening – then move very very slowly and smoothly across the scene and finish at another meaningful static shot. Even then it should involve a smooth *controlled* panning movement of something like 25 seconds duration if it is to be slow enough for the viewer to take it all in. And that is an incredibly long and

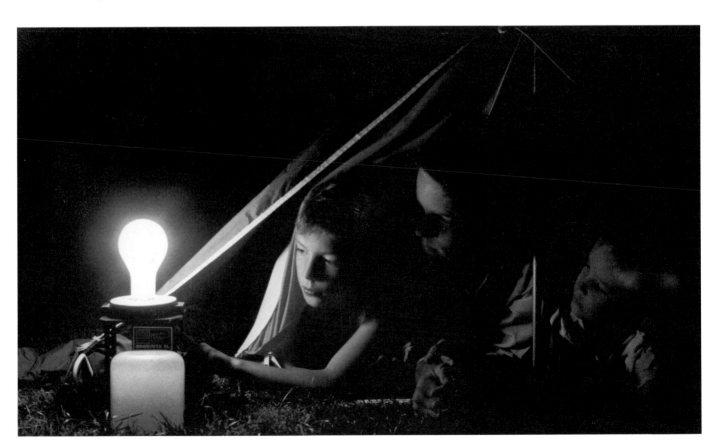

boring time on screen if the message is simply, 'This is New York's sky-line.'

In these circumstances the videographer needs to create interest by *directing* what his viewer will see by selecting one or more parts of the scene, and shooting them with, say, three-second long-shots intercut with cut-aways to mask the cuts. This is because the viewer only sees what he is shown and therefore does not miss what he is not shown.

When to pan

Having said that, panning works well if it travels slowly over a *short* distance in an arc of no more than 30 degrees, and is used for a specific and *meaningful* reason such as showing the relationship of one place or object to another. For instance, on one side of a park is a church and fifty yards to its right is a bar. We show a three-second static shot of the church then pan to show how close it is to the bar. Even then it's more effective if it follows someone or something moving between the two.

In general then, pans of static subjects should start and finish with a stationary shot, and panning a static scene should only be considered as an option if it is the best or *only* option.

Panning with a *moving* object is a different kettle of fish. It works and works well because this is precisely what eyes do – the inner circle locks onto the movement and holds it in perfect focus all the time and is only vaguely aware of the passing background. Therefore, pans to follow someone crossing a room, to follow a car, or to follow a dog chasing a stick are all legitimate 'eye-function' shots.

The only general rule when holding a moving object in the frame is: split the frame vertically into thirds. Locate the object to one side – in one third – of the picture, leaving two thirds in front of the object as *apparent* freespace for the object to move into.

This 'freespace' is a psychological screen phenomenon. If it's not there,

Juxtaposing similar shaped images provides a thematic or "arty" link between different locations.

the viewer gets the impression that the object is running out of space and about to leave the scene.

Maintaining continuity of direction is important: the shot of a person or object moving from (say) screen-left to screen-right should not be followed by a shot of the same person or object moving from screen-right to screen-left. When this happens, the camera is said to have *crossed the line* of travel direction.

A way of grasping this is to imagine this *line* is a road upon which a person is walking and passing the camera from say, left to right. As long as the cameraman makes all his shots from one side only of the road the person will always be seen walking in the same direction – left to right.

But, if the camerman stops shooting, then crosses to the opposite side of the road and starts shooting again, these new shots will show the person *apparently* walking back the way he came, in the opposite direction to the previous shots, from right to left.

Head-ons and tail-aways

However, *crossing the line* can be done and in a 'grammatical' way by intercutting or shooting head-on and tail-away shots – sometimes referred to as *neutral* shots – which, if used with our old friend the cut-away, mask the apparent change of direction. My pictures show how a sequence of shots can be constructed to do this.

A close-up pan of runner's face.

Mid-shot pan which follows the moving runner. Note the "freespace" for the runner to move into.

The camcorder was placed directly on the line with the runner coming "head-on" towards the camera-position.

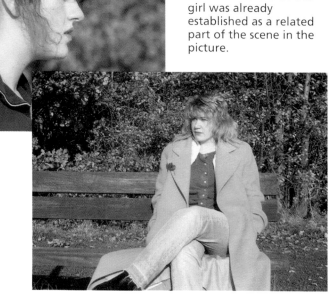

MS cutaway of the seated watcher: note that this girl was already established as a related part of the scene in the picture.

A panned close-up of moving feet. At this point the line has been crossed.

The tail-away – another "on the line" neutral shot – completes the sequence.

The camcorder stops filming when the boy (walking towards the camcorder) reaches this point.

The incorrect second shot. The camcorder resumes filming from the same position. Result? Boy appears to 'jump' towards the camcorder.

After a long shot, to establish the scene, we cut to:

1. Mid-shot pan which follows the moving runner. Note the 'free-space' for the runner to move into.
2. A close-up pan of runner's face.
3. MS cut-away of the seated watcher: note that this girl was already established as a related part of the scene in picture 1. This shot helps mask the next cut to:
4. Head-on or *neutral* shot. Here, the camcorder was placed directly on the line with the runner coming head-on towards the camera position. The shot would have started with the runner much further back in the frame but has been cut at the point shown in the picture.
5. A panned close-up of moving feet. At this point the line has been crossed. This pan would also have been started with the feet farther back and could either be cut with the feet still in close-up, or the pan

could continue (but widen) into the next shot.
6. The tail-away – another 'on the line' neutral shot – completes the sequence.

From this point the 'line' could be crossed yet again by following shot 6 with shots similar to pictures 1 or 2.

With all these shots (except the cut-away) the trick is to keep the runner – and therefore the action – in the frame all the time. Don't let her travel out of frame, or the action is slowed and the cuts become more obvious to the viewer.

Jump cuts

When a jump cut occurs, the video-grapher (or the tape's editor), must take all the blame because cam-corders cannot, by themselves, create them – only a *human operator* can.

Usually, jump cuts are a conti-nuity error created by novices who have not yet learned what a jump cut is. But, once they know, they are far less likely to repeat the error. If a jump cut is accidentally included in a program's final screen version it seriously disrupts the visual flow. In

short, an unintentional jump cut is the first crime of continuity.

Describing it in words is more diffi-cult than showing a tape containing one, but three examples should suf-fice.

1. We're at a wedding, outside the church, waiting for the bride and groom to walk from the door and proceed down a 50-yard path to a gate. The camcorder is set up on a tripod in front of the gate and the couple are framed in a wide-angle long shot. Because of the distance between them and the camcorder they are quite small in the frame.

When they've walked about 10 yards, getting progressively larger in the frame, the video-grapher stops shooting. The couple walk a further 20 yards and the videographer starts shooting again. When this scene is screened, the image-size of the couple will suddenly 'jump' to a much larger size as the second shot appears – they will appear to have 'jumped' the 20 yards that the camcorder was not filming. Jump cuts occur whenever the

The correct second shot is made by changing the angle which disguises the cut and eliminates the jump.

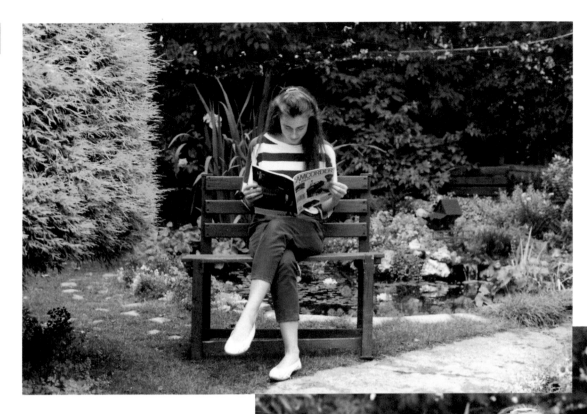

Wide-angle shot with girl's image-size comparatively small in the frame.

Incorrect second shot. Changing the image-size without changing the angle results in a jump cut.

camcorder stops filming then starts again from the same position.

2. Look at picture 1 and imagine that it's a moving image of the boy walking towards the camera. On the left of the picture a girl is seen entering a gate. At this point the camcorder stops but the boy continues his walk.

When the boy reaches the point in picture 2 the camcorder is started again. On playback, as this second shot hits the screen, the boy will

seem to jump suddenly forward – and the girl has 'magically' disappeared.

Change the angle

So far we've been talking about *moving* subjects, but jumps can also occur when filming a comparatively static subject as in picture 4. Here, the girl is shown (framed in mid-shot) sitting on a garden seat which is in front of an ornamental rockery.

At this point the camcorder is stopped. The focal length is changed to frame her in a medium close-up (picture 5), and the camcorder is started again. On playback, this change of image-size will seem to propel the girl forward. In other words – a jump cut.

Three things have caused all the above examples: the camcorder stopped filming, the image-size changed, and the camcorder was started again from the same or similar position. Therefore, although I hate to use 'rules', if ever a rule is vital it's this: 'If you stop filming in mid-scene then start again – *move the camera to change the angle.*'

Look again at the moving boy in picture 1. If, instead of following this shot with picture 2, we go straight to picture 3, no jump cut will occur because the camera angle has changed and the viewer will accept this as a 'natural' cut. Note here that when changing angle, make it a good one – between 50 and 90 degrees. Angle-changes less than this are largely ineffectual.

Study also, the girl in pictures 4, 5 and 6. By leaving out picture 5 and going straight from picture 4 to the changed angle in picture 6, no jump occurs.

A method of avoiding the jump without changing the angle is to insert one or more cut-aways between the offending shots. These can either be done while editing or insert-edited via the camcorder if it has this facility. If neither of these options is available, then you must rely on remembering what a jump cut is and avoid creating one.

Correct second shot. Angle changes should be bold to be effective.

Inserting a relevant cutaway can also help disguise a jump cut.

12

UNSCRIPTED MOVIES

Think sequences;

The shooting;

Real editing method

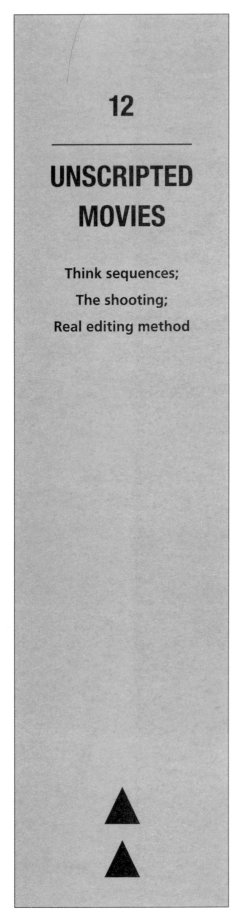

Experienced film and video club members will tell you that whether or not your intention is to 'edit in camera' or edit after shooting, it's brainpower (not the camcorder) that separates the moviemaker from the casual snapshotter.

They'll also mention the importance of pre-planning and writing a tight script. They're right and I've no argument with them.

There are times, though, when events unfold in an unpredictable way and planning and scripting are impossible. Nevertheless, if you can train yourself to think like a 'moviemaker' you can still end up with a worthwhile product. Let's look first at the type of thinking needed.

Going on holiday, for instance, whether it's in foreign climes or a day trip to a local area, often places the videographer in a dilemma: whether to make a blow-by-blow personal record of events as they occur, or to research the location beforehand and pre-plan as much as possible with a view to making an edited 'Hollywood' production out of it. It's tempting to try to do both but, usually, the program-maker falls between two stools: the program ends up as a long piece of self-indulgence which is neither a true holiday record nor a proper travelog.

Of course it's always simpler if the holiday area is familiar – somewhere you've been before – because a couple of days spent in one of its locations (say a fishing village) is usually enough to capture sufficient material to make a reasonable documentary about the life of the local fisherman and spend the rest of the holiday doing other things.

But if the location is somewhere completely new, you may have no alternative to shooting each day as it comes.

This doesn't mean the result needs to be a meaningless collection of random shots. On the contrary, since you are in charge of the camcorder you are, in reality, able to control exactly what you want your viewers to see. And if you don't like a particular shot or make an error you can always erase it or insert a replacement.

The point has to be made, though, that a little bit of creative thinking before shooting means fewer errors and a better, more meaningful, end result – especially if you intend 'editing in camera' as you go.

Think sequences

First, it's important to remember the principles of movie-grammar and shoot everything in *sequences*, of which the conventional method is to shoot:

(1) Long shots (LS) to establish a geographical location.
(2) Mid-shots (MS) to get closer to a particular scene within that location.
(3) Close-ups of the action itself.
(4) Cut-aways – shots of something or somebody (possibly a person watching) which, although not part of the actual action, are related to the scene in some way.
(5) Bridges 'n' Links: shots which, in some way, bridge the jump to the next scene or location to give the whole thing a smooth and continuous flow.

However, if the accent is to be on creating something to interest more than just yourself then each sequence needs:

(A) Movement: camcorder picture-quality (and a TV screen) is not as good as film or photographic slides for capturing distant *static* scenery: mountains, valleys, or a long-shot of the Leaning Tower of Pisa. There just aren't enough pixels or lines of resolution – not even with broadcast equipment – for good definition on an average TV.

Such long-shots should only be included if they are: (a) absolutely essential; (b) rocksteady; and (c) kept short – held just long enough to establish the location before getting into mid-shots and close-ups of something, *related* to the scene, which *moves*. Something *moving* in the frame is always far more interesting, to a viewer, than a *static* object.

(B) Likewise, *faces* are *always* more interesting than places. A place without a face is a *dull place*. So include lots of cut-aways of: people (including one or two of your family), children, babies, dogs and other pets. In fact, pin-

Establishing the location.

Establishing the scene.

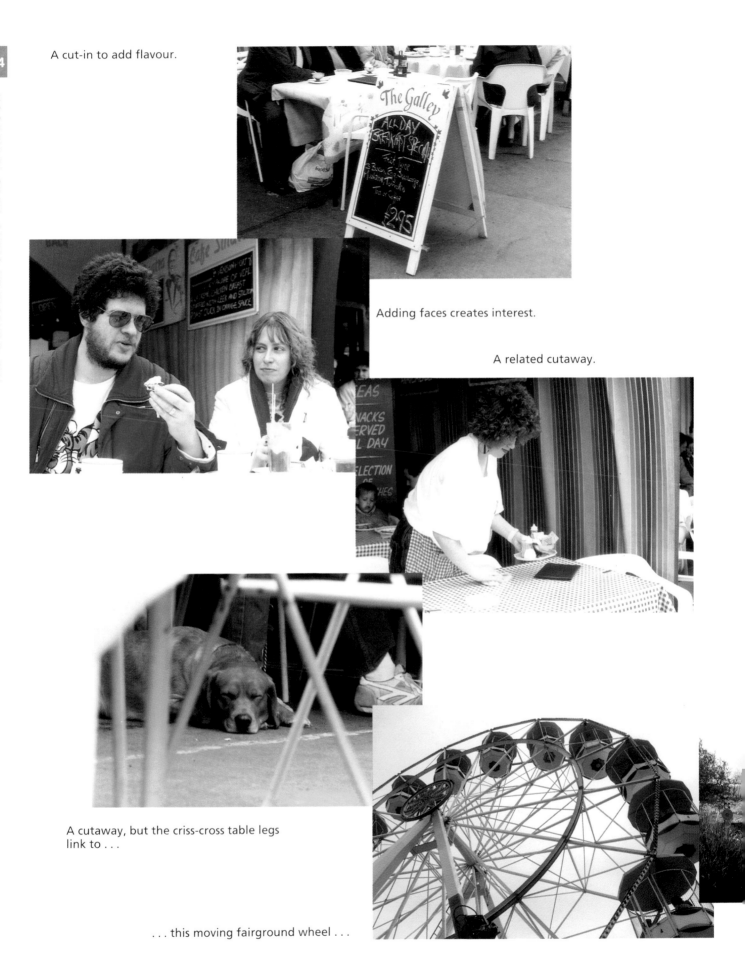

A cut-in to add flavour.

Adding faces creates interest.

A related cutaway.

A cutaway, but the criss-cross table legs
link to . . .

. . . this moving fairground wheel . . .

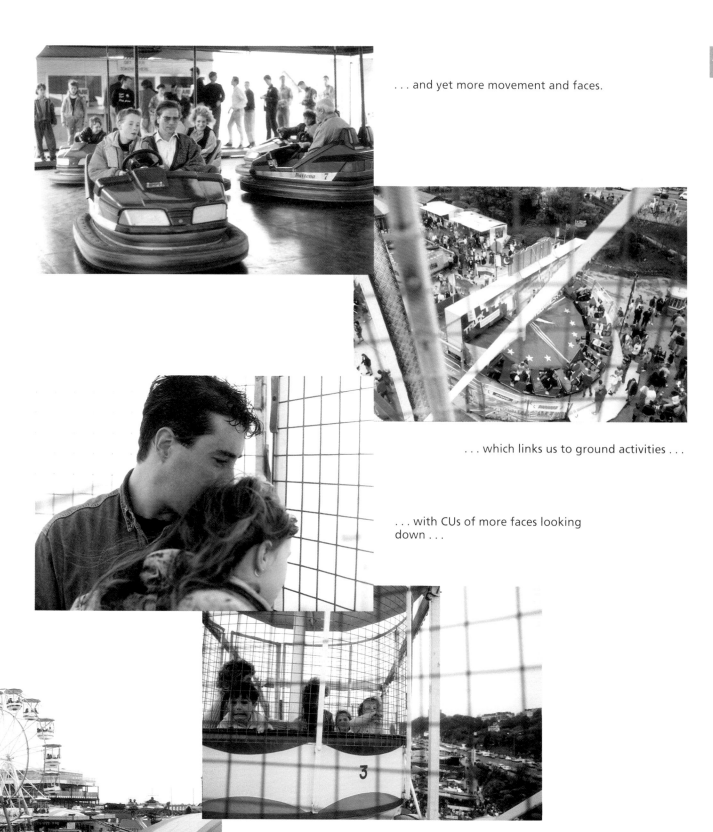

. . . and yet more movement and faces.

. . . which links us to ground activities . . .

. . . with CUs of more faces looking down . . .

Up in the wheel, more movement is provided . . .

. . . and a LS establishes the new location.

A conventional LS to establish the location.

A surprise big CU breaks the 'rules' but grabs attention.

sharp CUs of faces, always produce the greatest screen *impact*.

Of course the conventional method of constructing sequences need not be treated as 'gospel' and you may wish to experiment with breaking some of the 'rules'. To illustrate all the above, let's imagine we're on holiday in England in summertime and we want to capture local flavor.

Every English town has a recreational park; an area of green grass, sports pitches, children's swings, duckponds and flower gardens. And Sundays are the days where maximum activity takes place.

As this represents just a part of our holiday we'll spend just one, late afternoon there and produce a 10-minute montage (about 120 shots) of events. There will be no explanatory voice-over, the pictures and natural sound must stand on their own yet make everything clear.

Before shooting we'll recce the

A MS gets you into the action.

locations, study the activities, look for the best camera positions, and formulate some kind of plan. In other words, we get our brain working.

We decide to cover the activities in a thematic way; concentrating on the odd ball games the Brits seem so fond of: bowls, cricket, and tennis, then wind the pace down with shots of the players and participants going home.

If this sounds kinda corny – it can be. But, done well, and with flair and creativity, it beats the more traditional 'lecture-type' approach any day.

The shooting
Armed with camcorder, tripod and shotgun mike, we start shooting something which might go as the accompanying pictures suggest.

At first sight, picture 1 is nothing more than a conventional establishing LS. It is. There's still no finer way of opening the first sequence. But note that this was taken from the top of a very high building and this provides a view of the park and its surrounding area which is not seen by

the average visitor. Over this we superimpose a sub-title (say) *Brits on Sunday*.

Convention would have us follow this with one or two MS and the average viewer would subconsciously expect just this. But instead, picture 2 – the giant CU of the bowl (sorry – wood) with its sound – provides a surprize with considerable attention-grabbing impact.

We hold this just long enough for the viewer to read the words 'Ladies B.C.' then cut to picture 3 which clarifies what the forthcoming sequence will be about.

As we planned to spend three minutes screen running-time on the bowling green, we need plenty more shots like pictures 3 and 4, plus more screen impact-shots and imaginative angles as in picture 5.

And while the shots of the bowlers provide plenty of action and movement, we must also ensure that we intersperse the midshots with plenty of giant CUs of hands, woods, jack and plenty of faces. We must also include lots of reactions: smiles of joy, frowns of disappointment.

A MS cutaway adds flavor.

An imaginative shot – a worm's eye view of the action.

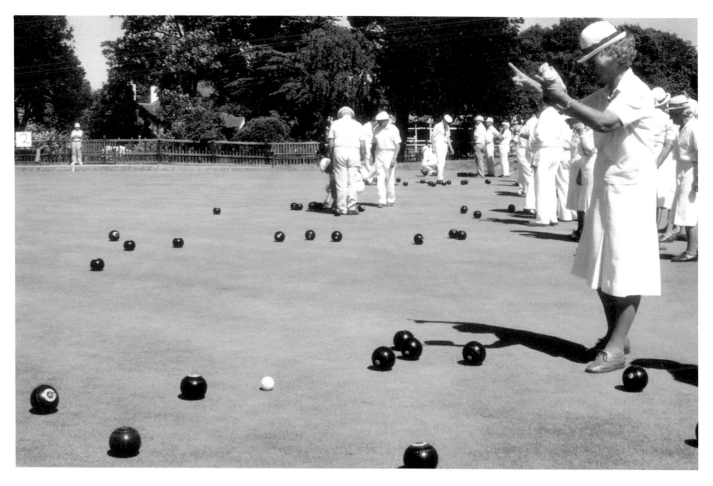

A LS continues the action even though it was shot some time after shot 5.

A CU cutaway which doesn't take you where you think.

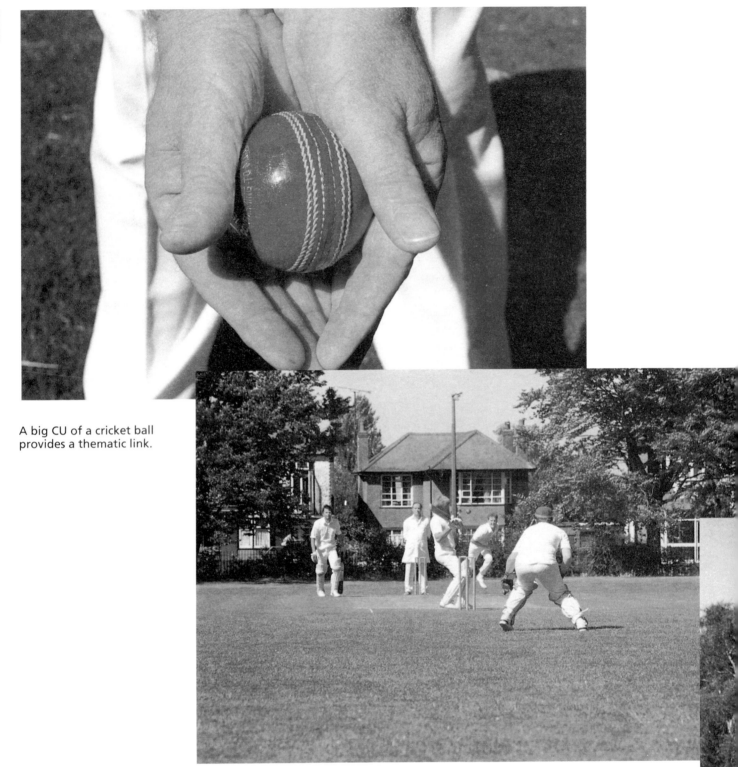

A big CU of a cricket ball provides a thematic link.

A MS introduces the cricket action.

In between all this come the cutaways: people watching, drinking, eating, the score-board and so on.

And no, we don't have to ensure that the wood seen coming into shot in picture 5 is the same as the one being bowled by the lady in picture 3. Apart from it being impossible for a lone cameraman to run (carrying equipment) from one end of the green

to the other, then get in position to make the shot, viewers won't know the difference.

Instead of starting the cricket sequence with the conventional establishing LS, we break convention by using picture 6.

It's appearance at this point will first lead the viewer to think that it is yet another cut-away at the bowling green. But the sound will have changed from bowling 'atmosphere' to cricket – another surprize. And followed by picture 7 (the cricket ball) the thematic transition becomes obvious as we shoot (say) a further four minutes at the cricket pitch before moving to the tennis and other activities.

One further point: because it's not always possible to interrupt an activity in order to get those giant, impact-shots so necessary to good moviemaking, it can pay to fake them. People are remarkably co-operative in front of a camera, and if you ask their permission and tell them what you want them to do and why you want it, the vast majority will be only too willing to take part.

A shot "faked" later.

Bowls players and cricketers, awaiting their turn to play, were used to fake the action in pictures 3, 5 and 7.

Real editing method

The fact is, editing in camera is extremely difficult to do well over lengthy periods of shooting, which is why post-production editing is a craft worth mastering. Several 'takes' of each shot, using different camera angles, can be made with only the best to be included in the final version; this allows any faults, whether of picture or sound to be put right.

If you shoot the movie with editing in mind, a simple formula can help you make the best of it. There is, though, no guarantee that it will turn your movie into an instant competition winner because each winner has that little bit extra; that undefinable *something* that sets it apart from the rest.

Nevertheless, there is a simple formula for making *competent* movies. And it sounds so simple, so obvious, there's an almost overwhelming urge to pay it scant regard. Resist the urge at all costs and consider the formula carefully:

(1) The movie must be *about* something. In fiction this means having

believable characters doing believable things. Facing challenges and obstacles to their ambitions or desires and winning (or not winning) through.

(1a) In documentaries, it means having a theme: something worthwhile and original to say, or presenting an argument or point of view. Or, like fiction, showing how something was achieved or not achieved.

(2) The treatment: working out whether to treat the subject in a comical, mildly humorous, or deadly serious way.

(3) Ensuring it has human interest (people).

(4) All movies need shape and structure – a proper beginning, middle and end. There's nothing worse than a movie that starts anywhere, dithers about all over the place, and just when you think it's never coming to any kind of conclusion it stops, abruptly, leaving the viewer in no-man's land.

Ironically, the beginning, middle and end do not necessarily have to be in that order. For example, a fiction movie may start with shots of a man in jail, which then cuts to flashbacks of how he got there.

Planning, scripting, storyboarding are key elements in most top competition winners, but if you shoot in sequences it's possible to do all that *after* the material has been shot, provided, that is, you get firmly and seriously into editing.

The top award at an International Festival, for example, went to my colleague, Terry Mendoza – who kindly let me help with the editing – for his movie *The Most Famous Train*, which also won at many other internationals. This brought us both satisfaction, since it started as a simple, unscripted holiday movie.

Terry shot it on a JVC S-VHS-C camcorder and, using two synchro-cabled Panasonic S-VHS jog-shuttle VCRs, we edited the two hours of tape to that formula – 167 shots with a total running time of 15 minutes.

To sum up: if you can train yourself to edit, to think sequences, movements and faces, and remember that formula, you could be well on the way to being a winner.

13

ADDING TITLES

Computing methods;

Letraset

▲
▲

Adding a title to a program gets it off to a good start. If it's a family record, it needn't be much more than 'Our Vacation' or 'September in Spain.' And giving the audience, say, a five-second visual clue to what they're about to see, adds to their feelings of anticipation. In addition, as your taped records grow in number, the title 'tags' each tape and helps to identify such things as date, time and place.

For the more ambitious program-maker, the title might well be several 'pages' and include: names of the stars, thanks for help to some organizations, and a list of the 'technicians' who helped make the program. A typical club documentary might start with several seconds of black followed by mood-music starting behind a *fade-in* to a stock-shot of the club logo over which, say, **'Westcliff Film and Video Club presents'** appears for four seconds then cuts to the main title as the music dissolves into the action.

The program proper then starts but the credits: acknowledgments for the loan of a helicopter, loan of a stately home, etc., cast and crew names, are not displayed until **'The End,'** timed to coincide with the last note of end-music, looms large in the frame.

On the other hand the newcomer, who aspires to greater things, sometimes goes title crazy; he tries to emulate professional TV programs and produces great long scrolling lists in which his own name invariably appears several times under such grandiose titles as 'Director of Photography,' 'Sound,' 'Editor' and 'Producer.' As if this wasn't enough, everyone (and everything) else gets a mention including Humphrey the pet poodle and 'Catering Consultant, Aunt Flossie,' who made the sandwiches.

Of course it's a nonsense; the reason professional programs have such lengthy and fast scrolling titles has more to do with trade union rules and contractual obligations that the audience couldn't give a damn about. So beware of overkill; there's a lot to be said for the *if in doubt leave it out* approach. It's the *program* – not the title – they've come to see.

The best approach is to keep titles short and to the point, with lettering styles clean, crisp and easily readable.

Computer methods

Most camcorders have some form of in-built title generator. Some scroll, and some have the facility to store shots of low-resolution graphics for super-imposing over the picture. For visual note-taking, like recording the date, time and name of a location, they are an invaluable tool but, very soon familiarity with its limited lettering style (font) breeds a need for something more; something less 'electronic' and more in keeping with the style of the program that follows.

Perhaps the most complete title system, available at amateur prices, is available for users of some home computers. Simple programs, with a choice of around four low-resolution fonts in varying colors, exist for the early 48K Spectrum among others. But again, there is a 'sameness' about them which soon palls.

If you're going the computer route, specialist floppy-disk programs offer a vast range of graphics which can be drawn, moved, colored and animated in what seems like an endless variety of combinations. And, depending on the program, a whole range of different styles and different sized fonts may be used to 'print' titles.

However, although it's by no means necessary to be computer-literate to operate them it's true to say that the average novice would need to spend considerable time to get the best out of them. In addition, the basic computer cost is only part of the story. You'll also require another TV, an extra 'memory' expansion unit, at least one external disk-drive and, for synchronizing two video sources so that medium to high-resolution titles or graphics from the computer can be superimposed over a picture, a *genlock* is essential. Altogether it may well mean spending more than the price of a camcorder.

Letraset

For the guy who already has a full complement of editing gear, the computer system makes a super piece of add-on luxury. But for clean readable titles that bring both simplicity and individual creativity – of the sort

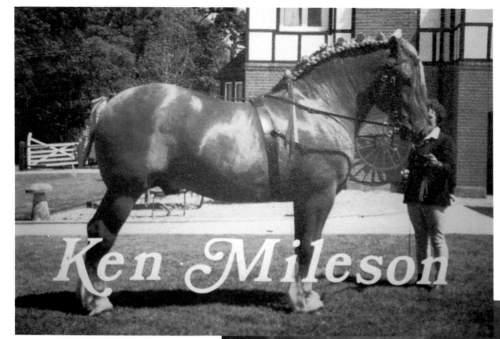

Examples of rub-down letters on photograph title-cards.

Dry-transfer letters for sub-titles.

Computer generated title. (Courtesy: *Camcorder User*)

seen on so many TV programs – good old-fashioned and inexpensive dry-transfer systems like *Letraset* are back in fashion and probably give the best visual result.

Proper art shops (check the Yellow Pages) stock a show-catalog that displays an enormous range of font sizes – from minute to huge – and styles of which the popular *Times, Helvetica, Palace-Script* and *Futura* are among many.

To be useful for *creative* titling the letters need to be large – around a three-quarter-inch or more high – white or black, and rubbed down on a piece of artwork, glass, or glossy photograph that is a minimum of 10″ × 8″.

Some practise in lining up the letters is required and most art shops are only too pleased to give tips. Of these the most valuable is: do not position letters forming a complete word too far apart. Sounds simple, but this mistake often occurs.

The background artwork may be anything from plain colored paper to a photograph, painting, hand-drawn logo, or a picture cut from a magazine. But usually it's best to rub them down on a clear piece of glass then lay that over the artwork; it prevents paper curl when filming it under video lights and produces pleasing shadows behind the letters. And varying the position of the lights varies the position of the shadows.

If you don't have manual override of the iris try to select background artwork that contains a good mix of average colors. Autoexposure doesn't take kindly to white letters on a jet-black background – the whole thing records as a wishy-washy gray.

Whatever you do, select letter styles, backgrounds and colors that are in sympathy with the program: *Medieval* for a documentary about an old castle, *Times Italic* for the sausage factory, and *New Palace Script* for a wedding.

Finally, you can, using scissors or a craft knife, cut your own fancy letters or graphics from all manner of colored material, and using lighting effects or filters, produce an 'exclusive' font and design to suit your own needs.

But please remember that 'readability' is the priority. Beware of going title crazy. Keep it simple – but do it well.

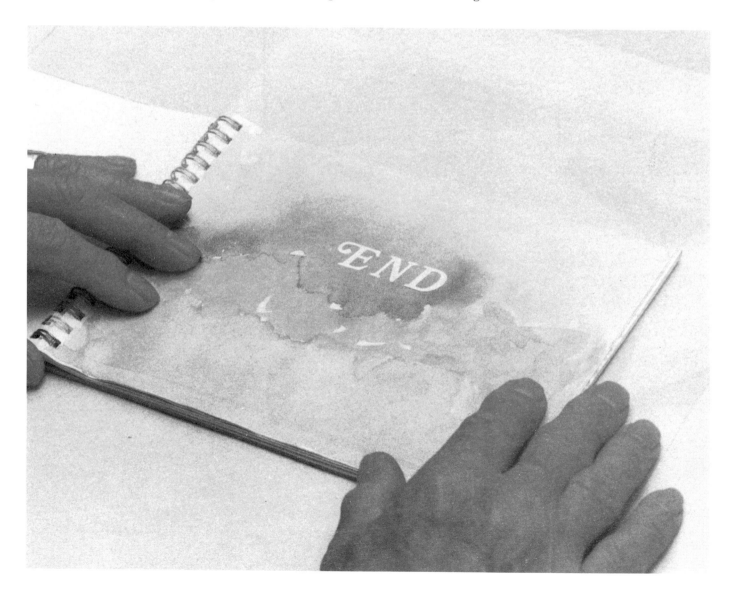

Rub-down letters on hand-painted artwork.

14

EDITING PART 1 – BASIC

The basic set-up;

Dubbing procedure;

Adding sound – direct input;

Backspace edit;

Synchro-linking;

Control track;

Enhancing the picture;

Audio dub and hi-fi

▲
▲

Since editing is what distinguishes the snapshotter from the more serious hobbyist, and since it is the only way to construct the sort of program that won't bore the neighbors or intended audience, I propose to deal with it on two levels: (a) the basics; and (b) up to a good semi-professional level of competence.

However, before rushing out to buy new gear – possibly the wrong type – I advise every newcomer wishing to get in on what is arguably the most creative and satisfying aspect of the whole hobby, to start by keeping things very simple. And, on the basis of learning to walk before you run, use the equipment you already have – camcorder, mains VCR, and television – and only when the basics have been mastered, progress to more sophisticated ways and means.

The basic set-up

All video-editing, regardless of format, is done by copying (dubbing) the pictures and sound from a *player* machine (a camcorder or VCR) to a *recorder* – a mains VCR upon which the 'edit-master' is assembled. The *player* plays back the camcorder originated tapes and the shots or sequences may be recorded in any order you choose onto the *recorder*. It's a procedure referred to as assemble-editing.

Connecting cables hook everything together. The video-out socket (possibly BNC or Scart) of the player is connected to the video-in socket of the recorder, and similar connections are made between the (phono or Scart) audio-out/in.

With Video 8, check the camcorder's instruction book for hooking up via its mains adaptor.

European Scart connectors need adaptor leads, and if you can't get them locally many firms supply them by mail order. Be certain, though, to specify the make and model numbers of your equipment and how it is to be used because even Scart connectors can vary. Additionally, if copying stereo audio to a mono VCR, a 'Y-shaped' connector, which converts the two channels to one, will also be required.

Finally, connect the RF (aerial) socket of the recorder to the TV.

Using this set-up means that when

the recorder is in its 'play' mode *its* picture will be on the monitor, but when it's in 'record' or 'stop', the monitor shows the picture from the player.

If you have two TVs, connecting them separately to *player* and *recorder* means that when both are on play/pause at their edit points, the two halves of the 'cut' can be seen simultaneously.

Dubbing procedure

To start, load the recorder with blank tape and set it to record; loading the player with the original tape and setting it to playback starts the transfer. Use this first run to check it all works and ensure that the tracking controls of both machines are at optimum, then rewind and proceed as follows:

(1) Transfer approximately 60 seconds of camera 'black' tape to the recorder. This is first produced by filming it on a spare tape in the camcorder with the lens covered (black lens cap) and closed iris. Alternatively this shot could be of your own test card, logo or color-bar sheet.

We do this for two reasons: (a) the first 60 seconds on most VCRs is electronically unstable and produces drop-outs, glitches and visual nasties; and (b) we need its control-track (more about this later).

(2) Play it back for checking then *stop* both machines.

(3) On the player, locate the beginning of the section (the edit-in) you have chosen to be the first picture or sequence, and press 'pause/play.'

(4) On the recorder, again playback the 'black' or test card but after (say) 50 seconds press 'pause/record.'

(5) Releasing both pauses simultaneously makes the transfer and you'll be monitoring this incoming sequence on TV, but continue transferring for about five seconds longer than you need (I'll explain why later), then *stop* both machines. Don't use 'pause' at this stage because pausing for more than a minute or two causes excessive head wear and might kink

the tape, which in turn can cause a black line to scroll down the screen a split-second after the next join.

(6) Locate the edit-in of the next incoming sequence on the player. Press 'pause/play.'

(7) Playback the previous shot on the recorder and press 'pause/record' at the point you wish to edit out.

(8) Repeat from (5).

Adding sound – direct input

While transferring a scene it's possible to change its sound. For instance, a 1–2 minute continuous sequence about night clubs and discos in *Costa Packet* might be better if the 'live' sound is replaced by bright bouncy 'Pop' – or, a sequence driving through rural Spain might be improved by a gentle guitar background.

This can be done by the 'direct input' method. It means removing the cable from the recorder's audio-in socket and replacing it with a lead from the output of your hi-fi, CD, or record-player although it is better – more controllable – if the music is first recorded on an audio cassette-deck or Walkman with a good pause control. Try the following:

(a) Time the video sequence using some kind of stop-watch.

(b) Copy the music onto a blank audio-cassette, timing it so that the amount recorded approximately matches the length you need.

(c) Pause it in playback just before it starts and release it about a second after step 5 (above).

For many home videos, the above procedures might be all that is required, but sooner or later you will notice two things. Firstly, the copied pictures are of a slightly worse quality than the original. This is because copying degrades the video/audio signals somewhat. Nevertheless, this second-generation edit-master is perfectly acceptable, but making a copy of *that* copy (third-generation), in lo-band formats – VHS, VHS-C and Video 8 – will be a bit of a fuzzy mess.

On the other hand, hi-band (S-VHS and Hi-8) will not degrade much because they start with much higher quality so the quality loss is minimal and third-generation copies can be made, even if that final copy is to a lo-band format.

Secondly, at some joins a visual disturbance (glitch, white noise-bars or flagging) lasting about half a second, takes place and the 'joins' are not exactly where you wanted them. This is because the last part of the outgoing shot's picture and maybe the last word of a piece of conversation, has been chopped off. Similarly, a second or two at the beginning of the incoming shot has also been removed.

Backspace edit

Curing the above problems means understanding a little about the way both machines work. For starters, glitch-free joins can only be achieved if the recorder-VCR has a *backspace-edit* facility (most do).

This works as follows: when 'pause/record' is pressed on the recorder, the tape is rolled back for a second or so. At this point we need to remember that every second of normal playback time is made up of separate frames (25 PAL, 30 NTSC).

When 'record/pause' is released in order to record the incoming shot from the playback machine, the rolled-back section is run forward

Adding sound from a tape-recorder.

(pre-roll) to allow the incoming shot to lock onto the outgoing shot's control-track pulses before recording begins.

This backspace time varies from VCR to VCR. For example, on some it's around 65 frames (approx 2½ seconds), but the average machine is 1½ seconds.

Therefore, to prevent chop-off at the edit-in, this backspace time must be allowed for; it means adjusting the procedures (3, 6, above) so that the play-machine is started at a point at least 1½ seconds in front of its edit-in point if the first 1½ seconds of wanted material is not to be lost.

There's more. When the tape pre-rolls it starts recording a few frames *before* it reaches the end of it. This means that the last few frames of the outgoing shot will be recorded over and lost unless you *frame-advance* its edit-out point those same number of frames farther on to make up for this again; each make and model is likely to vary between five, eight or even 15 frames.

To calculate the record-machine overrecorded frames:

(a) Record a shot for (say) three seconds.

(b) Replay it but 'pause/play' its first frame, then, using 'frame-advance', count and advance a further 50 frames. Press 'pause/record.'

(c) Record a second shot from this point then return to the first frame of the first shot.

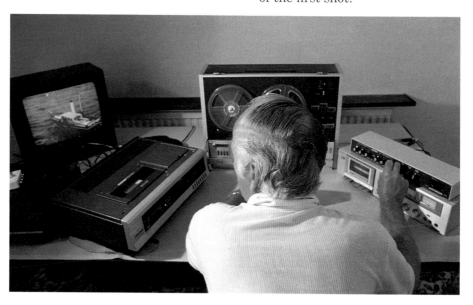

(d) Count the frames from the first frame of the first shot to the first frame of second shot. The difference between counts is the number of chopped off frames.

To calculate the backspace to be allowed in front of the play-machine's edit-in:

(1) Repeat (a) and (b) (above) but this time add (single-frame advance) the above calculated frame difference to the 50 frames. Press 'pause/record.'
(2) Record a second shot but ensure it starts from 'pause/play' on the play-machine at a readily identifiable frame.
(3) Replay the resultant recording and note the frame where the second shot actually starts.
(4) On the play-machine only, count the frames from the readily identified one to the matching frame where the recording on the record-machine actually started.

Since these frame allowances should be the same for every cut thereafter, you only need to calculate them once.

Synchro-linking
If the program requires many cuts this counting procedure becomes very tedious. It can, however, be greatly simplified if both machines are fitted with compatible sockets that enable them to be linked via a synchronizing cable thus slaving one machine to the controls of the other.

Systems vary, but it usually means that when 'pause/record' is released on the recorder, the backspace and pre-roll times are automatically allowed for, and 'pause-play' is synchronously released on the player. It's not exact but should not be more than about five frames (1/5th of a second) out, usually at the edit-in. Where such edit points are critical, some trial and error tests may be necessary to work out the frame-error so that the point may be frame-advanced to compensate.

Control track
Glitch-free joins also depend on an electronically stable control-track – a series of invisible electronic pulses

(one per frame) laid on the edge of the tape by the camcorder while shooting, which may be thought of as being like sprocket holes on frames of film.

If they are not evenly spaced when the control-tracks of both tapes meet, they will not synchronize with each other and a 'crash' ensues which causes glitches, flagging and 'noise.'

This is often due to the camcorder (when the tape was being shot) being started from 'stop.' It needs to run for at least five seconds (professionals use at least ten) before its speed, and therefore the control-track, stabilizes. This in turn means that, when editing this shot, the first five seconds are best ignored. And, if while shooting you know you are going to press 'stop' at the end of the shot, overshoot for a further five seconds to allow some editing tolerance.

In other words, when starting from 'stop' shoot at least five seconds before the shot 'proper' plus five seconds after it.

Enhancing the picture
If you're worried about the loss of lo-band picture quality while copying you might consider buying an enhancer. It's a piece of hardware that is connected between the player and recorder via the relevant video/audio sockets and its job is to minimize quality losses by electronically processing the signals. Some also provide the means to introduce effects such as wipes and fades.

The word 'enhancer' may be misleading since it cannot improve upon the original material. No enhancer will turn a sow's ear into a silk purse. If the original shot was made in low light, lacks contrast and depth of field, the enhanced copy is not likely to be better. The best option is to exclude such a shot from the edited version altogether.

Never misuse any of the enhancer's controls. For example, use a fade-to-black control for fading. Don't use it simply to darken the pictures or to reduce contrast because electronic instability can be introduced which 'confuses' the edit process.

Good quality starts at the shooting stage. It means remembering the

five-second starts, using the best quality tape, shooting in the best light, and ensuring pin-sharp focus so that the enhancer has a good picture-signal to get to grips with. Don't expect an enhancer to enhance a signal that isn't there to start with.

Finally, the 'enhancement' seen while monitoring is not always identical on the copy-tape to that seen on the monitor because compensatory circuitry in domestic VCRs sometimes *over*-compensates. Therefore, 'enhancements' need to be tested on another tape first, and adjustments made, before going ahead.

Audio dub and hi-fi
If the VHS/S-VHS recording VCR has hi-fi capability, the hi-fi sound signals plus those you have replaced via direct input will be mixed with the picture signals and cannot be overdubbed.

But the 'normal' (linear) track also carries those same sounds and can be post-dubbed with additional sounds provided the VCR has the 'Audio dub' facility. To do this buy or borrow a simple three-channel sound mixer; it will help you take the first steps in creative multi-mixed soundtracking. Try the following:

(1) Assemble-edit the entire movie, replacing sounds with direct input where appropriate. Rewind to the beginning.
(2) With the record-VCR switched to hi-fi only, connect the audio-out to channel 1 of the mixer.
(3) Connect a microphone, CD or audio-cassette-recorder to another, appropriate, mixer channel.
(4) Connect the mixer's output to the record-VCR's audio-input.
(5) Press play (not record) and press audio-dub on the record-VCR and fade up and balance the mixer channels. You can now mix the sounds from the hi-fi tracks with additional sounds from the other mixer channels onto the linear track. This simultaneously erases the previous linear sound but if you make a mistake you can always start over since the original hi-fi track will still be intact. To get the mixed effect on playback, switch the VCR to 'normal' linear only.

15

EDITING PART 2 – ADVANCED

Insert-edit;

Creative inserts;

Audio-dubbing;

Edit-controllers;

Time-code;

Vision mixers;

Off-line editing;

Editing jargon-buster;

*More about
edit controllers:*

Timebase

Advanced editing starts by recognizing that any 15 minutes of a properly structured program is likely to contain between 150–200 separately edited shots. And although this means the average duration of each shot is less than four-seconds, some will be between three and eight seconds, some may be less than one second, and only rarely will one shot be as long or longer than 25 seconds.

Some of their cutting points will need to be made *between* words of a speech whilst others will need to synchronize with a particular word, phrase or (say) every eighth beat of music.

The soundtrack, including commentary and short pieces of mood music, will be mixed with the 'live' sound and post-dubbed.

For editing this many shots, using a camcorder to act as a player or record-machine is not recommended for three reasons:

(1) Its edit-points are impossible to locate speedily and precisely.

(2) It's more fragile than a VCR and the amount of tape shuttling and pausing while locating these points can cause serious wear on its record/playback heads and comparatively fragile tape transport mechanisms.

(3) The tape itself will stretch and wear causing drop-outs and glitches which transfer to the edited master.

A camcorder is best left to do its proper job – shooting pictures.

The best equipment set-up is two hi-fi edit-VCRs of the same make and model number, which can be linked with a synchronizing cable to purpose-designed in-built sync. sockets. Since identical models have identical back-space and pre-roll – which is calculated and allowed for by the synchro-linking – virtual frame – accuracy is achievable without the need of an edit-controller.

If makes and models are not identical, an edit-controller will be necessary (more about this later).

Both VCRs should have a true jog/shuttle dial. With it, the tape can be shuttled *backwards* as well as forwards at speeds varying from fast to slow motion, then jogged a frame at a time (in either direction) to the exact edit-point. Other vital requirements are insert-edit and audio-dub.

At the present time, VHS and

Equipment hook-up for advanced editing.

Terry Mendoza at his S-VHS editing bench.

S-VHS formats are well catered for with decks from Panasonic, JVC, Mitsubishi and others, while with 8mm formats the choice is limited and some ingenuity is required to overcome its inherent dis-advantages.

For instance, since Video 8 does not have an audio linear track, the only option for post-dubbing multi-mixed soundtracks to an 8mm VCR is via the very basic direct input method described previously in part 1.

This, though, is not entirely satis-factory since it means producing a sound jump-cut at every edit-point. Another method is to lift the original sound from the assemble-edited master onto a third-generation copy while mixing in the new sounds – but this produces an unacceptable loss of picture quality.

Hi-8 with PCM audio tracks can be post-dubbed but, since the vast majority of people – especially those to whom you may wish to supply copies – prefer to playback tapes on VHS format VCRs, it is easier if an 8mm VCR is used as the playback-machine only, and the record-VCR is VHS or S-VHS. But you will need an edit-controller that can be adjusted to calculate the differences in back-space and pre-roll.

If, then, you are about to decide which format suits you as a serious hobbyist/editor the advantage – in terms of quality, compatibility and user-friendly equipment – is greatest if, currently, you choose S-VHS for-mats throughout. Note also that S-VHS edit-VCRs will also edit and play/record in regular VHS so you will still be able to watch regular or rented tapes.

Additionally, S-VHS edited-masters can be put in the player-VCR and, with the recorder-VCR in normal VHS mode, acceptable quality third-generation VHS copies can be made.

Whichever you choose, everything that follows assumes that the record-VCR is either VHS or S-VHS.

Insert-edit

Unlike assemble-editing where the control track is transferred with the sound and pictures as one package to the copy-tape with *insert-edit* the control track is not transferred.

Since you can only *insert* onto a tape which has a control-track and video signal already in place, the en-tire virgin copy-tape must first be 'blacked' or no control-track will be recorded.

This doesn't literally mean *black*, any pre-recorded material will do

Panasonic WJ-AVE5 vision/audio mixer.

Panasonic EC10E VITC edit-controller.

but, to ensure stability and prevent previous colors bleeding through, black is favored. Try either of the following:

(1) Load the VCR with the virgin tape, plug the camcorder (with black lens cap) into its camera-input socket and set the VCR to record.
(2) Camera-black a virgin tape in the camcorder, then put it in the player and copy it to another virgin in the recorder.

Most professional programs are entirely insert-edited since a stable control-track guarantees glitch-free edits. Amateurs, though, edit using a *combination* of assemble and insert techniques; the assembled material is done first, then shots, such as cut-aways, are inserted over them, which simultaneously erase that portion of the picture underneath without affecting the previously recorded linear soundtrack.

On some decks, though, the linear sound *is* transferred if the insert and audio-dub buttons are pressed simultaneously.

Creative inserts
Cutting talking-head sequences, such as drama or interviews, often requires the edits to be made before or after certain words of the dialog; the dialog is assemble-edited first, cutting out unwanted words, sentences, fluffs, pauses and repetitions until it flows naturally and sounds right. This may include adding material with the right background ambience to *lengthen* pauses between words.

This will leave the edited sequence with a series of visual jump cuts which are then covered by inserting a variety of listener's reaction shots (mute 'noddies'), or cut-aways that visually illustrate the words.

This technique is especially useful for visually illustrating a piece where the interviewee gives a list of things. For example, he says: 'Each mountaineer has an ice-pick (pause), anti-glare goggles (pause) and a supply of oxygen . . .' At each of the key words: 'ice-pick', 'anti', 'supply' the relevant shot is inserted.

'Pop' videos are another such

example; the band can either be filmed 'live' or miming to a tape-recording. The camcorder is set to a fairly wide shot and kept running throughout the entire length of the performance to ensure that the sound is continuous, although you may include a few speedy zoom-ins and outs to capture in-sync. close-ups of the vocalists.

The performance is then repeated while the camera changes to a variety of positions and shoots non-sync. material such as close-ups of feet, hands, the audience, instruments, etc., which are then insert-edited mute into the original take while ensuring that the in-sync. original close-ups are left intact.

The insert/assemble combination also allows 'arty' split-edits (also known as 'L' cuts); the cut is arranged so the sound of the incoming shot overlaps or precedes its picture.

Audio-dubbing
Unlike linear sound, hi-fi tracks are multiplexed with the picture and are transferred with it unless the audio lead is removed, or the sound is replaced by the direct input method; it cannot be separated or replaced by audio-dubbing. The choice of which tracks to use is very valuable to the soundtracker and will be discussed later.

Pressing the audio-dub button while the recorder is in its play mode erases the linear-track sound while allowing a new sound to replace it. You *could* do this on a shot-for-shot basis after the assembly is complete but a small gap or audible 'plop' (about three frames) may take place at each edit-out point.

It's useful, though, when assemble-editing a fast cut sequence of 15 two-second shots of (say) a sports event; where changing from shot to shot loses sound continuity and creates aural jump-cuts.

If, however, the sequence is assembled for its visual content first, then shuttled back to its beginning, a general 'sports atmosphere' sound can be audio-dubbed over the lot. The sound continuity is maintained and that 'plop' at the end gets erased by the following assemble-edit.

A better method is to record two

minutes of 'atmosphere' at each location while shooting, using the camcorder as an audio-recorder only. While editing, choose that part of the recording which gives the most suitable sound, assemble-edit this first then insert-edit your best visuals into it.

Audio-dub is the only practical method of laying a full and proper soundtrack where the 'live' sound is copied to another tape, mixed with commentary, music or additional effects, then laid back in sync. on the edit master's linear track.

Edit-controllers
An edit-controller is a piece of hardware that offers a more sophisticated form of synchro-linking. When the two VCRs are connected to it, it takes charge of the pause, play, record and tape-transport functions of both. Other conveniences are:

(1) The operator can set it to play back either machine, press buttons to select the edit-in and out point of each shot and a further button 'memorizes' them by counting the control-track or tape-counter pulses.
(2) Depending on the make and model, several edit-ins and outs can be 'memorized,' and another button sets both VCRs to run automatically and make the edits.
(3) Most also offer the facility to preview the programmed edits so that adjustments can be made before committing them to tape.

Numerous models are available, but if your VCRs are different makes you may not be able to get a hard-wired one that is compatible with both VCRs' edit sockets but must rely, instead, on the more awkward and less efficient IR (infra-red) control system.

Time-code
There are broadly three types of time-code available for hobbyists: longitudinal (LTC), vertical integrated time code (VITC), pronounced 'Vitt-See', and Sony's RCTC.

VITC, easily the best for hobbyists using VHS or S-VHS-C, is a system of recording electronic information – in the unused video lines between pic-

tures – that identifies each frame with a series of eight-digit, consecutive address numbers such as 07:49:32:17.

These numbers represent hours, minutes, seconds and frames and are put there in the first place by the camcorder with a VITC generator during shooting. These are available as separate add-ons for some camcorders, though an increasing number have them built-in.

And when the tape is played back in slow motion or paused on a VCR, the VITC digits are displayed on the miniature LCD monitor of a VITC edit-controller.

The controller can then be programmed with these numbers and counts them instead of control-track or counter-pulses. This is a distinct advantage because: (a) to a controller all control-track pulses look alike and if one is badly recorded, electronically damaged, or is missing because it coincides with a dropout or tape stretch it will be skipped over by a control-track controller; and (b) counter-pulses are not frame-accurate.

RCTC is to Video 8 what VITC is to VHS except that it can be added to the tape *after* shooting.

The main advantage of time-code is locating to-the-frame edit-points and repeatability; once the whole series of edit-points is programmed into the controller's memory, several identical edit-masters can be made from the original material which avoids the need for making third-generation copies.

A further advantage is that these digital edit-points can be logged – either on paper or on the controller. This is a very important benefit when rough-cutting (discussed later). It means alterations can be made to the programmed edits should you change your mind about the order or cutting point of any shot. It's simply a matter of job/shuttling the new order and re-programming the new numbers into the controller and letting it get on with it.

Longitudinal time code (LTC) is similar to VITC but has the great disadvantage that it is recorded on a tape's linear soundtrack which then cannot be used for recording and compiling a mixed soundtrack. It is therefore more suitable for professional systems which have two or three separately recordable linear tracks to play with, for example those found in television editing studios.

Sony RME 700 RCTC compatible edit-controller.

Sony EVS1000 edit-VCR with swing-shuttle dial.

Vision mixers

To merge two separately sourced video signals, as in a dissolve, requires at the very least two play-machines – A and B. Such effects are only used sparingly, so player B can be the camcorder.

Until recently, the only way to do this was to connect a timebase corrector to each source player before routing them through a vision mixer or the signals would not synchronize. The resultant mix would suffer from jitter, sway, color distortion and other visual nasties. Panasonic's MX10, WJ-AVE5 and WJ-MX12 mixers led the way to getting round this by incorporating a frame-store; one video channel's signal is stored until it makes a complete frame before releasing it in sync. with the other channel.

Dissolves though, need to be planned at the scripting/shooting stage. If, for instance, you want to dissolve from the shot of a building to the shot of a ship at sea, the building must be shot on one tape and the ship on a separate one. And, because you need to manipulate three machines with one pair of hands, player B (the building) is started first, so it pays to shoot it with about a 20-second run-in to give yourself some extra control time.

Off-line editing

Without a proper working procedure, editing can be frustrating and time-consuming. Even with one it's not unusual for a 15-minute documentary averaging 11-15 shots per minute to require hands-on for 30 or more hours. The more you plan, mentally conceptualizing the order of shots in advance, the better the end result. This means going 'off-line.' Here's how.

(1) Make a copy of each camcorder master tape and use it as a 'working' copy. This is to protect the masters against accidental damage, excessive tape wear, tape stretch and drop-outs caused by numerous shuttlings and pausings.

(2) Use these off-line copies for reviewing, and list each shot on paper: brief description, start and stop counter-number, sound suitability.

(3) From this list, 'conceptualize' and write down the shots to be used and in which order.

(4) Assemble one or more 'rough cuts,' concentrating on shaping the program's beginning, middle and end, checking for continuity and visual flow. Do not, at this stage, worry too much about each

shot's exact length. The object of off-lining is to see if the concept works; to provide the chance to try out different ideas and shot combinations. (5) When satisfied, go 'on-line' – back to the master tapes to edit the program proper.

More about edit-controllers

It is important that a controller actually does control fully and accurately the VCRs slaved to it. To do this it must have a means of having two-way conversations with them. It must, for example, be able to instruct the player and/or recorder to commence a certain function and receive back a constant update of its progress – such as at which frame it is playing or recording – and collate this information in order to issue the next instruction to both machines at the right time.

Sony's LANC ports for Video 8 and Panasonic's five-pin ones for S-VHS/VHS are two-way communicators.

Infra-red systems are less efficient because they can only send information – they cannot receive it. And there's always the possibility that, on some decks, an IR command is not acted on instantly and consistently.

Video 8 users might like to note here that since Control-S is Sony's hard-wired version of remote-control, it is only a one-way communicator.

Two main types of controller exist: those which locate time-coded frames, and those which locate edit-points by counting the control-track pulses (sometimes referred to as 'counter' pulses).

The one-per-frame control-track pulses are automatically written to tape when camcorders or VCRs are recording. If, though, they coincide with a dropout on the tape, the controller will miss it and skip to the next. And if a deck bounces the tape when going from (say) slow to fast (or vice-versa) the controller will mis-count.

Theoretically time-code should not suffer from these problems. However, do not take it for granted that any time-code edit-controller will *guarantee* frame-accurate cuts on

mismatched decks; it will only be as accurate as a deck's tape-transport system and differences between backspace/pre-roll allow.

Finally, whether time-code or counter-pulse, we must look at what we want the controller to do. For the serious editor I suggest the following are the most basic priorities:

(1) It must be hard-wired to both player and recorder.
(2) Where VCRs are not completely compatible it must have a means of fine-tuning pre-roll and edit-points to provide frame-accuracy.
(3) Since vision-only insert-edits will, on average, be 30–40 per cent of the program, it must offer this facility. Note here that many do not.
(4) It must be able to control audio-dubbing.
(5) It must have a facility for previewing cuts – especially insert-edits – before committing them to tape.
(6) It must be able to do all the above more quickly and more efficiently than simple synchro-linking.

Invariably all this means choosing the controller from the same manufacturer as the two VCRs.

The facility for automatic assemble-editing of, say, 99 cuts is less important than some suppose because most top hobbyists rarely use it.

The reason is that a seamless 'live' soundtrack can only be built as each on-line shot is lovingly and to-the-frame assembled to the edited master-tape. Each shot's sound might need to be sweetened, deleted or replaced with SFX, and its levels must be adjusted to the previous shot and the one coming after it.

Only when this 'live' track is complete can further tracks such as commentary and/or music be added by the 'lift', mix and lay-back method.

Automatic programming of assemble-edits takes only the visuals into account so the 'live' soundtrack would be a cacophony of aural jump cuts with all the disaster sounds (including wind noise) left in.

In addition, a program might be constructed from many source tapes,

and constantly changing them is not conducive to auto-assembly. If, however, there are not too many source tapes, some auto-assembly can be useful for speeding up off-line work where the sound quality is less important.

If each frame carries time-code, going from off-line to on-line is very simple, provided of course you have a means of reading the codes. You can then easily identify the frames you want to cut and list their codes on paper ready for on-line.

Timebase

When signals are written to tape, optimum results occur when that tape is drop-out- and stretch-free and runs at a constant speed. If the speed is not constant the signals will not be written at the correct timing.

Further timing errors can occur when the camcorder, while recording, is jolted or swung about sharply, and when the tape is slack or damaged.

Similarly, timing errors may be caused when a tape recorded in one camcorder or VCR is played back in another. The second deck may 'track' differently on its spools and tape-guides and use a slightly different tension. And the playback heads may be set marginally differently.

These timebase errors need not be out by more than a couple of micro-seconds to affect the pictures in some way: shakes, shimmers, and untrue verticals in all or some small part of the scene are typical symptoms.

Connecting a timebase corrector (TBC) to the playback circuits picks up the errors and rewrites them. Note it only rewrites the playback circuits – it cannot rewrite the recording on the original tape. If though, a TBC is connected to the player-VCR it will transfer the corrected rewritten version to the tape in the record-VCR, ensuring a stable edit-master.

TBCs are available as separate units but since they invariably provide additional facilities such as control over black-level, signal boost/cut and color burst, they are not cheap. However, some Panasonic edit-VCRs have a built-in (switchable on/off) TBC which makes them ideal for use as a source player-VCR.

Editing jargon buster

Assemble-edit – a procedure where each shot or section is edited sequentially.

Audio – another name for sound.

Control track – electronic pulses recorded on videotape to maintain a constant playback speed.

Dissolve – a slow transition of shots, where the incoming shot is gradually superimposed and finally replaces the outgoing one.

Drop-out – tiny white flashes or other discontinuity on the picture caused by that part of the tape's oxide being worn away.

Dubbing – copying video or sound from one tape or source to another.

Edit-in – that part of a shot chosen to be its beginning.

Fade – a sound or picture transition that goes from one intensity to another such as picture going from full color to blacked out.

Edit-master – the second-generation tape resulting from the editing process.

Frame – each one second of normal speed contains 25 individual still frames (pictures). Each frame is made up of two scans.

Frame store – a digital device that stores one frame or scan for an indefinite period.

Glitch – a visual disturbance between joined shots: bars of 'snow,' wobbling or shaky picture, etc.

Head, video – an electro-mechanical rotating device. The part of VCRs and camcorders that records or plays back the pictures.

Jog shuttle – a dial on a VCR that allows tape to be 'shuttled' backwards or forwards at variable speeds, then 'jogged' a frame at a time or held on pause.

Master tape – the first-generation recorded tape before being edited.

Monitor – the television(s) to which the player and recorder are connected.

Preroll – the point from which the tape rolls forward, after backspacing, to enable control tracks to synchronize ahead of the edit point.

Slave – when one or more machines (player or recorder) are controlled by a master-machine, such as an edit-controller, they are said to be slaves to that master.

Timebase corrector (TBC) – a device that corrects an unstable video signal, e.g. a jittering picture. Some VCRs have them built-in and are therefore recommended as main play-machines in any editing set-up.

Time-code, longitudinal (LTC) – as above but recorded on tape's linear soundtrack which then cannot be used for other sound.

Time-code, vertically integrated (VITC) – a system of recording electronic information in the unused video lines between frames that identifies each frame with a series of eight-digit, consecutive address numbers such as 07:49:32:17 representing hours, minutes, seconds, and frames. When played back in slow motion or paused on a VCR or edit-controller with 'reading' circuitry, they can be seen on a monitor.

16

EDITING PART 3 – THE CRAFT AND ART

Creating structure;

Making a start;

Shot duration;

Cutting point;

Time control;

Linking sequences;

Cuts to avoid;

Fiction;

Rhythm and mood

Because each human being is unique, no two editors will edit the same material in exactly the same way; some will be no more than unimaginative button pushers, whilst others will display varying degrees of craftsmanship. A few will reach the stage where their work can be considered art; where pictures and sound marry in such a way that an audience is emotionally stirred by them without realizing they've witnessed the editor's influence.

No book can teach this type of art, neither can it pretend that there are 'rules' of some kind which will turn you into an instant craftsman. What it can do is point you in the right direction by explaining some basic guidelines that, over the years, have established themselves as fundamental to the basic craft.

Creating structure

First, every 'movie' – and by this I mean anything from *Our Holiday* to a serious documentary or fiction story that is intended to be shown to an audience – needs shape and structure. In other words it needs to be *about* something and – just like a good novel – have a proper beginning, middle and end.

It means thinking of the camcorder-originated shots as no more than raw material from which *some* shots and sequences are selected. It involves reviewing and becoming familiar with all the material, logging each shot, looking for sequences that can be edited into some kind of theme.

The sad fact is, most people's holiday movies are incredibly long and boring. The thinking seems to be, 'Here's 2½ hours of how it really was – and that's how it has to be.' But how would you feel if you were forced (through politeness) to sit through a friend's wobbly holiday epic? Enough said?

Most people's attention span on any one topic is less than half an hour. It pays, then, to split 'boring' holiday films into shorts with running times that vary according to *entertainment* value. It means considering that 2½ hours as no more than raw material from which several short movies on separate themes can be made.

The way each one is treated might

also vary; a three-minute *Look at Wildlife* 'dancing' to humorous music might go down better than a 15-minute factual lecture-type documentary, whereas the latter treatment of a 15-minute *History of a City* might strike the right note. What I'm getting at is: holiday films don't have to be about holidays; look for the films within.

Even so, you might still want a comprehensive record of the whole thing, but if you can't edit that 2½ hours down to, say, 300–400 shots with a total running time of no more than half-an-hour, its unlikely to be of interest to others.

Making a start

The craft of editing starts by dropping all material irrelevant to the script, chosen structure, or theme. From the rest, select shots which can be welded into sequences and condense each shot and each sequence to its *minimum* duration – just long enough to convey its meaning and hold interest.

It means examining each shot, looking for the exact frame where it should begin and end. If a shot is too long the sequence is too. If sequences are too long the whole movie drags and becomes boring.

The general principle here is that a sequence of many short shots showing different camera angles of one scene is better than one lengthy shot from the same viewpoint.

Where, however, some specific action is taking place, the general principle is that if some piece of action is shown to start it should also be seen to finish, not forgetting that it can be shortened or expanded by inserting cut-aways.

Shot duration

Now let's look a bit deeper into the 'how long a shot should last' question. To illustrate this I'm going to describe first, an example of how to get it wrong.

Part way through a recent amateur video about a holiday in Paris, France, there was a five-second establishing long-shot of the Eiffel tower. This was followed by a 27-second, huge telephoto close-up of the top of the tower around which a seagull circled, before, after making

Each picture represents 15 frames: the edit-in has started after the action started but the edit-out must wait until the action has finished.

two abortive attempts, finally settling on a spire. While this was on screen, the commentary was delivering some historical facts and figures about when the tower was built, by whom, the numbers visiting it every year and so on – reams and reams of dry statistics.

Unfortunately, nobody paid attention to the commentary; they were distracted by that gull.

An experienced editor would have cut that shot to three seconds, making the edit-out point a few frames after the gull had landed, since this brought a 'natural' ending to the shot.

To replace the cut-out 24 seconds while enhancing the commentary, he ought to have assembled or inserted six or seven more shots of different parts of the tower, including two taken from up the tower itself (it has a lift).

The filmmaker later explained that he had let the shot run so long because: (a) he thought it was a really great shot; and (b) he needed to cover the running time of the commentary and hadn't taken any other shots.

Three basic points emerge here:

(1) If you don't shoot the material with a large enough cutting ratio you've got nothing to edit – a potential disaster.
(2) If you don't have enough pictures to fit the commentary then you must shorten the commentary or cut that part of it altogether. The main point here is that it is the *combination* of words and pictures that provide information but, wherever possible, use lots of pictures to support the words because maximum pictures means maximum interest and prevent boredom.
(3) Be ruthless: a great shot on its own is worthless; if it doesn't fit the script or theme, get rid of it. It really doesn't add to the film.

In general then, a commentary-led documentary needs a new shot every three to five seconds or you end up with a boring verbal lecture. That's not to say a lengthy shot should never be used but, when it is, you need a very good reason.

Cutting point

Choosing the actual edit-in and edit-out points of each shot is not, though, merely a matter of its running time. And skilled editors spend a lot of time choosing the exact frame at which to cut – especially when the shot contains some kind of movement.

Generally, as in the seagull/tower shot, they'll be looking for 'natural' edit-ins and edit-outs. The problem here is that one shot may contain several.

Consider, for example, a 30-second mid-shot (MS) of a woman reading a newspaper as she sits at a table. After a second or two, she puts down the newspaper, pauses a couple of seconds, picks up a cup of coffee, drinks, pauses again while she looks round, then takes another sip and puts the cup down. Then, after lighting a cigarette, she returns to reading the newspaper.

From this you may need no more than three seconds or so as a cut-away – but which three seconds?

Remember the guiding principle here: *in a shot or sequence where a piece of action is seen to start it should also be seen to finish* – not forgetting that additional cut-aways may be used to expand or compress time.

Therefore, as we study our shot of the woman at the table, we notice it can be split into four pieces of action that are 'naturally' self-contained:

(1) Reading and putting down the newspaper.
(2) Picking up the cup, drinking, and putting it down.
(3) Choosing and lighting a cigarette.
(4) Picking up the newspaper and reading.

From this it becomes obvious that you must choose one of the four, and edit in a few frames before its action starts and edit out just after it finishes. If, though, the action still drags a little, you can make the edit-in *after* the action has started – say, where the cup is already to her lips.

What you must not do is edit out before the action ends or edit in and out between pieces of overlapping action, or the shot will cease to be self-contained.

Time control

Of all the devices for compressing time and/or changing location, the close-up cut-in is without doubt the most effective. To illustrate this, imagine we're on a motoring tour.

We edit a sequence of eight shots which show the car en-route, and then we cut to an interior giant close-up of the speedometer. This shot immediately isolates the viewer from any sense of knowing where the car is – there is no background to give him a clue – so we follow this with a shot of the car pulling into a new location and the viewer is unaware he's travelled several hours in under 20 seconds.

Ninety-five per cent of good editing relies on cutting directly from one shot to the next without any kind of artificial device like fades, wipes and dissolves. The novice, having forked out for the latest box of gizmo wipes, is prone to overdo them; he should bear in mind that, wrongly used, such effects distract the viewer by drawing attention away from the action.

A second problem is that such gimmicks soon become hackneyed or associated with a certain type of function: mosaic with concealing somebody's identity, strobe with sci-fi or discos; the split-screen with simultaneous happenings like two people holding a telephone conversation; and a fade to black with the old-fashioned technique of changing time or location.

Fading titles though, is still the most satisfactory way to open and conclude a program.

The dissolve – one of the oldest cinematic tricks – is still in favour but nowadays it's done much faster. Five frames, on most TV commercials, transports people from one scene to the next – but, how long a dissolve lasts should depend on the context.

For instance, dissolving from a mid-shot of several colorful flowers to a CU of one flower needs five frames or a simple straight cut.

Dissolving to create an impression of elapsed time, like from the mid-shot of a man starting to climb a cliff to the shot of him reaching the top, needs 20 or more frames.

The thing to remember about

special effects is that they should only be used where they add something *meaningful* to the scene; not just as a means of linking sequences or getting the editor out of trouble.

Linking sequences

If though, the camerawork has been shot with a view to the editor's needs, it will include several 'arty' shots and visual 'bridges' which act as sequence-linking material. But sound can also be used in an 'arty' way; a man opens his mouth to shout but what apparently comes out is the sound of a train's siren; we see the train a split-second later.

Dialogue also creates links, 'Tomorrow,' says the voice, 'we'll go and watch the carnival.' No prizes for guessing what comes next.

Fiction

Editing fiction drama is a completely different ball-game: the task is not only to create an apparently seamless event but to bring out the emotional content of the actors' performances.

In general, this means cutting to bring out action and *reaction*. For instance, in mid-shot, one actor raises his fist; cut to a close-up of the second actor's face as he reacts with surprize, anger or whatever. Alternatively cut-in a listener's reaction to a speaker's words.

Shortening or lengthening pauses between dialog – even cutting out some words – is also within the editor's remit.

But most of all he'll look for opportunities to cut-on-movement (also known as cutting-on-action) such as when, in mid-shot, a man raises his arms to light a cigarette; at the frame where the flame touches the cigarette the shot changes (with a change of angle) to a close-up. Done properly, at matching frames, the 'join' is invisible.

All of this, though, can only be done if the action is properly storyboarded, rehearsed, discussed and directed.

Normally each piece of action – maybe no more than two lines of dialog – is shot as a wide-angle or midshot which is known as the mastershot. The actors then repeat everything *exactly* several times while the camera changes position and shoots mid-shots and close-ups which are later edited with the master.

The editor's main problem is likely to be *matching the eyelines* (not to be confused with *crossing the line*) when he cuts in the close-ups; if actor A is shown talking, reacting, or looking screen-right and slightly upwards at actor B who is off screen, the following close-up of actor B must show him not only looking screen-left but also at the correct downward angle so that the viewer believes both actors are making eye contact.

This can be very tricky where a scene has lots of movement; actors crossing and recrossing the line or the camera tracking or panning to follow the moves.

Returning to the master-shot – or part of it – can always get you out of trouble but too many amateurs attempt too much cross-cutting which creates a predictable ping-pong effect.

Rhythm and mood

All life has changes of rhythm, mood and pace, and your film should too. On our motoring tour, for example, we might have a scene showing cars parked by a tranquil lake; people sunbathing, people fishing, waterfowl paddling and so on. If the shots are cut a little long, and accompanied by restful classical music, this can create a leisurely (yawn) pace. Later in the film, a sequence at an amusement park – traffic, funfair rides, slot-machines and other amusements – cut sharply to modern beat music will reflect the many activities and faster pace. Always examine ways of changing pace – a one-paced movie soon becomes a bore.

Finally, to improve your understanding of techniques, tape and analyze lots of five-minute sections of TV, especially your chosen genre. Play it back at normal speed to get the gist of it then switch to slo-mo. Count the number of shots. Examine the changing camera angles. Check how they used link-shots to change locations. Switch to frame-advance and check at which frame a cut was made.

Then make a separate analysis of the soundtrack and work out how it complements the visuals.

But my last piece of advice must be: don't bite off more than you can chew – a good 10-minute short is better than a 30-minute bore. Keep it simple but do it well.

Cuts to avoid

Some cuts create disturbing jumps – where possible avoid the following:

- Cuts which allow a person to walk out of frame then be found already in frame in the next shot.

- Intercutting which makes a person or object jump from one side of the screen to another.

- Crossing the line: where a person(s) or moving object(s) is facing or moving left then seen facing or moving right in the next shot.

- Cutting from static objects to fast moving action unless it's for effect.

- Cutting from one pan to another that moves in the opposite direction.

If you have no choice but to use the above shots, disguise the jumps by inserting at least two cut-aways related to the action between each cut, but *never* insert cut-aways or cut on the moving part of a pan or zoom.

If pans across scenery were shot properly – with a static beginning and end – most good editors will treat them as three separate shots and cut out the moving section.

17

LAYING SOUNDTRACKS

▲

▲

It surprizes many to learn that, with the majority of TV movies and documentaries, very little of the sound is recorded at the same time as shooting the pictures. It's added later or *post-dubbed*. In fact, professionals might mix and post-dub up to 16 separate soundtracks: dialog, background 'atmosphere,' spot effects (synchronized sounds like doors closing), several music tracks, plus special effects such as thunder, rain, gunshots and so on.

Amateurs can't lay 16 tracks, but they can lay three or four by pre-mixing two down to one, then mixing this combined track with the originally recorded hi-fi or linear-track 'live' sound.

This will involve 'lifting' (copying) off the 'live' sound onto another recording medium such as another VCR, or an audio cassette or reel-to-reel recorder, while mixing a second track – say music – and, using the audio-dub control, laying it back on the edited video's linear track while mixing in a third sound, say, a commentary.

We must remember here that only linear tracks, or Hi-8 PCM can be audio-dubbed. FM hi-fi sound signals are multiplexed with the picture signals and cannot be over-dubbed. They can, however, be replaced using the direct input method described in the chapter on editing. And, they can be copied from a camcorder or VCR – set to output the FM sound – onto the linear or PCM tracks of another VCR. In other words, FM tracks can be copied to linear or vice versa. Indeed, while making a copy, most VCRs will automatically copy the original's FM sound onto linear and FM tracks without special switching.

Making the tracks
Soundtracking should always be considered as part of the editing process – not something that is bolted on afterwards. It means that as each shot and each sequence is assemble-edited its sound should be listened to and decisions made on whether this original 'live' sound is good enough; whether it is the correct quality or whether it should be completely silent or replaced with a different sound from a sound effects disc or cassette. Alterations are then made

using the direct input and audio-dub methods described in the chapter on editing. And even though this has involved some faking, the completed track will still be known as the 'live' or location track.

Whichever you choose, the first objective is to build the location sound entirely on the linear track since it is the only way to insert-edit pictures in order to eliminate sound jump-cuts and maintain one continuous sound over different shots.

In these circumstances the pictures might not be edited first. Indeed, much tighter editing results from recording the commentary, leaving gaps where the story is told by pictures alone, then timing sections of it and editing the pictures to fit.

However you do it the location sound becomes very important since it acts as a reference for synchronizing all the other tracks.

The only problem with copying sound from VCRs to audio cassette or reel tape-recorders then laying it back on the VCR is doing it without losing lip-sync. because the motors in ordinary audio-cassette-recorders or reel-to-reel machines can speed up or slow down. Therefore, perfect speed synchronization with the record-VCR may well drift after a few minutes unless a synchronizer is used (see below).

Fortunately, perfect lip-sync. is rarely required all the way through a movie so it is not always that important.

Since there are numerous ways to lift and mix, this chapter is concerned with the more straightforward ones.

Method one
Because, for practical purposes, two VCRs run at identical speeds and therefore in synchronization with each other, the first method uses two VCRs – the player and the recorder. It also requires an audio mixer and an audio-cassette recorder. The audio mixer doesn't have to be that special; a three-channel stereo model which can switch the stereo channels to mono if required and control each one with proper slider controls (not round knobs) is adequate. A desirable refinement, though, is a tone control.

The basic method is to copy (lift) the 'live' sound from an edited-master tape onto another video tape while mixing a new track (from audio tape) with it, then copy the resultant mix back onto the edited-master while mixing in yet a further track.

It is, though, virtually impossible to mix more than two audio channels at any one time while simultaneously operating the VCR and watching the monitor. The answer, then, is to build up the soundtrack in stages – mixing no more than two tracks down to one at each stage.

Here's one method of mixing three sounds: 'live location,' music and commentary.

(1) Put the edit-master in the player VCR and connect its linear track output into channel 1 of the audio mixer.

(2) Pre-record the commentary on an audio-cassette deck with an 'instant' pause control and connect its output to mixer channel 2. Pause it just before the commentary starts.

(3) Copy the edit-master from the player-VCR to the copy-tape in the record VCR, releasing the cassette-deck's pause control where you want to start the commentary. Fade the location track enough to allow the commentary to dominate. Don't worry about the picture quality, it's the sound we're after.

(4) Swap the video tapes over so that the copy is in the player VCR and the edit-master in the record-VCR. Locate and 'pause/play' identical start points – or first frame – on each video. Take care with this because the synchronization will depend on the accuracy of it.

(5) Switch the player's sound output to hi-fi. On the recorder-VCR press 'audio-dub' and *play* to release its pause and simultaneously release the pause on the player.

While making this transfer add the music in the same way as you did with the commentary. That is, pre-record it in sections on audio-cassette and drop it in the appropriate places using the cassette-deck's pause control. The result – all three tracks should now be on the edit-master's linear track.

With each transfer you could, of course, add further sounds from the spare mixer channels, but don't attempt it unless you can work out a foolproof method to control which channel does what, and where and how it should stop and start.

In theory, too, further tracks could be added by repetition of 'lift and mix' but too many lifts from linear tracks will result in a build-up of hum, hiss

4-track cassette recorder.

THE CAMCORDER USER'S VIDEO HANDBOOK

and noise. For this reason the above method has utilized hi-fi tracks, where possible, since their inherent 'noise' is minimal.

Commentary

It's always better to pre-record the complete commentary on an audio-cassette recorder first. Trying to record it direct onto the VCR while watching the pictures and operating the mixer is a recipe for errors. Pre-recording it means you can eliminate fluffs, bad timing and bad delivery. In other words, do it as many times as is necessary to get it right.

Record it in short sections of a sentence or two, leaving (say) a one-second gap between each one – so that a speedy press on 'pause' can stop the commentary between sentences – releasing it only when the next sentence is required.

There is, of course, no rule to say that the commentary should be mixed first. Indeed, you may find it suits you better to mix the music with the 'live' track first then add the commentary later. Either way the benefit of the above method ensures that the 'live' track remains in sync.

Getting things right first time is difficult. It therefore pays to experiment with mixer levels and rehearse all procedures on an *additional copy* of the edited tape before going for the final mix-down.

Method two

Using a stereo ¼in-tape reel-to-reel audio-recorder is probably the easiest, most professional and efficient method to produce an intricate multimixed track consisting of lifted live sound, commentary, various short pieces of mood music, and additional 'atmospheres' from (say) a sound effects (SFX) disc or one of the many SFX tapes advertized.

As well as new machines, some of the stereo hi-fi models produced in the seventies and eighties are absolutely ideal and can be picked up secondhand from specialist dealers or secondhand shops.

The beauty of ¼in tape is that it can be edited by physically cutting out sections of it with a razor-blade on a purpose-made splicing-block and joining sections with special splicing-tape.

Cleaning the heads with a cotton bud.

The audio edit-in/out point is located by listening for it and pausing the tape in its play mode then manually rock 'n' rolling the spools until the exact point is on the playback head. The tape is marked with a wax or chinagraph pencil where it sits against the playback head then removed to the block for cutting and splicing. It's all done in a matter of seconds.

Typically, these super machines allow: full manual recording control of both tracks together or separately; the ability to monitor one track while recording on the other; transferring one track to the other; 'bouncing' sound on a previous sound while simultaneously adding further sounds. And finally, both tracks can be fed separately into a mixer.

The idea is to build up a complete master soundtrack on ¼in tape first, then transfer it to video only when everything is right.

Its disadvantage is that, without some means of synchronizing it to the VCR, it will only run in sync. with it for a limited period – approximately 10 to 15 minutes.

Multi-track recorder

Audio-cassette recorders are available that can separately record four or eight parallel tracks running in one direction. On playback, each track can be routed through a built-in mixer and mixed down to one. This output can be in stereo and 'panned' across both channels in either direction or centred for a mono output. Tone (equalization) controls are also provided.

Two major manufacturers provide four-track models within the amateur price range: Fostex, who call them 'Multitrackers', and Tascam, who label them 'Portastudios.' These machines bear close comparison with their professional big brothers, as used in studios and edit-facility houses.

Typically, they allow one track to be recorded while listening to another, or while listening to the mixed output of all the others, and a one-touch record button allows an error to be overrecorded or erased. And any track can be transferred to, or mixed, with any of the other tracks.

Therefore, a videotape's 'live' track can be lifted onto, say, track 1 and used as a cue-track (see below) leaving three more tracks available for commentary, music or whatever. A 'start' mark, to synchronize with the first video-frame, must be made and this can be the point where the end of the leader is spliced to the audio tape. This point is then hand wound to coincide with the centre of the slot in the cassette shell.

Keeping the transfer in sync. is not as automatic as between VCRs since the multi-tracker's speed will not remain constant, but synchronization is assisted with a control knob which can vary the audio tape's speed plus or minus 15 per cent.

Demagnetizing the heads.

At least one manufacturer supplies modified multitrackers with a device that synchronizes them by using one of the tracks to lay down sync. pulses, and continuously adjusts the speed of the multi-tracker to match that of the VCR.

Cue-tracks

Not all tracks need to be in perfect lip-sync. all the time. Such sounds as birdsong or countryside background ambience, mood music and some commentary can be out of sync. by half-a-second or so without undue concern. But even so, when using non-synchronized multi-trackers, or similar facility reel-to-reel tape-recorders, the cue-track method is to be preferred. It works as follows;

(1) Compile the location track on the video edit-master, put it in the player VCR on pause/play and connect its sound to playback through a mixer onto track 1 of the reel-to-reel or multi-tracker switched to record/pause – not forgetting to align the start marks.
(2) Connect a microphone to an appropriate mixer channel.
(3) Release the pauses and, as the video plays, watch the pictures and call out a series of audible cues through the mike. By now you will know the program so well that you should be able to anticipate each shot.
(4) Watching the pictures, call out a brief description at each shot

change, tapping the mike with (say) a pencil at the precise point – 'Anchor ... 2' ... (tap) for the second shot, 'Quayside ... 3' ... (tap) for the third and so on.

After checking – by playing back the reel-to-reel machine with the video – the videotape can be put aside and the other tracks are recorded while listening to the cue-track.

Finally, track 1 is re-recorded with the location sound – which simultaneously erases the cues – leaving all tracks in sync. with each other ready for the final mix-down.

Sound quality

Maintaining the purity and sound quality of any multi-mixed track will depend, to a great extent, on the quality of the recording equipment – especially tape and cassette-recorders – and whether you can use manual recording controls.

Quality chrome-tape hi-fi cassette-decks with noise reduction systems such as Dolby B or C will always produce better sound quality than Walkmans and cheap portables, although the best of these are perfectly adequate for playback.

Poor quality sound manifests itself as excessive noise or hum and a loss of those crisp treble frequencies so important on music tracks. And commentaries sound muffled, as though the commentator has his mouth full of wool.

To ensure optimum quality, record-

ing heads, playback heads and pinch wheels must be cleaned. Nothing degrades high frequency sounds more than allowing tape oxide to build up on the heads.

Do not use so-called head-cleaning tapes; some are abrasive which prematurely wears the head. Use a cotton bud moistened with methylated spirit or a proprietary fluid based on freon and repeat the procedure every 6 hours or so.

After every 15 hours, demagnetize the heads and any metal parts that come in contact with the tape. Since a demagnetizer only costs around half the price of a camcorder tape and takes no more than 20 seconds to do its job, it has to be a shrewd investment.

Perhaps the ultimate sound quality comes from DAT (digital audio tape) recorders; they are virtually noise-free like compact discs but pricewise you might be better off buying another hi-fi VCR for soundtrack building and recording, with the certain knowledge it will stay in sync.

A VCR's heads should be cleaned if you suspect its picture and sound are noisy. Take it to an expert service dealer. DIY cleaning is not advised.

One last tip is worth mentioning: since the quality loss is greatest because of the loss of high frequencies it can pay if, while transferring, a tone control or graphic equalizer is connected to the audio-mixer's output. This allows the higher frequencies to be crispened and boosted to make up for any loss. As a rule of thumb, boost trebles by 10 percent and cut bass by the same amount.

Manual recording controls

All manual recording-level controls, whether on camcorders, VCRs or tape-recorders, provide better quality sound than automatic systems because, once the level has been set to fully modulate the loudest sound, all quieter ones remain at their respective levels and hiss and noise are reduced.

Two methods exist:

(1) VU (volume unit) meters have a quick acting needle which moves across an arc-shaped scale marked in decibels (dBs); typically −30dB

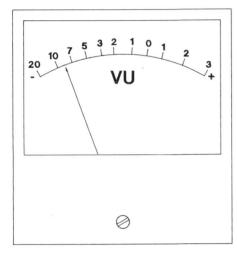

VU meter: when the loudest sound flicks the needle to zero (0) the sound is fully modulated.

to +10dB. All the +figures are marked in red and are on the right of the scale.

To set the level, the record/pause mode is selected and the recorder's amplifier control knob is turned until the loudest sound flicks the needle up to zero dB. Going into the red produces distortion.

(2) Peak LEDs (light emitting diodes) are usually a horizontal series of five green miniature lights and two red ones. The control knob is turned until the loudest sound lights the first red LED but does not allow it to stay lit continuously. When either meter is set like this the recording is said to be fully modulated.

Finally, getting mixer levels and timings right first time is difficult. It therefore pays first to make a backup videotape copy of the location track in case things go wrong. Then, experiment with mixer levels and rehearse all procedures on an additional copy before going for the final mix-down.

Alternative methods

So many alternative methods exist that it would require a whole book to describe them. Most of them are based on some variation or combination of the above three methods. To maintain better sync., you might, for example, build a sound master track almost entirely using video-tape then use a multi-tracker to build non-sync. tracks.

It all takes practise. Tracks aren't built in a day. And at the end of all your efforts, if you've done it correctly, viewers will rarely mention the soundtrack. They'll take it all for granted – the ultimate accolade.

Using music and sound effects

Record companies and some broadcasters such as the BBC issue dozens of sound effects (SFX) disks and cassettes; each one contains around 50 SFX and, for amateur use, is copyright free. Your local record store will be able to get them but first I recommend writing for a catalog because you'll need to know exactly what SFX each disk contains. Some public libraries stock them and hire them out by the week.

Each disk contains several groups of SFX based on themes. For example, a farm theme will have a general 'atmosphere' sound plus several recordings of different animal sounds, tractors starting and stopping, plowing, rooks nesting and so on. And a seaside theme will have a general atmosphere plus a series of different sea-wave sounds, boats, children splashing, etc.

The themes don't stop at domestic situations. Disks are available for sounds of war and at least three have sounds for horror movies: screams, vampires, torture, creaking doors, hollow footsteps and all sorts of incredible nasties.

And one BBC disc, 'Sounds of Victorian England', contains bygone sounds, of which, ticking clocks, trams, ponies and traps, and barrel organs are among many.

Many such SFX will be suitable, just as they are, for replacing badly recorded original sound when building the 'live' track. Others, though, may need a little doctoring; speeding them up or slowing them down, alter-

BBC SFX are available on CDs or audio-cassettes.

ing the tone and so on to suit your needs. And some may need mixing with others to produce an entirely new sound.

If, for example, you shot a motor boat cruising up an inland canal but all you can hear is wind noise or the rumble of out-of-shot traffic, this bad sound could be replaced by motor boat SFX direct from disk. Alternatively, you might premix the motor boat with another sound – such as country 'atmosphere' or rumbling thunder – onto a separate cassette, before laying it on the video.

Music

Professional movies often contain pieces of music: title music plus several short pieces over sequences, short 'stings' when, say, the baddies appear, and short 'bridges' over a transition from one location to another.

But music should never be used as a substitute for real sound or SFX: its

purpose is to enhance the *mood* of a shot or sequence.

Many amateurs fail to grasp this and plaster their videos with music from end to end – nothing else, just music. And all too often the only reason for it is that it's the easiest thing to do. It gets worse: the music they choose is often a well-known piece associated with a TV program or movie. When a viewer hears this his mind is distracted from the visuals – he's thinking of that TV program.

Ninety percent of the time there is no substitute for building a proper live track. Where music is used it must be to enhance the scene in some way, to create a mood or stir an emotion. And its duration and loudness should be such that the viewer is no more than vaguely aware of it.

Record libraries and copyright
Many hundreds of pieces of music are specifically composed and recorded for mood-music libraries – a sort of off-the-peg service to film and video makers.

Professionals usually get free demo-discs from these libraries but each piece of music selected to be included in the movie has to be paid for – up to several hundred pounds or dollars per thirty seconds of music.

For UK amateurs, the Institute of Amateur Cinematographers (IAC) provides a similar service. They supply catalogs listing many LPs, CDs and cassettes. Each one contains several music themes, most of which have cutting points for shortening or lengthening the piece. IAC members chose a disk and buy it outright, and the price is often less than that of a normal record.

To help you choose, they offer a musical advisory service; you send them a letter outlining the film and the type of mood you are trying to create. You also enclose a blank audio cassette. Within a week or two this comes back with samples of mood-music taken from various disks, and a voice-over gives its catalog number.

There is no fee for using the music but you do need a copyright license – especially if you intend to exhibit the movie outside your home or enter in an amateur competition. For less than the price of a video tape the IAC can supply this too and it also covers copying most other types of commercial disks from classics to pop.

Further sources of copyright free music are advertized in the monthly video magazines. Be careful with these; some are no more than a series of tracks recorded by a one-man band with a couple of keyboards and the quality of the music and the recordings can vary.

Finally, let's repeat the most important point: music can be important to enhance a movie's mood or dramatic situation but it's not a substitute for a complete soundtrack.

18

THE SCRIPTED MOVIE

The script;

Shooting script;

Storyboard

Fiction movies:

The script;

Conceiving a plot;

Characters;

Dialog;

Stealing a story;

Story length;

Locations;

Actors;

The shooting script;

The crew;

Getting together;

Double check;

The shooting;

Rehearse then shoot;

Idiot boards and

equipment;

Preparing to edit;

First rough-cuts;

The cutting;

Post-synchronizing

dialog

Professional movie producer, Gerry Boarer MBE, once said to me: 'Give me a good, storyboarded script and an imaginative editor, and the camerawork need be no more than adequate.'

Now Gerry knows what he's talking about. Several of his documentaries have received international acclaim and recognition.

What he means is this: no matter how good or how sophisticated the camera and no matter how skilful its operators, a good movie starts first and foremost when a well-written script is broken down into sequences of shots and sketched on a storyboard.

Amateurs often neglect the importance of scripts. After all, so many ads extolling the virtues of, say, the latest 'Marzipan Camcorder' suggest that all they have to do is point and shoot and a professional quality movie is assured.

And, having cut their video teeth on *Baby on the Lawn* or *Our Week in Costa Packet* and received the warm and appreciative applause of family and friends, the thought of writing a script or making any other type of movie either seems downright pretentious or impossible.

I'm not suggesting there's anything wrong with family records – I've plenty of that type of material myself. In any case, shooting real life as it passes the lens in real time is rarely predictable so preparing a full script is hardly practical.

Sooner or later, though, the keen enthusiast will recognize he does have the creative ability to make more serious stuff – properly structured programs with something worthwhile to say to wider audiences. Such programs might be documentaries, fiction films, comedies, or a travelog based on holiday material – and all done for love rather than money. Many of them, too, will be entered in club and other amateur competitions.

Others will consider semi-professional applications: promos for businesses such as real-estate agencies or small manufacturers. Staff training films might also figure here. And videographers with specialist knowledge might make 'How to' videos: *How to service your car*, or *How to rewire your House*.

It's at this stage that the videographer realizes it is himself, not the camcorder, that must come up with all the ideas and work out how to carry them out. The Marzicorder is simply a tool, a dumb, non-thinking instrument that, without his input, cannot make any decision or render any kind of creative judgment. It's the caliber of this human input that separates the snapshotter from the real program maker.

The script

Successful hobbyists will tell you that, to turn an idea into a good movie, what is needed more than anything else is a plan – a working blueprint of some kind, in other words, a script.

How detailed the script is depends on the subject. A heavy drama will require a lot of details: locations, props, dialog, instructions to actors and crew, sound requirements and so on. It's a specialist and creative craft in its own right and beyond the scope of this one chapter. Whole books have been written on it and many will be available from your library.

Don't let this put you off. A good script cannot be measured on whether it's typed and laid out in a professional manner; it's only important that you, and anyone working with you, understands it.

In any case, some scripts need be no more than ideas jotted down informally as they occur to you. But, the more time and trouble spent thinking and writing, the better the movie will turn out to be. A famous script writer once said: 'The toughest part of my work is thinking – just thinking.'

As you research and make a camcorder recce of various locations the 'plot' will develop. And, as you jot down ideas visual images will appear in your mind's eye. Then, as you read and re-read these notes, variations or even different images will occur to you.

The net result of this 'editing' in the mind will be that the script will need to be rewritten several times. Each of these fine tunings will polish and hone the final blueprint leaving you no doubt of your intention and purpose.

Shooting script

Simultaneously, prepare a shooting script – written descriptions of the images in your mind, allocating each one a number. It's usual to write them on the left side of the paper with details of dialog and sound requirements on the right (see example).

Even so, these visual images are still in your mind; all you (and everyone else) have as a guide is *written* words not pictures. So when the script is shown to those taking part the chances are the images formed in their minds will be entirely different to yours.

Result? – confusion. Clients, in particular, may well be disappointed if the end product is not how they saw it in their mind's eye.

Storyboard

This is where the storyboard comes in – a series of hand-drawn cartoon style images drawn within their own TV shaped frame or simple 4×3 format rectangles. Underneath each one write its shot number and any camera instructions such as 'pan left to right.'

The drawings don't have to be expertly done. If you can't draw faces, draw circles with noses and eyes. If you can't draw objects such as cars, draw oblong shapes with wheels.

The point is: a competent 15-minute program might contain more than 150 to 200 separate shots from several locations. Keeping so much in your head while trying to get the movie grammar and continuity right is virtually impossible without some kind of visual reminder.

It will, for example, remind you to work out which type of shots – and how many – are needed to establish each location; to work out shots which bridge or link sequences; to ensure that you don't inadvertently 'cross the line;' and that you have allowed for plenty of cut-aways, cut-ins and close-ups. So your mind is now freed to concentrate on the full creative use of that Marzicorder.

Professional TV people take enormous pains with storyboards, particularly if they're producing commercials. Each second of transmitted time is expensive, so every shot must satisfy the client and make its point in the minimum amount of screen time.

Amateurs may not have to worry about budgets and ratings but the main principle – maximum information (shots) in the minimum time – is the same.

The failure to grasp the significance of this is often the reason so many amateur movies are just plain boring. Put it this way: if, instead of showing one shot with a duration of 12 seconds, you show the same thing in four shots (using different camera angles and focal lengths) totalling 10 seconds, the viewer's interest will increase.

A storyboard. (Courtesy *EBA Video Communications Ltd* and *JVC*)

This is particularly important for documentaries showing slow-moving action such as a craftsman at work: *The Glass-Animal Maker, The Potter's Wheel, The Painter* and so on. Any type of action that is of fairly predictable and repetitive nature needs lots of shots, including cutaways to compress the real time, if the boredom factor is to be avoided.

Of course, not all programs can be storyboarded from beginning to end but only you can decide what, and what not, to include. Do bear in mind, though, that a few rough sketches is all it takes to save time, frustration and, possibly, money. In short, the storyboard can act as your salesman, your visual continuity person and your memory jogger.

Making real movies is fun, but good ones are 90 percent planning and 10 percent actual shooting.

That's not to say that the shooting is not important – it is. But it's the script and the 'Marzicorder' *between your ears* that makes the best use of it.

Fiction movies

Producing a worthwhile fiction movie is arguably the most difficult of all the video genres for the amateur videographer to succeed at. It's like expecting someone who has just learned to write his first letter to write a blockbuster novel. So many problems can occur that it's nothing less than a miracle that any amateur fiction ever gets started let alone completed. But many thousands do get completed. And some go on to receive awards at clubs, national and international competitions, and those run by TV companies.

If you ask any of these top film-makers why they do it you are likely to receive a pitying look; as if you'd asked them why they breathe. Then they'll say things like, 'Just shooting pictures or making holiday movies isn't enough for me. I need to create something exclusively mine; something that fully tests and stretches my creative ability.'

Next, they'll talk about the hurdles: six or more script rewrites, researching locations, obtaining permissions, overcoming equipment breakdowns, and whole shooting ses-

Scenes from the making of Westcliff Film and Video Club's *Undercover* – a 7-minute spoof of the UK's *Cook Report* TV series. Producer Terry Mendoza, Cameraman Simon Frith, and all the crew and I were delighted when it received many top awards in international competitions. (Photos: Terry Mendoza)

sions rained off. To these add people problems: finding actors who can really act, a key person going sick, having a baby, having an accident, moving house, and so on.

And even when the shooting is over there are weeks of editing and soundtracking.

If all that sounds to you like masochism I wouldn't disagree. But, speaking from experience, I have to tell you that when that masterpiece finally hits the screen it produces a sense of achievement that no other video genre can match. It puts you on such a high that you can't wait to start the next epic and get another fix.

The script

Absolute beginners are likely to fail at the first hurdle: writing a script with a properly structured *believable* story and characters who are more than stereotyped cardboard cut-outs.

The fact is, many perfectly normal people *think* there's nothing to it; they attempt to write a story script without ever studying the subject or taking any kind of tuition. The resulting plot is usually embarrassing, a great welter of incredibly amateurish tosh that wouldn't challenge the mental agility of a seven-year-old. Believe me, no matter how good you are in every other department of video, without a good script there's no worthwhile movie.

To learn to be a good storyteller, however, doesn't mean you need to learn to become a writer, but you do need to study the craft of plot construction and be prepared to get your ideas on paper then *work* at them – examining and re-examining every detail, fine tuning and honing them to perfection.

Your public library should have several 'How To' books on the subject.

Conceiving a plot

Believe it or not there are only 36 known plots – it's true. If anyone can come up with a 37th he'll make a fortune. What makes each story seem different is the different characters and the way the plot is treated. All this means that constructing a plot is not as hard as you first thought; it all boils down to a straightforward formula. Here it is in a nutshell:

- **Premise:** the story must have an emotional premise (what it's about) or theme of some sort: the eternal triangle, struggle for justice; all for love, power, survival, jealousy, greed, fear etc.
- **The key situation:** early on – the earlier the better – the leading character(s) must be presented with a problem, dilemma or challenge. He wants to achieve or attain something or prevent something he holds dear being lost.
- **Motivation and intention:** the problem must be sufficient to motivate him or her to act, to have a target, aim or goal: to seek revenge, win back a lover, commit a crime, right a wrong, etc. It must be believable and in character. For example, the respectable government official wouldn't normally commit a crime, but he might if his wife is being held hostage.
- **Conflict:** this is the *essential* heartbeat of fiction. It does not necessarily mean violence, it can simply mean man against his own conscience or man against the elements. Or a conflict arising where someone or something tries to prevent him attaining his goal.
- **The narrative question:** 'What will happen next?' The audience must be kept in doubt about the outcome until the very end.
- **The reversal:** character sets about his intention, then meets disaster. Something happens to make his situation worse. He thinks about it then acts again. Will he succeed or will there be another reversal? The more hurdles to overcome the longer the film. Use at least two.
- **It must be believable:** could it happen? Are characters credible? At all costs avoid an ending that relies on any form of coincidence.
- **Angle:** your job is to use the above formula to find an original angle.

All the above applies equally even when the plot is a comedy. Do not rely on verbal gags, jokes and smartass one-liners. Laughs are best if they evolve from a story and characterization. The only difference between serious stories and comic ones is that the comedy character's attempts to jump the hurdles or extricate himself from misunderstandings and misfortunes should make us laugh.

Characters

No story exists without characters. But they need not necessarily be human. All sorts of movies, since *Lassie*, have had animals as main characters. And science fiction relies heavily on computers with brains and emotions, or various 'splodges' of alien matter that have minds of their own.

Each character must have an identifiable personality – a way of thinking, prejudices, beliefs, attitudes and ways of thinking that control the way he or she is likely to behave in certain situations such as stress, love, anger, confrontation, etc. Put it this way: a character is a body with a brain and emotions, a body without a brain is a cardboard cut-out.

Dialog

Apart from the character's physical appearance and clothing, his accent, voice, and dialog help put his social status and personality across.

But good screen dialog is not a faithful reproduction of real life talk where people waffle, leave sentences in the air, repeat themselves, fumble for words and, worse still, rarely stick to the point – the sort of dialog that rarely seems to get anywhere.

Screen dialog has four simultaneous functions:

(1) to establish the character;
(2) provide information;
(3) reveal emotion; and
(4) advance the plot.

One of the writing devices for concealing these functions so that the words seem to flow in a natural manner is to construct speech in such a way that, wherever possible, it should try to influence another character's attitude, behaviour or intentions.

There is simply no point in wasting previous screen time by dwelling on 'nowhere' talk.

Stealing a story

Since there is no such thing as an original plot, every fiction film, book or story must have its roots in some

one else's work. The film *West Side Story* has its roots in *Romeo and Juliet*, and many romantic rags-to-riches plots have *Cinderella* to thank for the idea. For example, *Cinderella* begat *Pygmalion* which begat *My Fair Lady*.

I could quote many more examples but the point I'm making is that it is perfectly legitimate to steal a plot, or part of it, from another film, book or short story.

What is important, though, is that, in order to make it appear original, the characters, locations and dialog must be changed. If, for instance, the original story was set in an Australian city and concerned a farmer robbing a bank because he needed money to pay his mortgage, then you can adapt it to be set in an English village. And you could, perhaps, turn the character into a computer-programmer, turned hacker, stealing funds from someone else's computerized accounts.

As long as the new characters are believable and have real motives for doing what they do the story will appear original.

Story length
My last tip on scripts is crucial: keep the number of main characters (not including extras with non-speaking parts) and locations to a minimum because they all need screen-time to explain their relevance to the plot; the more you have the longer the film, which also means it takes longer to plan, script and shoot. If fiction is new to you don't bite off more than you can chew; a maximum of three characters and three locations should be more than adequate to build a story with a screen running-time of 15 minutes. In amateur terms that's a lot of movie. Working at it during weekends and spare time can mean up to two months scripting, six weekend shoots, and two months editing.

Locations
At some point during scripting you'll need to check out the proposed locations even if they are already familiar to you. Take the camcorder with you. What *it* sees and the way it sees it will be different to the way your eyes see it. And it's the camcorder's

version your audience will see.

Interiors provoke several questions: is there enough space for the crew, equipment and props while leaving enough room for the actors to do their stuff? Is the decor suitable or does it contain extremes of dark and light colors that will cause exposure problems? Can you change it in some way? Will windows cause contrast and mixed light problems or can they be fitted with orange gels or curtained off? Are there enough power sockets for lights? Will lights need blue gels.

It also pays to make some audio recordings and check whether they contain echo or sound boomy? Is there some machinery, a central heating pump or icebox creating hum? Can it be turned off during the shoot?

If everything checks out OK, measure the area and make a rough floor plan, then make notes about items which can or can't be moved to make way for props.

Exterior locations must not be taken for granted either. That lush grass meadow might, on the days you plan to shoot, be under the plow. The main highway might be cordoned off for a VIP's visit or there may be bye-laws restricting the use of tripods. Some locations may be militarily or security sensitive.

Check everything with the appropriate authority, police or owner. It can save so much hassle if you get their permission and co-operation beforehand. And, as all location research may have some bearing on the final draft of the script, don't leave it until the last minute.

Actors
Actors – and I don't mean friends and relatives who are prepared to take part for a giggle – are the next vital ingredient. If you are halfway serious about good drama you'll need people who take pride in the *craft* of acting. People to whom acting is a serious activity; people who understand that sometimes they'll be hanging about while others perform or while camera, lights and sound are repositioned between shots.

Almost inevitably it means approaching amateur drama groups but, don't expect them to fall over

themselves to help you without some salesmanship on your part. You'll need to attend one of their shows and get to know them. They'll need to be persuaded to read your script. And most of all, you'll need to inspire them; to convince them that it's worth *their* effort.

Three things will help you do this:

(1) Offer those chosen to take part a free copy of the film.
(2) Show them the recce tape of the locations and explain how you intend to go about things.
(3) To actors, used to doing their stuff in one continuous stint on stage, the shot-at-a-time technique won't be easy to put across without some means of painting visuals in their minds. The storyboard, no matter how crudely drawn, and coupled with your explanation, can do this. Chances are you'll need one anyway, even if its purpose does no more than remind *you* of certain aspects of the film and how you've conceptualized splitting the action into its separate shots. It should, of course, illustrate the script in story order. From it also the shooting script is prepared.

The shooting script
This is a descriptive, numbered, list of every shot you need to make at each location. The idea is to save time, frustration and money by shooting all the shots needed at one location, ticking the list as you go, before moving on to the next location. Therefore, shots will rarely be shot in story order.

Stage actors need to be told all this, but tell them also (and mean it) that they are the most important element in the film; that everybody will be rooting for them and everything will be done to help them deliver their best on-screen performance.

The crew
Overlapping all the above will be the need to find a crew. You may decide to direct the action and do the camerawork yourself; it's your baby and nobody knows better than you what you want on the screen. But having someone

whose sole responsibility is recording and monitoring sound, frees you to concentrate on the acting and creative visuals.

A lighting man with responsibility for the monitor, and who doubles as a continuity checker, is also a good idea. And finally, you'll need at least one production assistant – a gopher who will arrange all the props and lend a hand at what ever else is required.

If you're a club member, finding a crew won't be difficult but, if you're a lone worker, you'll need to think very carefully about writing the script to suit your capabilities.

Finally, don't, in your enthusiasm to get on with it, skimp on the planning. The artistic and creative side of a fiction film can only flourish if it's free of worry about what might go

Cuts-on-action: the action was repeated so that a close-up of the girl (right) could be edited in at matching frames in order to produce a "seamless" cut which doesn't interrupt the flow of action.

wrong. Something will anyway – that's Murphy's law. But a good plan keeps it to the minimum.

Getting together

A couple of important steps need to be taken before the director-cameraman can shout 'Action!'

The first is to ensure everyone has a copy of the full script at least two to three weeks before calling them together for a 'read through' and briefing. This meeting must not be a one-way lecture on your part; let everyone have a say and make suggestions although, since you are the director, you must be in charge of the agenda and act as chairman.

Naturally, everyone will be concerned with their own individual task; the crew with the technicalities, the actors with dialog and acting. But, it's your job to weld them into a team and explain how each job relates to everyone else's. Nevertheless, it's necessary to make it clear, gently, that where a difference of opinion occurs the director's decision is final.

The crew's queries should occupy no more than the first third of the meeting then, following a short break, the remainder should be given over to actors' concerns.

Start this session with a complete read-through of all the dialog scenes, trying not to let anyone, including yourself, interrupt the flow.

This 'read' will probably reveal a severe problem: what you thought was perfectly written dialog doesn't sound right when spoken. There's no getting away from this one, you'll have to agree with the actor just what words to use and how they should be delivered – even if it means great chunks of rewriting. Don't become discouraged as this is quite usual.

It also helps actors become familiar with cameras and lights if you have arranged for their part of the meeting to be taped. On this occasion let one of the crew operate the camcorder and ensure it's connected to a monitor; *you* should be concentrating on the meeting and giving full attention to the actors.

Do not, at this session, attempt to correct a stage actor's exaggerated facial expressions and body language. This will need to be done, but not until the shooting begins. Doing it now will sap their confidence. You should, however, explain that they do not need to shout as though trying to reach the back of the theater; their voices need to be projected no further than the microphone. In other words, concentrate their attention – and yours – on getting the dialog to sound right.

Double check

Between now and the first shoot, take the crew on a tour of the locations to sort out potential technical problems. Together, work out a checklist and ask questions: will you need extra cables, adaptors and blue gels for lights? Have you spare fuses and bulbs – a soldering iron perhaps? And what about masking tape, that general purpose fixer? Are you going to use a boom-mounted microphone, tie-clip types through a mixer or simply rely on a hand-held shotgun. Have you enough batteries, or will a mains supply be available? In other words, all the things you checked and discovered on your initial recce must be shown to the crew.

The shooting

And so we come to the shooting sessions. Before each one, arrange for the crew to set everything up before the actors arrive. Acting is an emotional experience and some will be psyched up for their part or be nervous. They should not, then, have to shoulder the extra burden of being troubled with technicalities or worried about anything other than their performance.

Make a fuss of them, because, everything you have done so far has led to this point – the entire object of the exercize. Even post-production depends on how well the actors perform and how well it's recorded.

Make the first shooting session a simple one. Choose a scene from the shooting script that is comparatively easy; do not expect everyone to start a heavy emotional scene from 'cold.' And, where a single camcorder is used, do not expect crew or actors immediately to get the hang of the rehearse-and-shoot technique which works as follows.

Extract from COCKLES shooting script

Location 8. Exterior about 12 noon
Focus pull from 29a.

30. Establishing LS from sea (POV) of 3 cockle-boats moored at quay, unloading taking place.
20 secs . . .

40. MS of centre boat (camera ashore) as Jim walks down gang plank laden with two cockle baskets and walks R to L out of frame.

41. MS (but closer) of Jim as he enters frame R then stops on way to storage sheds.

42. CU (head and shoulders) as Jim, looks right, pauses, then turns to face camera which slowly zooms to big CU of Jim's face. He speaks

Sound . . . etc.
Low dubbed gulls BBC Disc
Music: 'Alive alive Oh!'

Music fades under: Commentary: 'Jim has been a cockler since the age of 14 like his father and his grandfather.'

Music out – gulls Commentary: 'Now, the new EEC regulations are threatening Jim's . . .

. . . livelihood.'

Jim's interview

Rehearse then shoot

Let's imagine this first sequence takes place in the interior of a lounge. A woman is sitting on the couch. She turns her head as the door (in the far corner) opens. A man pokes his head round it. He sees the woman, smiles in surprise and walks in. She smiles as he greets her. She gets up. They walk towards each other and kiss.

This could be done in one shot but, to prevent it looking stagey, the shooting script splits it into four:

(1) Long-shot showing the layout of the room with the woman on the couch closest to the camera. Door starts to open. Cuts as it does so (on action) to:
(2) Mid-shot as door opens wider and man appears. He pauses, registers surprize and greets her.
(3) Head-on mid-shot of woman turning and smiling, which pans to follow her as she rises and walks to man. They kiss.
(4) Waist-up close-up of the two kissing.

If these four shots are to edit together as if they were one seamless piece of action, the whole scene must be acted out and shot several times. Each time the acting must be identical in every detail. Between each shot, the camera, and possibly the lights and microphones, must be repositioned to suit each new angle.

The rehearse-and-shoot method means shooting the first long-shot as a master-shot – letting it run to encompass the entire sequence. Actors rehearse this as many times as is necessary to get it right before going for a take; each one can be taped on a 'rehearsal-tape' and played back for checking on a monitor. This enhances the actor's memory of the action and allows them, and the director, to make corrections. Each sequence is done in a similar fashion: rehearse and shoot a master-shot, then go for the changes of angle and close-ups from within it. This may seem like a slightly tedious process, but it's worth it for professional end results.

Idiot boards and equipment

If an actor has trouble memorizing dialog, use an idiot board – a poster-size white card upon which his lines are written with a black, felt-tip marker. The card is held up out of shot for the actor to read. A trick here is to persuade the actor to write his own board because the very act of writing it drives the words into his memory and, when it comes to making the shot, the board often becomes redundant.

In order to assist trouble-free editing, the beginning of each shot should be marked with a clapper-board. This is not being pretentious or playing 'Hollywood;' the editor may need to plow through many takes from many tapes just to identify one shot; a few seconds clapper-boarding can save him hours.

In any case, each shot needs to be run at least five seconds before it electronically stabilizes so clapper-boarding can be done during this period – before the director calls 'Action.' In addition, each shot should be allowed to overrun five seconds before calling 'Cut!'

Exposures can be tricky if the camcorder does not have the aperture-lock facility. When using auto-iris or so-called manual iris, be certain the actors are not wearing contrasty clothing – some wearing dark clothes and the others very light ones – or the exposures will fluctuate alarmingly. Be careful, too, of reds, they are likely to 'bleed' or fluctuate from deep maroon to light pink.

Audio agc also needs careful consideration, especially with dialog. Immediately after 'Action!' it will be pumping up the background noise while it searches for a sample of dialog to set its audio level to. When this occurs, the first words of dialog will be extra loud or slightly distorted and, when shots are edited together, the volume of the background sound will fluctuate between cuts.

So after 'Action' is called, actors must delay for a further five seconds while one of them provides the agc with a sample sound by counting aloud: 'Five, Four, Three', then silently counts the remaining two seconds before starting to act.

It all boils down to a simple drill:

(1) Camcorder starts. Director calls 'Rolling!' (pause) 'Mark it!'
(2) Clapper-board.
(3) 'Action!'
(4) 'Five, Four, Three' aloud. 'Two, One' silently.

The last step is only used where silence precedes dialog. It is unnecessary when the overlapping dialog technique is used. For example, on 'Action!' an off-shot actor speaks the last part of his lines as a cue for the on-shot actor. In these circumstances the cue-line takes the place of the countdown and provides the sample-sound for the agc.

Outdoors, supercardioid or hyper-cardioid microphones mounted on some kind of boom and operated by someone wearing headphones will *always* produce the best results. Position them within three to four feet of the sound source. Alternatively, where the action permits, use tie-clips through a mixer. Don't expect the camcorder's on-board or in-built mike to provide other than background sound. Wind roar on the mike must be eliminated so remember to provide windshields.

Finally, the shooting schedule must be arranged to tackle exterior locations first so that if the weather is too bad the interior shoots can be done instead.

Preparing to edit

One of the most likely side-effects of getting a fiction movie as far as the editing stage – especially if it's your first attempt – is that it brings home to roost all its flaws: scenes you'd unwisely hurried over, things you took for granted you'd done but hadn't, and a whole load of wishing you'd thought of shooting certain scenes a completely different way.

The sets, which you'd spent hours building, no longer look that convincing and that replica gun *looks* like a replica. Continuity errors will also hit you hard: the character in the World War II flashback is wearing a digital watch, and a modern car can just be seen in long-shot.

In some scenes the sound isn't too clever; there's a definite clothing rustle on the tie-clip mike as hero and heroine get together, and in that quiet outdoor scene the agc has pumped up the twittering of two sparrows until they sound like the

parrot house in a zoo. Of course, if the continuity person had been on the ball, and if the sound engineer had monitored *every* shot through proper closed-back headphones you wouldn't be in this mess – panic!

Similar situations attack nearly every filmmaker. I've never met one – not even a top award-winner – who never makes mistakes or is completely satisfied he's achieved his best standard. But if there's one thing these top guns have learned it is that, for three reasons, it never pays to try to shoot the whole movie on just one tape:

(1) There's always the risk of damaging or losing it which could mean having to abandon the project or start again.
(2) The amount of shuttling while reviewing and logging long tapes is too time-consuming and causes more wear.
(3) One tape per location and a separate one for each shooting session means being able to review them as 'rushes' from which any mistakes are seen while there's still time to correct them.

First rough-cuts
Even so, these camcorder originals need to be considered as fragile and precious and, to prevent them wearing, stretching or being accidentally damaged, most editors will make second-generation copies of each one as soon as possible after *each* shooting session then use them as the working tapes for off-line reviewing – logging each shot on paper and checking that each one has been completed as per the shooting script. It's here you'll be glad you identified each take with some form of clapper-board.

It is also recommended, when possible, to use them between each shooting session to practise off-line rough-cutting some of the sequences. Up until you do that these sequences have been no more than concepts in your head or rough drawings on a storyboard. Actually putting them together on tape is the proof – or otherwise – of that concept. And with the rough-cut-as-you-go method it is easier to reshoot some scenes since the actors still have everything fresh in their minds, and props and locations are still available.

The cutting
Newcomers usually need to reshoot some of the dialog; they make the mistake of concentrating most of the camerawork on mid-shots and close-ups of the on-shot actor speaking, cutting the shot at the point where he stops, then following it with a shot of the next actor speaking. At times this may be all that is required but, cutting too often in this fashion creates that predictable table-tennis rhythm of talking heads. One must not forget to shoot mid-shots and close-ups of the reactions of the listening actors, insert-editing them where appropriate.

If, when shooting, you used the master-shot, mid-shot, close-up technique, some of the action is repeated in each shot. This overlap creates opportunities to use pro-style cuts-on-action – also known as matched cuts.

For instance, in the wider angle master-shot an actor raises his hand to pick up a glass of wine. Since this action has been repeated in mid-shot or close-up they can be edited together at matching frames – say, where his hand touches the glass or the glass touches his lips – and the continuous flow of action disguises the cut. Hence the expression cut-on-action.

The actual cut doesn't have to be as precise as to the exact frame although this should be the objective. Most cuts will be successful if the cut is within three to four frames (the time it takes to blink). Two synchro-linked VCRs with jog-shuttles and a monitor for each should easily cope with this.

Unfortunately, when using a camcorder or a VCR without the benefit of a jog-shuttle, locating and matching identical frames is more hit and miss. But, a close approximation of the matched cut can be made if a part of the overlap is selected where the matching action is slow or almost static; where, say, a man puts a flame to the bowl of his pipe and the flame hovers in this position for at least a second or two. This allows at least a one-second tolerance for matching the cut.

Post-synchronizing dialog
When re-shooting dialog is not possible you might try post-dubbing it in the 'studio.' Two methods are favored.

(1) Copy the rejected take – complete with clapper-board – say, seven times in succession onto one copy-tape. Plug a microphone into the VCR in audio-dub mode. The tape is played back and the actor, while watching the seven takes, speaks his lines while trying to match his on-screen lip movements. Audio-dub the best take back to the master-tape, using the frame where the clapper-board closes as a sync. mark for lining up the two tapes.
(2) An audio-recording of the rejected dialog is made on track 1 of a multi-track audio cassette-deck or stereo reel machine. The actor, wearing headphones, listens to the recording on track 1 while trying to record an in-sync. new version on track 2. When successful it is audio-dubbed on to the video.

The second method is favored if the scene contains some special background ambience. A separate ambient-sound recording (possibly from an fx disc) can later be made on track 1 then mixed with the new dialog on track 2 while audio-dubbing it to the video. Remember, though, you will need a start sync.-mark on the audio-tape for lining up with the clapper-board on the video.

When the shooting is complete, do a complete off-line edit. Different pieces of music – from 'themes' to short 'stings' or bridges and links – and sound effects off-disc are also best tried out during this final session. And detailed notes of which take, which shot, which part of the shot, and whether the sound was satisfactory will help you produce the final edit-list (EDL) to go on-line – back to the camcorder master tapes to commence the proper editing.

Finally, enter it into one or more of the many competitions. Even if you don't win, the judges' comments will help you become a better movie-maker. After all, even the great Steven Spielberg started with amateur movies.

19

DOCUMENTARIES

The novice;

The veteran;

Compressing time;

Experience;

The entertainment factor;

Find an angle;

People not things;

Creating suspense;

Originality the key;

Creating originality;

Drama and actors;

Sales promo documentary;

Buying motives;

Commentary or interview?;

Interviews:

The formal interview;

Camera angles;

Lone workers;

Asking the
right questions

Nobody has yet come up with a satisfactory definition of the word 'documentary' although it is often thought to mean: 'The visual and aural documentation of real life.' Others are prepared to argue that training films, commercials, education films, and even 'pop' videos qualify for the documentary tag. It would be a brave man, then, who insisted that there is such a thing as only one type of documentary.

In my view, the intention of most documentaries is either to tell a version of real life or get some message across. Whether this message takes the form of a formal lecture, blatant sales propaganda or a balanced argument is up to the filmmaker and what he thinks is the best way to put it across to a particular audience. And, since the producer, director and editor have total control over the way so-called facts are presented, I would go so far as to say that most documentaries are anything *but* a documentation of real life. Very often they are the personalized viewpoints of the documentary-makers.

However, in general, if any message is put over in a way that *entertains* it has always a better chance of being remembered. This, then, is the method amateurs should choose if the intended audience is made up of a cross-section of people from all walks of life – a general audience. Doing this, though, is easier said than done, especially for the novice.

If you asked two amateur videographers, one a novice the other experienced, to cover a real-life event (and taking into account the experienced guy will be more familiar with his camcorder and editing equipment) how different would you expect their edited tapes to be? I've witnessed two such tapes and I can confirm that there was a difference, a huge one, that had little to do with equipment, but a whole lot to do with creative flair and thinking.

Usually, creativity is something that only a few people have as a 'gift.' But, once pointed in the right direction – and given practise and experience – we lesser mortals can be creative too, and these two tapes were such a pointer. Let me explain. The event was a English seaside town's air show that took place over a two-mile stretch of its seven-mile coast road (promenade) and sea front. It's billed as the largest air show in Europe and annually attracts more than 500,000 visitors including many camcorder users and photographers.

The whole area is pedestrianized, and market stalls, burger bars, sideshows and static displays line the centre of the prom. A funfair dominates one end. Emergency services: ambulances, fire engines and police are all in attendance. A public address (PA) system provides a commentary and other information. It's all on a truly huge scale – and ripe for filming!

The novice

Eric, a 31-year-old designer-draughtsman, using Video 8, had been shooting for just over a year. Indeed, his first ever experience was at the previous year's show during which he learned that extra batteries were essential as the event lasts four hours.

The weather, that day, was brilliant sun, a clear blue sky and a 15mph wind which often created 'roar' on his unprotected add-on shotgun mike.

He'd edited the tape down to a running time of 50 minutes, and audio-dubbed a military band over the first shots – the Royal Air Force's Red Arrows display jets which occupied some 10 minutes.

This was followed by a shot of empty sky, then more aircraft sequences all in chronological order: girls on wings, a Spitfire and other World War II craft, an army parachute team dropping into the sea, Toyota Pitts Aerobatics, and so on. Each sequence was 'bridged' by the empty sky shot.

Despite having to face south and video the aircraft against the light the auto-iris coped pretty well because the sky background was deep blue. Had it been lighter, with some patches of white clouds, the auto-iris would have closed down by at least a further f-stop and the aircraft would have been underexposed into black silhouettes. And because the camcorder was not designed for shoulder-mounted operation some wobbly hand-held panning was inevitable.

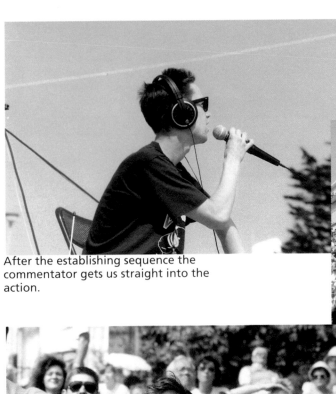

After the establishing sequence the commentator gets us straight into the action.

LS shots of the crowd . . .

. . . are intercut with MS . . .

. . . and CUs of individuals looking up link to . . .

. . . shots of the aircraft.

Cutaways of ground activities . . .

The film ends as people go home.

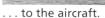

. . . to the aircraft.

A pause in the action as we shoot an
"eating-drinking" sequence.

A CU cutaway links us back . . .

. . . between shots of aircraft.

. . . provide parallel action and help
compress time . . .

Conventional LS and MS . . .

The veteran

41-year-old Graham, a computer salesman and former journalist, assisted by Trevor, his 14-year-old son, shot two hours of tape using a S-VHS-C shoulder-carried camcorder with its own onboard mike windshielded by two layers of ¼″ open-cell foam interleaved with layers of nylon, long-fur fabric. It worked well.

In addition, he carried a Manfrotto fluid-head tripod and a DSM battery belt which, he reckons, is better and cheaper than several separate batteries.

Trevor carried a holdall containing: 0.6 wide-angle add-on lense, 2X telephoto converter, a tie-clip mike, Sony Walkman cassette-recorder, headphones, S-VHS-C tapes, and several polythene bags 'In case it rained.'

Graham's been shooting 'movies' (originally on film) for 15 years, but bought a VHS 'tube' separates system in 1983. 'It never had picture quality to compare with film,' he says, 'And editing equipment in those days was just pathetic, so I only videoed the usual family stuff and never attempted to edit – yuk!'

But S-VHS-C and the editing gear now available has changed all that and he now edits with precision between two synchro-linked S-VHS VCRs and a mixer – using the camcorder as a third player through the mixer for dissolves and special effects.

Graham's film opened with an early morning close-up of the town's famous pier (shot from high up on the cliffs overlooking the promenade) which zoomed out to show the whole seafront. Over this he'd dubbed seagull cries. We go down to the promenade and several shots show the market stalls and sideshows setting up.

People start arriving, a police car-radio crackles . . . ambulance crews drinking tea, sharing a joke . . . an empty rubbish bin . . . more people arrive . . . deck chairs being set up . . . CU of an air show poster zooms in to show 'Starts at 1.45pm.'

Rubbish bin now half full . . . several shots show thousands of people sitting, standing, drinking, eating, waiting. Over this the sound from the tannoy (PA) gives a brief history of the event.

. . . establish the location which cut to . . .

. . . MS and CUs of Steve (the hero).

Tannoy signals the start and . . .

... we hear Steve's voiceover as we ...

... watch the race ...

... intercut with crowd shots.

Introduce two personalities watching ...

... as quick cutting ...

... hots up the pace ...

Steve wins and shows his trophy to admirers.

... up to the chequered flag.

Tannoy announces 'Girl wing walkers' . . . people look up . . . post-dubbed 1920s Charleston music as biplanes and wing walkers pass . . . girls wave, people wave back.

Policeman holding six-year-old girl's hand walks to police tent – she's crying. . . . 'Crunchie' (chocolate bar) aerobatics team strut their stuff . . . cut-aways and close-ups of people watching . . . PA: 'Will Caroline's mummy please come to the police tent where Caroline is waiting.'

More planes, more cut-aways . . . six-year-old wet-eyed Caroline sitting on policewoman's lap . . . helicopter performs mock air-sea rescue . . . rubbish bin now overflowing . . .

Punchy, beat music begins, people look up – the Red Arrows tumble, twist and scream across the screen cut to the beat of the music. It lasts three minutes but seems shorter – exciting stuff.

Colored 'smoke' is everywhere as the tannoy crackles: 'The last remaining Vulcan bomber still flying' . . . People shield their eyes and splutter into hankies. The noise is deafening and as it fades we cut to people walking away and stall-holders packing up . . . Miles of litter and piles of rubbish are everywhere but the final shot is of Caroline being reunited with her mummy . . . fade to 'END.'

Compressing time

When I showed it to Eric he was taken aback. 'I must get a windshield' he said, 'and a good tripod. I shot too much stuff like that guy in Graham's film.'

He was referring to a running gag: on two separate occasions we see a close-up of a videographer panning skywards, and each time this is followed by an exaggeratedly jerky pan of an aircraft which is out of frame more often than in.

'But I could really kick myself for not seeing the *whole* event as something to film. I just concentrated on the planes period. But Graham's film – well, it was so like being there you could almost smell it.'

And the lost child? 'Well, the tannoy must have announced at least two dozen lost children during the day but I just didn't think about it.'

Eric was also mindful of Graham's

editing skills – the use of insert-edit to cut the Red Arrows to music, and how he had compressed a whole day into 12 minutes without seemingly leaving anything out.

He also noticed that some events were not in their true order; the Red Arrows started the show but Graham had placed them last but one.

Graham had the answers: 'Subconsciously I must still think like a journalist covering an event, but now it's with pictures not words. And as for the editing, I remember my newspaper editor repeatedly cutting my deathless prose saying: "Brevity with lucidity."

'On video, it means editing real life with the boring bits cut out while some sequences are jiggled around. For instance, the little girl was, in reality, only missing for about half-an-hour but I rearranged it to add a bit of drama and emotion.'

Experience

Technically, Graham's film had rock-steady tripoded shots, although panning with the aircraft was done with the camcorder shoulder-mounted, and there were no exposure fluctuations because experience taught Graham when to open up the aperture shooting against the light, then using the aperture lock facility.

And although I saw a VHS copy of the second-generation S-VHS edited master, the picture quality was superior to second-generation VHS.

But the main reason Graham's film was superior was because he'd thought creatively and looked at the whole day's event through the eyes of a true documentary maker. Watching his film wasn't like watching a video at all – it was like being there.

However, since there are many different ways to document an event or real-life story, let's examine a few.

The entertainment factor

Whether your intention is to enter competitions or simply do your own thing, a surefire way of improving your video skills is to concentrate on the entertainment aspect of the program while, at the same time, getting information across. It's a kind of thinking akin to the professionals' approach and produces a greater awareness that the end result is more

important to audiences than any of the technical devices that helped put it there.

In any given month, an amateur film or video competition takes place somewhere in the world. It maybe no more than the local club's competition or it may be a prestigious international affair like the IAC International or *Camcorder User*'s British Amateur Video Awards.

At stake for the entrants is the prospect of winning trophies, equipment, cash and other awards. But most of all, there's the satisfaction of creating a film or program that, over the years, will be duplicated and shown to thousands of fellow amateurs (maybe worldwide) as an example of how it's done – ensuring that the filmmaker's name and talent are enshrined in history.

In most competitions where the subject is open, the vast majority of entries, maybe 70 per cent, will be classified as 'documentaries', although this usually simply means non-fiction.

Many will be technically well made and demonstrate good camerawork, soundtracking and editing skills. Yet few will make it to the final ten. Over the years, in competitions worldwide, the top places have mostly gone to producers of fiction dramas.

I asked several top judges why most documentaries fail to make it. Here's a summary of their answers: 'Most are unimaginative, many are no more than thinly disguised holiday films that look like an advert for the place. Others tend to deliver a "how to" lecture: how to build a ship in a bottle, how to grow giant tomatoes, how to hang-glide and so on.'

'*Most amateurs have simply nothing worthwhile to say; no original angle; no point of view; no human interest; nothing to stir the emotions. And nearly all are far too long-winded to sustain interest.*'

Irrespective of whether you want to enter competitions, read those words again, for therein lies the key to two things: judges' minds, and the award-winning entertainment formula. It's a fallacy to think, though, that judges are something special – they're not. There's no judge I know of who attended a training school for

judges. None exist.

Sure, a judge has, or should have, some understanding of the difficulties facing the average amateur, a low budget and, compared to the pro, 'mickey mouse' equipment. But other than that, a group of judges is likely to view an entry by the way it does, or does not, *entertain* them. In this respect they represent no more than the average Joe Public, a general audience.

General audiences don't worry too much about a few technical faults.

Steam trains: are they "useless" pollution creators or fine pieces of heritage? What's YOUR angle? (Photo: Mark Wilkins)

What they want most is a movie that appeals to their gut reaction – an almost entirely subjective inner feeling for the *content* (what it's about) of the film.

This point cannot be labored too much; it means that while a lecture-type documentary about (say) steam trains may appeal to a specialist audience of train buffs who'll drool over every second of running time of the great iron beast – wheels turning, pistons pumping, coal shovelling, palls of smoke anchored to chimneys, and a commentary that relates speeds, bogey configurations, horsepower, and the coal-per-mile ratio – a general audience will soon become bored.

Find an angle

So the first thing that documentary makers must understand is that unless the program is restricted to a special-interest audience, forget the lecture. Make it in such a way that it appeals to a *general* audience. This is how.

Remember the first thing the judges complained about was: '*Most amateurs have simply nothing worthwhile to say; no original angle or point of view.*'

So what do they mean? Well, ask yourself what *your* opinion is of the sort of people who voluntarily, and with great enthusiasm, give up their free time to buy, restore and run an old train.

Maybe you wonder what the hell one can say about a bunch of nostalgic cranks trying to turn the clock back and pollute the atmosphere with a heap of rusting old iron – pretty it may be, but, like, hey man! isn't it a waste of time?

And that's it – your angle, your point of view. Well, it's certainly one point of view.

On the other hand, your opinion might be that these good people are selflessly trying to restore a vital piece of national heritage that they passionately believe will be for the benefit of future generations.

The trick is to make this film so that, by the time the end titles appear, you come down heavily on the side of one viewpoint or the other. *Never* try to make an even-handed, balanced discussion out of it. Leave that to the TV newsmen. *You* will not gain many points making a piece of hackneyed, bland reportage.

By favoring only one point of view, you force an audience to examine it, and mentally, especially if your point is a controversial one, they'll argue with it.

You might arouse their anger, indignation, or amusement. Good! At least they'll remember your film because your point of view has done something magic – aroused an emotion. Doing this means they'll have done more than merely watched, they'll have *participated*.

People not things

Equally important is to provide *human* interest because trains, tomatoes and hang-gliders are no more than *things*. And believe it or not, general audiences are much more interested in people than they are in things.

This means that your train film needs a character (it could be yourself) or characters who can carry your viewpoint to the audience; someone with whom the audience empathizes.

This character could be Tom, a bank manager, whom we first see behind his desk fingering a train-shaped paperweight. This cuts to a shot of a real train. Tom enters the scene wearing overalls and cap, and carrying an oil can and a shovel.

The audience will love seeing the contrast between his efficient, but sedentary, clean city life, and shots of him sweating amid the grime and hissing steam.

We watch as he fries an egg on the shovel over the engine's fire and brews a mug of coffee. Is he some kind of genius or simply a nutter?

Your film finds out: with great enthusiasm he tells us that since the age of 12 he's been a train-spotter and nurtured a secret desire to be a train driver. But there's more. With on-camera interviews and his voice-over shots of the train's journey and other relevant visuals, we learn how his group found this rusting relic and financed its restoration. And yes, we'll also hear about those speeds, wheel configurations, tons of coal and so on.

But from now on, because we're interested in Tom, we'll allow him to tell us many 'boring' facts and, provided it's not overdone, the audience will lap it up. Needless to say, Tom rejects the 'crank' notion with some vehemence.

The film might end with shots of Tom cleaning the engine at the end of a day and filling the boiler with water. This cuts to a coffee-pot filling a cup. Then we zoom out to show Tom picking it up. He's back in city togs behind his desk, looking at the paperweight.

Getting characters in on the act is an age-old device that works every time. You appear to be telling *their* story and *seemingly by coincidence*, the real story – the steam train – emerges. Seemingly by coincidence – geddit?

One important point: few ordinary people are articulate when first faced with a camera. So find out what they have to say and rehearse them. If they're still not good enough replace them with 'actors.' Cheating? No, professionals do it constantly.

Creating suspense

Documentaries about 'events:' rallies, horse/car/racing, even giant leek competitions, can be made more interesting if you add one more ingredient – suspense.

A 10-minute film containing (say) 150–180 shots about banger racing might be constructed something like this:

Steve, carrying a piece of paper, emerges from a motor insurance office and drives off in a car that is towing a trailer loaded with his racing banger.

This cuts to an in-car shot of Steve driving along a busy motorway.

He tells us (over inserted shots of a learner-driver doing, say, a three-point-turn, shots of smashed cars, ambulances, and a funeral) that thousands of people die in road accidents every year; that 40 per cent are caused by drivers with limited experience of proper vehicle control.

He says: 'Banger racing is a sure way of learning how to control a car in any situation because it teaches drivers the limits of the car's and their own abilities.'

On the words 'banger racing' we insert the establishing shots of the meeting, then a close-up of Steve sitting in his banger waiting for his race to start – then we're off!

Several exciting action shots of the race follow intercut with plenty of cut-aways and close-ups of the spectators, plus a cut-away of the public-address tannoy that is giving a (post-dubbed fake) commentary of the race.

Cut to a panned close-up of Steve in his speeding car, the tannoy fades down as Steve's voice-over fades up.

He talks about he rules, roll-bars, compression ratios, safety grids and a few more 'facts.' During this 'speech' we insert shots illustrating what he's saying.

Back to the race as he tells us that this is the last race of a series of seven; that he's already won three and if he can win this one he'll take the overall trophy.

From now, if filmed with plenty of action shots, tannoy commentary, and in-car close-ups (faked later) of Steve's reactions, the audience will be in suspense. Will he do it? Go on Steve!

He wins, gets a kiss from an admirer, then receives the trophy.

Cut to an in-car shot of him travelling home. The camera pans down to that piece of paper on the dashboard – his insurance cover note – and highlights the words: '50 per cent no claims discount.'

In both the above examples some faking was involved. Neither were truly real-life in the sense that every

piece of action was filmed at the time it was supposed to be happening. Nevertheless, it documented the truth. That is, the truth as the film-maker wanted it seen and yet some of it, for entertainment's sake, bor-rowed from fiction techniques.

Originality the key

Of course it's a nonsense to suggest that the above formula guarantees a competition win if one key element, *originality*, is missing.

No one has yet devised a recipe for originality because this implies something completely new, and those of us who make a living out of some sort of creativity know that practically every subject has been done to death already.

But what we can do is choose an old subject and present it in an original way; some way that's different to the way it's been done before, hacking out our own pathway looking for that original angle.

That's not the same as being dif-ferent just for its own sake. You can't break all the rules of movie grammar or tear up the formula completely. It's no good being *that* original if no-body knows what you're being original about. And for that you need a method of finding ideas.

Creating originality

But it's in the original ideas depart-ment that the amateur falls short. It needn't be so because while there is no formula for original thought there is one for triggering it, and it relies on developing something we already possess – curiosity. If we became curious (the more the better) about something it's a safe bet that others will too.

For instance, walking my fingers through the *Yellow Pages* I became curious about aerial photography, artificial eye and limb makers, brass foundries, crop sprayers, dog train-ers, detectives, model agencies, natu-rist clubs, pawnbrokers and stained glass artists.

Newspaper stories do much the same thing. My local rag had one about a retired railway worker and his wife who had converted their bungalow into a replica of a station complete with ticket office, waiting room and platform.

On weekends they dress up in uni-forms and invite the public to ride on a miniature railway installed in their garden. She sells tickets, serves home-made refreshments, and works the signal while he drives the train. Plenty of human interest there.

Readers' letters, and radio phone-ins are natural outlets for controver-sial angles. You might read or hear 'Bring back hanging' or 'All dogs should be exterminated.'

If such things make you think, make you laugh, get mad or sad, this could be where you start using the trigger formula, or a device 'mind-people' call parallel thinking. It works like this.

In a notebook, or in the centre of a sheet of A4 paper, write down the subject that made you angry, sad, or curious. Now play the word associa-tion game and write down as many associated words or thoughts as you can so they surround the subject like spokes stemming from the hub on a wheel.

It's not necessary to do this in one go. Leave it a day or so and return to it with more thoughts. And when you do you'll discover that your subcon-scious has been triggered and literal-ly dozens of new words and ideas will crowd in. It's a snowball effect.

The idea turns into an angle or point of view. You get on the phone to the advertizers or pay them one or more visits to research facts, loca-tions, interviews, demonstrations, and so on, asking questions in the time-honored journalistic style: Who? Where? What? When? Why? How?

When the research is done, and you've worked out how to major on human interest (children for empathy and emotion), write a script. It needn't be too elaborate but, because you have the facts and an angle, you'll know whether a shot or sequence is going to fit.

National issues can also be tackled. If you feel strongly about un-employment, homeless people, racial problems, the greenhouse effect, or whatever, it always has some repre-sentation locally.

For instance, you might be curious about Mr Patel and his open-all-hours family shop. Check him out. He might be very interested in 'star-ring' in a video that features his history, his culture, the problems of integration and so on.

Don't regard any issue as 'too diffi-cult' simply because of your amateur status. Many a pro will envy your freedom to make a personal state-ment unhindered by 'politics' and ratings.

Drama and actors

Sometimes, the real characters in a documentary need not be real at all, they can be 'planted.'

Let's suppose that the subject is an old castle, a haunted house, or about times (maybe hundreds of years) long gone.

Usually, amateurs rely on illus-trating this with a commentary that turns the whole exercise into nothing more than a boring history lesson.

But suppose instead, a ghost in period costume, and speaking Olde English, walks through the wall and takes us on a guided tour of the tor-ture chamber, or whatever. It's a way of providing human interest that might otherwise be impossible.

Another method of documenting history is to give it the full dramatic treatment.

Some years ago, Anne Vincent, now professional, with help from the UK's Weymouth Film and Video Club, made a 40-minute dramatized documentary about the life of Thomas Hardy, the famous poet and novelist, who lived in Dorset, England, at the turn of the century.

Her film opens with stunning shots of the Dorset countryside around 1914. We know this because an old man (Hardy) meets a young soldier in 1914-1918 uniform, and the dialog tells us that the soldier is off to France.

With Hardy's voice-over and lots of dialog scenes, we get to know him and the feel of the times. Then, with flashbacks, we see him as a young man, his courtship of Emma (Hardy's wife), and a host of characters and events that influenced Hardy's work.

The settings, locations and props – everything from furniture to vintage cars – are authentic (not replicas) and must have taken months and a lot of hard work to find.

The film has made Anne quite

Two scenes from *Hardy's Country* – a dramatised documentary produced by Anne Vincent of the Weymouth (UK) Film and Video Club. Note the historical detail in costumes, props and set.

famous in her locality and in the Dorset area. She's had write-ups in the press plus appearances on radio, and she has sold hundreds of video-copies of *Hardy's Country* through the local stores and the Tourist Information Centre.

So there you are – success is merely: curiosity, playing the word game, human interest, and finding an angle. But don't just read this and say, 'Oh yes, I might try that sometime.' Get those Yellow Pages out right now and give it a test run.

Sales promo documentary

Since salesmanship is a skill in its own right, many small firms employ specialists to do the job for them. Their marketing budgets are not usually very high, so here is where the amateur and semi-pro might find an opening.

On the other hand you, yourself, may have something to sell – your car or your house for instance. That something, such as expensive jewellery, a stamp or coin collection, or maybe pieces of antique furniture, porcelain figurines or works of art, might be risky to put on show or carry around.

In all the above examples, a short video is far more effective than stills photographs since, with music, sound fx, commentary, lighting, etc. the video can influence the buyer's mood and response.

At the same time, the video must make points that appeal to the buyer's buying motive. A skilled salesman knows how, by asking questions, to discover these and slant his 'sales pitch' accordingly. But since a video will be slanted in more general terms it must appeal to several motives.

Buying motives

Marketing companies have long since discovered that someone's desire, or motive, for buying something falls into seven basic categories. A desire for:

Health
Efficiency
Leisure
Pleasure
Status
Modernity
Economy

If you take the first letters of each category, they spell the words 'HELPS ME.'

The promo's job is therefore to show how a particular service or product *benefits* the end user in some way by appealing to one or more of the above motives.

For example, a business supplying paper clips might show that its product is just the right size to be seen easily, has no sharp finger-pricking edges (health), is supplied in a dispenser that does the job quickly and neatly (efficiency), is the latest design (modernity) and saves time and money compared to other clips (economy).

If you apply this logic to anything you want to sell – from services to swimming pools – remember that your video must not only show the customer what the product is but, more importantly, how he can benefit from it.

Remember this, too, if you are making a promo of your own video skills in order to start (say) 'Wedding Videos.' Don't go into lengthy details about all your equipment without mentioning how it is used for the advantage of the customer.

Commentary or interview?

One cannot set definite rules about commentary since some documentaries require none at all and some – usually information types – are better with comprehensive narration.

The general principle is that any section of film where pictures alone provide the information requires no commentary. Secondly, an on-screen presenter or talking-head interview is usually better than a disembodied voice-over.

Usually, though, some combination of all three is called for: an on-screen presenter might introduce the subject which cuts to his voice over pictures, which in turn cuts to interviews, then cuts back to the on-screen presenter in a different loca-

tion – and so on.

The toughest job for newcomers and the inexperienced is writing and recording a commentary that is to be post-dubbed. It's not easy to write words that, when read aloud, sound perfectly natural. Too often the commentary is delivered in such a way that it is obvious that they are being read. When this happens the film loses a certain amount of credibility.

This problem is caused because most of us write words differently than the way we speak. Our written words tend to be more formal and, since we have time to compose our thoughts before committing them to paper, they are as grammatically correct as we can make them.

The skill is to write as we speak – even if that means deliberately including some less than perfect grammar. One way of doing this is to write a list of headings only of the topics to be discussed. Then, under each one, record off-the-cuff remarks on a tape-recorder, not worrying about errors and fluffs.

Later, this is played back and written down just the way it sounds. Then it can be rewritten eliminating the errors. In other words, the end result will be a close approximation of natural speech.

A good cardioid stand-mounted, or tie-clip mike, should give best results and some experimentation with delivery and microphone technique is required to get the best sound. Speak across the mike – not directly into it. Note that the closer the voice is to it, the more bassy and intimate it sounds.

Always try to record all voice-overs in one session using the same mike in the same location. If it is done in different places or at different times the sound quality will not match.

Mistakes will also occur while recording. To correct them, it either means starting over or editing the tape. This is very easy on a reel-to-reel recorder since all the poor bits can be physically cut out, and gaps lengthened or shortened.

Editing audio-cassettes is not so easy. But, if you simply commence recording and carry on until you make a mistake there is no need to record the whole thing again provided you have a second recorder.

A "straight-on" two-shot introduces
the characters . . .

. . . but presents flat, one-eyed faces.

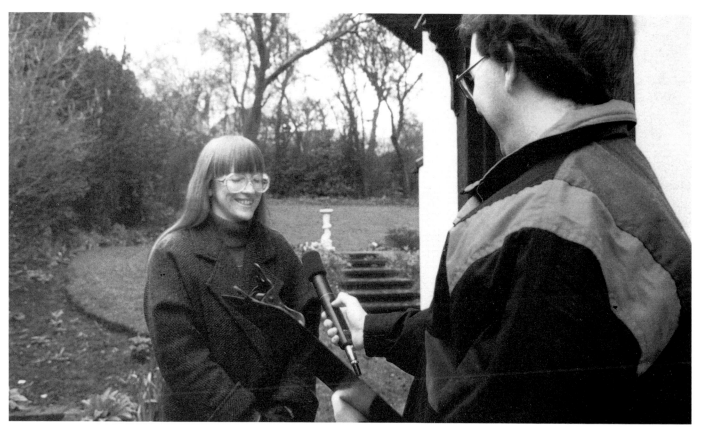

. . . and two-eyed close-ups.

"X" shots: The wider the "X" (cameras A and D) the fuller the image. Narrow "X" angles (cameras B and C) produce one-eyed faces.

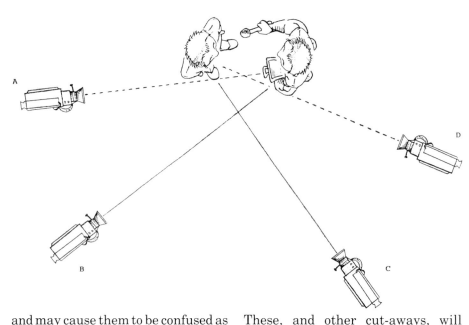

You simply go back to a convenient point, call out 'take two' and carry on. Later, the best takes are copied to the second recorder.

Finally, remember you have the choice of pre-recording the commentary and cutting the pictures to fit (leaving gaps in the commentary where pictures tell the story) or the pictures can be edited first and the commentary written and read to match.

Interviews

Interviews can be no more than 'vox pops' which are apparently off-the-cuff opinions of casual passers-by or spectators. Often, these are no more than one-line answers to a general question. For example, the presenter or narrator might say, 'I asked a crowd of holidaymakers what they thought of the no-alcohol laws.'

This is followed by three or four close-ups of unnamed individuals giving short answers such as 'Terrible. Never come 'ere again.' 'It's disgusting.' 'It don't bother me, I don't drink.'

In practise the interviewer would have asked that same question each time to each person but to avoid this repetition on screen, the editor used the question only once then cut to that part of each reply that fitted the script or supported his angle.

The formal interview

Here, the interviewee is named and his relevance to the 'plot' is explained by the narrator's voice-over shots of the interviewee doing something such as walking through and out of frame. This is followed by a two-shot (an MS of the interviewer and interviewee) as the interviewer puts his question. Alternatively, and probably best, only the interviewee appears in frame; the viewer should only see the interviewer when necessary.

The main thing here is (generally) the interviewee should not look into the camera as if talking direct to the viewer. This can disconcert viewers

and may cause them to be confused as to who is doing the interviewing. Secondly, such front-on shots are virtually impossible to edit without jump cuts.

Camera angles

The shots are best framed at the wide-angle end of the zoom. This inevitably means getting in as close as three to four feet or even closer if a wide-angle converter is used. Getting close will also help produce better sound if the camcorder's onboard mike is used. And it will be even better if the two people are fitted with tie-clip mikes fed through a mixer.

Changing camera angles to provide close-ups of the two must avoid crossing the line and care should be taken that the eyelines match. In general this means using 'X' shots (see diagram); the wider the X the more three-dimensional the facial image with both eyes visible. If the X is too narrow, a one-eyed image results. The camcorder should be kept running to provide continuous sound while the interview is being made, even when changing angles since cut-aways will be insert-edited to cover the movement of visual edits.

After the interview is complete, shoot two or three extra mute close-ups of each person which can be used as reaction shots while editing. Then finish up with a couple of mute long-shots of them both, positioning the camcorder far enough away so that their lip movements cannot be seen.

These, and other cut-aways, will make editing that much easier.

Lone workers

The lone worker has a tough task since he must operate the camcorder and monitor the sound while asking the questions. At the same time he must listen to the answers and appear to be interested.

Compromise is inevitable but the best option is to use a 0.6 wide-angle converter lens, fit a tie-clip mike on the interviewee and make the shots with the camcorder peering up from under one arm.

Alternatively, mount the camcorder on a tripod and rely on an onboard cardioid mike. Then stand to one side of it while conducting the interview. Either way, it prevents the interviewee looking into the lens.

Asking the right questions

Some thought is necessary to ensure that you ask a question in such a way that it provokes more than a one-word answer. If, for instance, you ask, 'Do you like the taste of that cake?' the answer is likely to be a simple 'Yes' or 'No.'

If, though, you ask, 'Tell me what you think about that cake and how it tastes' the answer is more likely to develop into a conversation.

This 'Tell me about' or 'Tell me what you think about' approach can be applied to nearly every question.

Which ever way you choose – voice-over – or interview, both need plenty of practise.

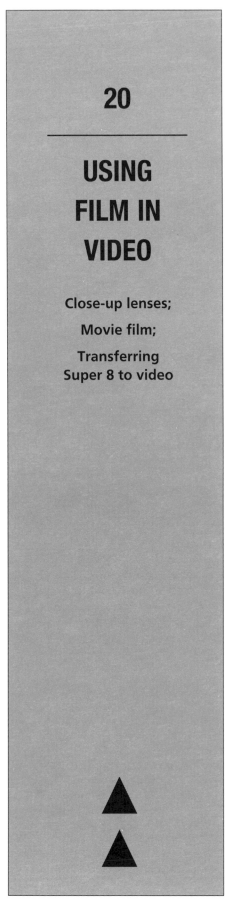

20

USING FILM IN VIDEO

Close-up lenses;

Movie film;

Transferring Super 8 to video

There are umpteen examples where incorporating still photographs or movie film can make an important contribution to a program. Title cards made from 10″ × 8″ photos and *Letraset* lettering are an obvious example as is cutting a stills montage to music. And copying photographs may be the only way of showing historical events.

Imagine, for instance, videoing a middle-aged or elderly lady talking about her early life. She brings out the inevitable family album and back come her memories.

You edit her dialog first, cutting out unnecessary words and phrases, then illustrate it by insert-editing close-ups of her hands turning the pages plus giant close-ups of individual photographs.

Close-up lenses

The camcorder's macro mode may cope with many of her snaps but, filling the screen with an individual portion – such as a face – from within the average snap-sized photograph is better achieved with a +2 or +3 diopter supplementary close-up lens.

Transparencies can be similarly photographed but they must be illuminated from behind. The slide is placed on a light-box or a sheet of white paper placed in front of a photoflood. However, careful adjustment of the manual iris is necessary for correct exposure. Alternatively, purpose-built 35mm transfer kits are available from photographic dealers and make the job easier.

Whether copying prints or transparencies, and whether illuminating them with artificial or natural light, reflections can play havoc so do use a monitor where possible.

Movie film

Film has been around since the late 1890s and millions of feet are preserved in archives worldwide. Some archives have already started making video copies for domestic distribution but copying *them* to incorporate them, either in whole or part, into your film does involve permissions and fees.

However, local libraries, historical societies, universities, the Institute of Cinematography (IAC) and film and video clubs often have their own

A woman is videoed as she discusses her early memories while looking through the family photo album.

Close-ups of the photos are insert-edited as she refers to them (see chapter on macro).

film collections or know where to get access to such footage so fees here are likely to be nominal. My club, for instance, has film dating back to 1890 and, since I am a member, I was able to copy and edit three minutes of it into a 12-minute movie which later won three awards.

Many videographers, too, will have their own film, mostly on Super 8, and may like to incorporate some of it into a short documentary showing how things or people were, say, twenty years ago.

Transferring Super 8 to video

Many DIY film-to-video kits exist but I prefer to borrow a cine projector and line up the camcorder to copy the image projected on to a sheet of brilliant white A4 typing paper.

Regardless of method, three problems exist for PAL users: flicker, poor exposure and a 'hot' spot.

Flicker is caused because Super 8 is shot and projected at either 18 fps (frames per second) or 24 fps, while the PAL camcorder is effectively recording it at the incompatible rate of 25 fps. Therefore, flicker is the camcorder recording those periods of blackout when the projector's shutter blacks out its light between frames of film.

For film at 18 fps flicker can be reduced by slowing the projector's speed (Eumig projectors are variable speed) to 16⅔. And speed up 24 fps material to 25 fps

Poor exposure on tape and wishy-washy colors – especially reds – occur if the camcorder iris is set on 'auto.' By the time it has adjusted to one shot, the next is on screen and auto-hunt starts again. Use manual iris control or aperture-lock, if you have it, and set it to expose for the highlights or brightest part of the film. Fitting a pale magenta filter on the camcorder improves colors but do use the preset for artificial light if the white-balance sensor is of the through the lens (TTL) type.

Hot-spot – that extra bright circle in the centre of the screen – can be subjectively eliminated by stretching kitchen cling film over the projector's lens – and, using a black fibre pen, block out a circle of approximately ¼″ diameter in the center. This acts as a neutral-density filter over the 'hot' spot. Do the whole thing in a dark room, eliminate or shield stray projector light, use a monitor and make a few practise runs.

You have the choice, while editing, of using this copy in the normal manner – with the edited version being second-generation. But, it could be first-generation if you first edit the film then copy by plugging the camcorder direct into the record-VCR – loaded with the edit-master – in insert-edit mode.

I've seen many so-called 'professional' transfers and many are terrible. The best, for film at 24 fps, are from those labs using a *genuine* Rank Cintel Flying Spot machine. For 18 fps material it's best to go to a lab where they can correct colors and exposure. Ask them to let you watch the process and make sure they understand exactly what you want.

21

WEDDINGS

Wedding partners;

Equipment;

On the day;

Editing;

Lone workers

Since weddings are important records of an event that bride and groom do not (at the time) intend to repeat, my advice to beginners is to leave well alone – until that is, you have at least a couple of years video experience under your belt.

To explain this, let's first examine how two very experienced videographers go about it. They, I think, make the above statement abundantly clear.

Wedding partners

For over twelve years, my Westcliff club's Paul Mercer and Don Mouatt have teamed up to make award-winning amateur movies which led to Paul turning professional in 1985.

They've built a reputation for weddings – to the point where fellow club members acknowledge their expertise and ask them to video relatives' events.

Says Don: 'A few years back anyone with a camcorder might have been asked to shoot a wedding. But customers have become more selective – they want evidence of experience, quality and a properly edited copy.

'We now shoot 2½ hours of S-VHS quality tape then produce an editmaster of between 40 minutes and an hour. From this we provide clients with VHS copies.'

Every job starts with interviewing the clients and copious notes are made of what they want and expect.

Paul Mercer (left) and Don Mouatt review the shots.

Usually this boils down to covering the bride's and bridesmaids' preparations before leaving for the church, the arrival of guests, the ceremony, signing the register, confetti and photo sessions outside, then on to the reception for speeches and cutting the cake.

Together, they recce the locations and attend the church's wedding rehearsal and meet the vicar or priest. They seek to agree that one camera, tripod mounted, and hooked to mains power will be up front so that the bride, groom and congregation face the lens; and that a stand-mounted cardioid mike can be placed within four feet of the couple during the vows exchange.

The second camera's tripod is placed halfway towards the front but to one side and uses an onboard shotgun mike.

They also ask for the church lights to be switched on in order to lessen the contrast caused by daylight streaming through the windows. Finally, they ensure they can make a backup audio tape-recording, using another stand-mounted cardioid mike.

Equipment

A few days before the event, Don checks the equipment: two S-VHS-C camcorders, 0.7 wide-angle converters, DSM battery belts, two fluid-head tripods with quick-release fittings, six hi-band tapes, four fan-cooled, 1Kw halogen lights, two shotgun and two cardioid mikes and stands, polythene bags in case it rains, and miles of mains cable, plugs, adaptors and fuses.

The preferred camera position for
capturing close-up visuals and sound.
(Photo: *Elizabethan Photographic*)

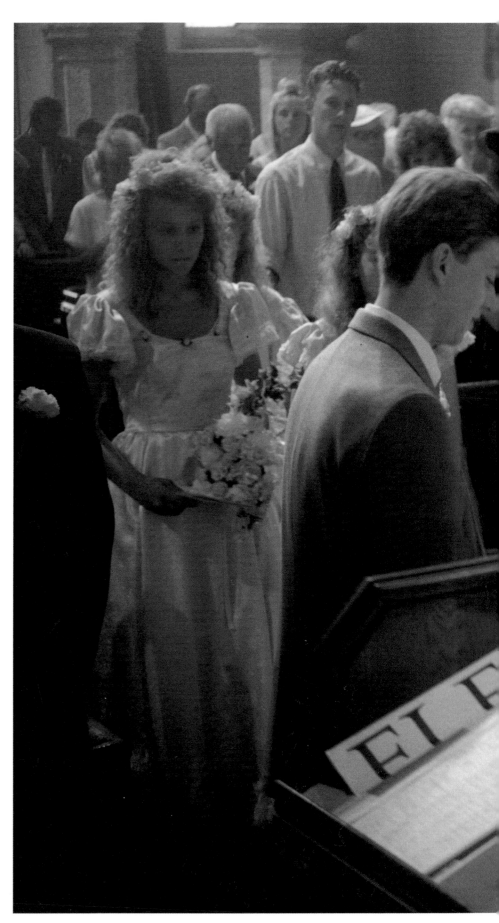

On the day

'Normally,' Don told me, 'camera 1
goes to the bride's house. A video
light, stand mounted, is 'bounced' off
the ceiling. The camera is shoulder-
mounted on wide-angle or with the
0.7 converter and, using an on-board
cardioid mike, we get in really close –
picking out every detail of that all-
important gown before concentrat-
ing on the bridesmaids and fly-on-
the-wall stuff . . . snippets of conver-
sation, nervous bride, proud mum
and so on plus plenty of cutaways.

'This sequence ends with a shot
which follows the bride down and
into the car. For this and all such
walking shots we use the Indian-
Marx walk; crouching like Groucho
but walking like an Indian putting
one foot precisely in front of the
other. It ensures smoother simulated
tracking shots.

'Meanwhile, camera [man] 2 has
taken establishing shots of the
church and set up the tripods and
mikes inside. Then, leaving the tri-
pods inside, he shoulder-mounts the
camcorder and goes outside to record
every guest arriving.

'Later this sequence will be
heavily edited – each group of arriv-
als (except the groom and best man)
cut to a running time of two or three
seconds.

'Next,' says Don, 'it's getting shots
of the bride arriving and starting to
walk a couple of steps up the church
path. Then scouting ahead of her to
fix the camera back on the tripod in
time for the organ music as she walks
up the aisle.

'By this time, camera 1 has also set
up and from then on concentrates on
cut-aways; panning and zooming in
on faces, stained-glass windows and
mid-shot back views of the couple.
Some will later be insert-edited into
camera 2's main coverage of the mid-
shots and close-ups of the couple
during the vows ceremony.

'We let both cameras run continu-
ously to ensure smooth sound but
later, all the moving parts of pans
and zooms are mostly cut out.

'So, too, are lessons, bible readings

and most of the hymns – although we might include one verse of a favourite hymn if it's important to the couple.

'One of us covers the signing of the register then, using the Groucho walk – but backwards, film the couple walking towards the camera back down the aisle and out of the church to the confetti and photo sessions.

'During this time, the other cameraman goes on to the reception and sets up the gear. Normally, we cover all the speeches with one camera and shoot cutaways with the second – it's all boring to us but the couple will love it. We leave just after the disco starts.

'By then, we will have put in six hours apiece – not including the recce time.'

Signing the register – a not-to-be missed item.

Editing

Don does all the editing, adding titles, extra sound fx and snippets of mood music, and reckons it takes him 15 hours.

Finally I ask him how he would advise beginners to approach filming weddings. He frowns for a moment then smiles: 'First, get to understand manual control of focus and exposure – churches are usually contrasty places with lots of windows that confuse autoexposure.

'Next, find an experienced partner, use shoulder-mounted cameras where tripods can't go and use good microphones.'

He frowns again: 'Even then, you'll need to experience a few different weddings before you have a real idea of what it's all about.'

He laughs: 'Paul and I are still learning.' He means it.

Lone workers

Since a lone worker cannot be in two places at once, emulating Don and Paul is virtually impossible. However, many weddings are covered by single-handed cameramen although they usually have a helper; someone to carry the gear and drive them from place to place. The latter is very important – especially when parking is a problem.

Two further points: the church usually requires a fee and you must check whether you require copyright and performing rights licenses for the church music, organist and choir.

And if you record any of the music at the reception, whether from a live band or disc, the same rules apply.

If you think I'm making it sound difficult it's because it is – I'm thinking of some of the really awful three-hour wedding tapes I've had to sit through If you really are determined to video a wedding, please get some practise in as a helper first – you need the experience and it's only fair to the couple tying the knot.

22

CLUBBING TOGETHER

Clubs

Many amateur video organizations exist in most countries. In the UK, the Institute of Amateur Cinematographers (IAC), established since 1932, is the best known and most respected. It is non-profit-making and is registered as a charity. And, although a national organization, it also has regional branches: Southern, North Thames, North East and so on.

Don't worry about the word 'Cine' in its title, this merely reflects its origins – over 80 per cent (and rising) of its members use video. Its title may change shortly – to incorporate the word 'video.'

Its activities are numerous: international, national and regional competitions, weekend seminars, away-days, film/video hire, provision of copyright music licenses – with access to a professional music library – fx library and advisory service, etc.

The annual subscription fee is not much more than the price of a hi-band tape and every member receives a free bi-monthly magazine.

Clubs

There are over 350 film/video clubs in the UK and many more in Australia, Canada, USA and Europe.

UK club members usually meet one evening per week between the 7th of September and the 14th of May – the winter months only. Again, the subscriptions are nominal.

Up to 1986, clubs were dominated by film users. But since then video has reversed the situation. In my club (100 members) only five members still use film. Clubs are entering a boom period and it's not unusual for the premises to be set up with four synchronized televisions and a 'big screen' projector going simultaneously.

Members usually start as novices, and over (say) two years make the transition to knowledgeable video makers, learning the craft from the more experienced members.

However, one should not think of club members as being of a particular type since all sexes, ages and professions are represented.

The clubs are usually socially orientated, too. Not everyone wants to become a 'Hollywood' director or TV-style journalist. Many are simply happy to get together to show off their latest bit of gear and have a chat in a social environment.

During the club's summer recess, some members will have formed themselves into 'production units' and made properly structured and fully edited movies – anything from full scale fiction-films with proper scripts, plots, actors, extras, period costumes and so on, to comedy sit-coms and spoofs of, say *James Bond*.

Others will have produced grant-aided or sponsored documentaries about some national or local issue – anything from: *How to Protect the Environment* to *The Steam-engine Rally* or *The Town Carnival*.

But the majority will have done no more than record holidays and family events.

Into all this will come the new members, 90 per cent of whom will be comparative beginners wanting to see what it's all about and learn something from the more experienced members.

Sometimes, especially during the first couple of months, the newcomer might be completely overawed by the sheer professionalism of some of the programs he sees and the amount of 'techno-speak' he hears. And this can be mighty offputting to someone who hasn't yet mastered the controls on his 'wondermatic' let alone entered the delights of post-editing and soundtracking.

On the other hand, some newcomers may well be disappointed because the club does not turn out to be what they thought it would be.

On the whole, these are people who expect a club to provide lots of equipment: editing-suites, audio-recorders, lighting gear, and practically everything else which they (the newcomer) doesn't have but thinks he's going to be able to 'borrow' on the cheap.

Clubs do own some items but they can only be bought from the income derived from member's subscriptions, raffles and activities like making sponsored or promotional movies and giving public shows. Most equipment is owned by individual members.

A few newcomers are disappointed because the club is not simply an 'educational institution' whose sole function is to give lectures and 'how

to' courses. Clubs do hold 'teach-ins' and these are usually provided by the more experienced members but that's only a part of it.

Clubs also have to cater for the needs of these same experienced people who, over their club life, have already attended many teach-ins and lectures. It would be a bit much to expect them to 'suffer' every week just for the sake of keeping newcomers entertained.

Then there's the club which caters for cine as well as video. And these are often the best ones to join because the cine-buffs have a lot of experience and movie-making knowledge to pass on which can benefit the videographer. And many use video as a means of recording rehearsals (both of actors, camera angles, and sound and lighting set-ups) and produce one version on tape and another on film.

And because movie-making structure, camera-work, lighting and sound are practically identical, whatever the medium, both types benefit.

The point of all this is to try to convince you that whether you want to get involved in making properly structured edited movies or simply do your own thing, joining your local club will benefit you by adding a whole new, pleasurable dimension to the hobby.

Your local authority should have the address. Or, UK readers can write to the Institute of Amateur Cinematographers (see classified ads in video magazines) and read the club column in *Camcorder User*.

Schools and colleges in most countries run video courses for adult students. If you can spare the time try it out on a 'I've nothing to lose and all to gain' basis.

Westcliff club members at a teach-in session.

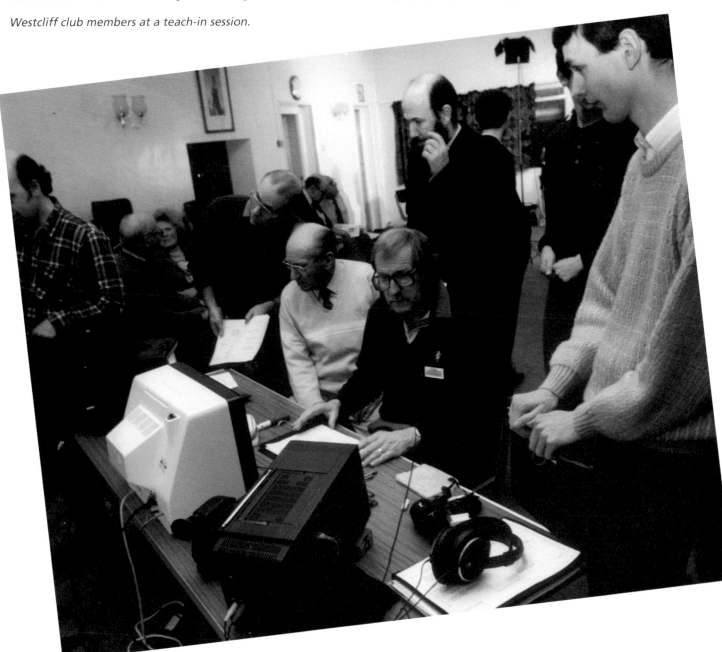

23

CABLES
AND
CONNECTORS

Soldering;

The attenuation pot;

DIY mixer

Editing and soundtracking can involve setting up many different pieces of equipment connected via cables. Indeed, some set-ups require a veritable 'rats nest' of connections. Even worse, a variety of connector plugs and sockets may also be used. The most common types are listed below.

(1) The European 21-pin Scart plug carries all the audio and video connections between TV and VCR or between VCR to VCR. Some of the pins are left unconnected for S-VHS and Hi-8 use.

(2) An 8-pin composite plug which carries audio and video signals between VCRs and monitors.

(3) DIN plugs may contain a different number of pins. Five-pin plugs are used in many domestic audio set-ups. If the plug is undone the pin numbers can be seen printed at the rear of the pins. Pins 1 and 4 are for connecting (with solder) the thin cables that record left and right channels; numbers 3 and 5 for playback; and number 2 is for the braided earth cable.

(4) RCA/phono carry one audio

channel only and therefore two are needed for stereo.

(5) ¼″ (6.3mm) jack plugs may be stereo or mono. Commonly used for headphones and microphones.

(6) 3.5mm Mini-jack plugs are a smaller version of the above and most domestic microphones and camcorders use them.

(7) BNC connectors have bayonet connections. Used on some machines for video in and out signals.

Because there is often a need to connect a cable fitted with one type of connector to a cable fitted with a different type, a host of adaptor and adaptor/connectors are available from manufacturers and radio spares stores such as Tandy, Radio Shack and by mail order.

Cables can be the single largest cause of frustration; one never seems to have the correct cable for the job in hand and bad connections or poor quality cables seem to be the biggest cause of equipment failure. Because of this, cables should always be kept as short as possible and it pays to label each one with some description of its function.

However, shop and factory ready-made ones are usually a standard length and the quality of the connectors and soldering is not always up to the constant plugging and unplug-

A similar mixer to the DIY one mentioned in this chapter. (Photo: Terry Mendoza)

1) Scart Euro-connector 2) RCA Phono connector 3) eight-pin A/V connector 4) Multi-pin connector with locking-thread 5) quarter-inch (6mm) phone jack 6) Mini (3.5mm) jack 7) 25k ohm attenuation potentiometer for audio 8) Phono cinch connector.

BNC/RF CONNECTORS

10Kohms

DIN CONNECTORS

3-pin 4-pin 5-pinA 5-pinB

5-pinC 6-pin 7-pin 8-pin

5-Pin Plug to Mirror-Image Lead

ging that the average editor/sound-tracker puts them through; hence the breakdowns.

It pays – in terms of time, money and quality – to learn to make up your own cables. The cable itself is very cheap; it can be bought in any length and cut to the size to suit the job. Connectors can be chosen for their strength and ease of use and buying the best means fewer break-downs.

Cables are available to suit the number of pins of a particular con-nector. A single core cable for phono plugs, for example, has a conductor wire covered with a thin plastic sheath, and surrounding this is the braided wire shielded ground (earth). Surrounding both is a thicker, outer PVC cover. Five-pin DIN cables need four different colored inner conduc-

tor cores for connecting to pins 1, 3, 4, 5 and the braided earth is soldered to pin 2.

Soldering

Soldering is not so difficult. An aver-age cable should not take longer than 15 minutes to solder provided, that is, you have the right tools for the job. You need the following:

(a) 25-watt soldering iron with a 2mm diameter bit.
(b) Cable side-cutters and cable stripper.
(c) Miniature table-top vise or sol-der clamp with 'crocodile' arms. Either will act as a third arm or hand.
(d) Fluxed solder.
(e) Fine emery cloth.
(f) Miniature pliers.

Note on this model the outputs have been put at the opposite end to the inputs. (Photo: Terry Mendoza)

First, plug in the soldering iron and allow it to heat up. This takes several minutes and, when it is warm enough, the solder will readily melt on its tip. All soldering irons need a small dribble of solder on them any-way – a process known as 'tinning.'

Both the cable wire and the rele-vant pins of the connector must also be tinned. For the cable this means stripping back the plastic cable insulators to expose the wire to be soldered. This should not be stripped back further than is absolutely necessary. Twist multi-stranded

wires together with the pliers; don't touch them with fingers because grease or sweat can prevent a good connection.

Place the cable in the vice and, using the soldering iron, apply heat to the twisted wire for a couple of seconds then touch some solder to the wire (not the iron) until a little dribbles over it. Spread this solder with the iron until the exposed wire is covered with a thin sheath.

Before tinning the connector's pin ensure it is cleaned with the emery paper to a bright shiny finish. And remember to heat the pin first then apply solder to the pin – not the iron.

Finally, lay the tinned wire on the tinned pin and apply the soldering iron to the two until both lots of solder fuse together.

A good solder joint should be bright and shiny; if it appears dull, you have a dry 'joint' and the connection will be poor and unreliable. The only way round this is to reheat the joint, split it apart, clean both sides with the emery cloth, apply a little more solder and start again.

If a cable goes faulty – especially shop ones – nine times out of ten it will be because the solder has oxidised and become a dry joint.

Once soldering cables has been mastered it's an easy step to make those DIY gadgets that, shop bought, are comparatively expensive.

The attenuation pot

When a signal's strength is reduced it is called attenuating that signal. When a line-in or microphone amplified has no in-built gain control, or where the ingoing sound signal is so strong it swamps the system, a load resistor needs soldering into the signal-carrying cable; the greater the resistance the greater the attenuation. Electrical resistance is measured in ohms and although resistors of fixed ohm values are used in a variety of circuits, of most use for attenuating audio and microphone signals is a variable resistor known as a potentiometer. In other words, it's a volume control.

These are available in either stereo or mono versions and when its plastic knob is turned the signal is varied continuously from loud to soft.

If the one shown in the diagram is fitted into a small matchbox-sized plastic box and fitted with the relevant input and output sockets, it can be used to control the output of a microphone thus preventing extra

loud sounds swamping the agc.

In effect, this is one channel of a mixer so if you can build this you should also be able to connect two, three or four together to make an audio-mixer.

DIY Mixer

The diagram shows how a three-channel stereo mixer may be constructed for about the price of a camcorder tape. Note that it uses slider-operated potentiometers (not round ones) since sliders are essential for easy cross-fading. Another point is that the input and output sockets do not have to be phono. Full-size jack plugs and sockets are easier to solder and easier to use, but they take up more space and therefore require a larger box.

It is also important to note that this mixer is 'passive.' This means it has no amplifier so requires no battery. It also means that it can only be used for mixing line-levels such as tape-recorders and VCRs: it is not suitable for microphones.

You will need:

1. A metal box approximately 6″ × 4″ ×1½″ deep, which has a flat lid.
2. Three 10Kohm log stereo slider

Stereo mixer schematic

OUTPUT 3 INPUTS 2 1

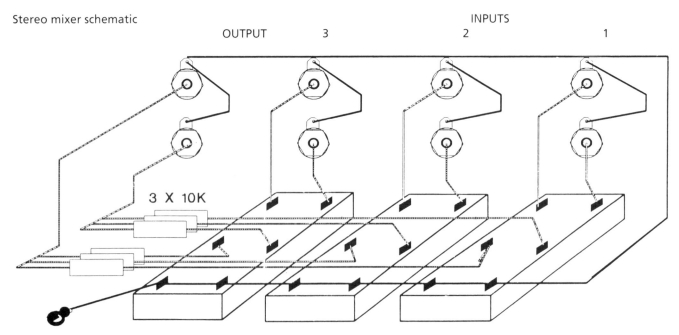

3 X 10K

3 Stereo Slider pots 10'log'

Key: S = Start W = Wiper F = Finish L = Left R = Right Individual pot types may vary in detail. Refer to supplier.

potentiometers with knobs – plus screws to fix them to the lid.

3. Six 10Kohm resistors.

4. About 1½ meters of thin plastic-covered wire for connecting the components,

5. One meter of thin uncovered wire (the earth/ground)

6. Four chassis phono sockets (stereo pairs) plus fixing screws.

First cut out slots in the box lid for the slider to poke through, then drill holes for the screws and fix the potentiometers up through the inside of the lid so that the plastic knobs can be fitted from the top. Fix the phono sockets into one end of the box base.

Solder the thin plastic-covered wire to the 'live' points of the components – as per diagram. Note here that the diagram shows the underneath of the potentiometers because the tops are now fitted to the underneath of the lid. Finally solder the uncovered wire, as shown, to the earth/ground connections; the point marked 'box' is simply a small self-tapping screw which taps the earth/ground wire tightly behind it.

Note that all potentiometers have one pair of 'start' tags, one pair of 'wipers' and a pair of 'finish' tags – one tag of each pair for the left channel and one tag for the right channel. The input sockets should be wired to the start tags. Sometimes the tags are simply numbered, 1, 2, 3. Check with the supplier which number and tag does which job since some variation in design is possible.

Further channels could be added provided each one's output is wired through its own pair of 10Kohm resistors.

If you really must have one channel for a microphone then that channel must incorporate a battery-powered pre-amplifier circuit.

All the components mentioned, plus ready-made and DIY pre-amplifier circuits, tone controls and a variety of other circuits may be found in radio-spares stores such as Tandy and Radio Shack.

3 Channel Stereo Mixer

Outside rear view showing connectors

24

COMPUTERS IN VIDEO

by Terence Mendoza
BSc (Hons)

Graphics;

'Paint' programs;

Using RAM;

Animation packages;

The third dimension;

Resolution;

Why interlace?;

Getting the artwork onto videotape;

Using a genlock;

Frame grabbers;

Building a system;

Disks;

Genlocks

Computers are well-known tools for business use but, in addition to word-processing and running accounts programs, a computer's inherent ability to convert electronic signals into numbers, then allow these numbers to be mathematically manipulated, is extremely useful to the video movie maker. Computer usage for video falls into two main categories: creation and manipulation of graphics, and computer-assisted control of editing equipment.

Some manufacturers have designed models and programs specifically for these purposes; pictures and graphics can be created direct on screen, or sampled from the videotape from a camcorder, then converted into strings of numbers and saved on magnetic 'floppy disks.' Once converted all sorts of ingenious modifications can be made to the images before finally reconverting them back to video pictures and outputting them on to videotape.

Because the Amiga is one of the few computers to output a video sync. pulse, it has dominated the desk-top video (DTV) market. Numerous other computers are also suitable but often require internal modification or additional circuit boards. However, should you already possess an IBM or Atari, it is certainly worth locating sources of hardware (plug-in boards and add-on boxes) and software (programs on floppy disk) despite the fact that graphics packages for these models are not as abundant as those for the Amiga.

Graphics

Graphics means drawings. These might include titles, logos, or more complex drawings where movement (animation) is involved. Many complex animated graphics, such as those seen – apparently in three dimensions – twisting and tumbling in space at the start of TV news and current affairs programs, are well within the scope of home computers. The greater the complexity, though, the more a computer has to perform its number-crunching function. This, in turn, requires increases in its memory (storage capacity).

Number-crunching is carried out in an area of the computer called the Random Access Memory (RAM) which acts as a scratch pad for the calculations. If, though, the computer is switched off – either deliberately, or accidentally through a power failure – work held within RAM is erased. It is essential, therefore, that work under way is saved to floppy or hard disk, say, every half-hour. And saved once again when completed since it can be reloaded into RAM at the next switch-on and the work continued.

RAM is also the home (until switch-off) of the *applications program* – a set of instructions, loaded by the main program disk, that tells the computer how to behave in response to keys pressed on the keyboard. A word-processing program, for instance, may assign certain keys that tell the computer to delete or move complete paragraphs of text. On the other hand, a *'paint'* program may use the same keys but assigns them functions that produce artwork.

'Paint' programs

When a paint program is loaded, the user is initially shown a bordered blank screen – the work areas in which the artwork will be painted. Drawing is carried out by moving a plastic 'mouse' on the desk beside the computer. A rolling ball beneath the mouse converts the movements into electrical impulses which are displayed on screen as movements of a *cursor*. When the mouse moves left, the on-screen cursor moves left; every movement of the mouse is faithfully mirrored by the cursor.

The border contains a number of little boxed drawings called *icons*. Each one represents a facility offered by the program. Standard facilities include: drawing circles, freehand line drawing, straight lines, and even simulating painting using a spraycan.

If this were all paint programs could do they would be a poor alternative to paper and ink. But, their real benefit comes from their ability to treat an area of any drawing, whatever its size, as a 'brush' that can be picked up and 'stamped' (placed) anywhere on the screen

Amiga computer with G2 genlock.

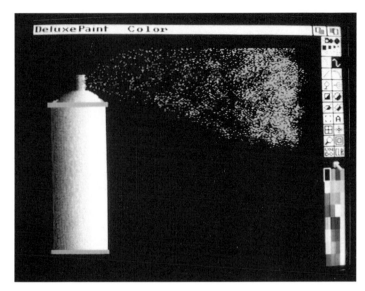

Artwork (spray can) drawn using
Deluxe Paint program. (Photo: Terry Mendoza)

This flower was drawn in a few seconds
using a "symmetrical-draw" function
(Photo: Terry Mendoza)

where, additionally, it may be bent, stretched, squashed or twisted.

A complete color scheme can be altered without the need to redraw. To create, say, a picture of a flower garden from the drawing of a single bloom, the bloom can be picked up as a brush and, literally in two seconds, a full bed of identical blooms can be painted.

Finally, let me give an example of how easy it is to create a logo containing some animated movement.

A drawing of an idealized camcorder was first created using a number of rectangular boxes 'filled' with a range of gray-blue colors set up in the paint program's customized palette option – Deluxe Paint. This is typical of paint programs and allows 32 different colors on screen out of a total of 4096. Next, the control knobs were painted using more saturated colors to provide contrast.

It was decided to animate (move) the camcorder across the screen from left to right but its lens was pointing the wrong way. However, it only took a moment to instruct the computer to 'flip' it so it faced the right way. A further step was to reduce it to one quarter of its size to make it compatible with a previously drawn background.

The animation was performed by 'stamping' it in one position and instructing the computer to move it by small increments over the next 20 frames. The program's rehearse mode shows how the movement will appear, thus allowing alterations to be made before instructing the computer to run the final version.

Using RAM

The picture elements (pixels) in each piece of artwork end up in RAM as a string of numbers or *bits*; eight of these bits make a *byte* and 1,024 bytes is approximately 1K. A standard Amiga 500+ RAM holds 1,024K. But, a large chunk of RAM is reserved for the program itself, leaving approximately half available for

The flower created in the previous picture is now picked up as a "brush," halved in size and "stamped" into a flower bed. (Photo: Terry Mendoza)

A 30 frame animated logo where "EFA" is spun into position and the "move" facility used to slide the camcorder graphic across the screen and into position. (Photo: Terry Mendoza)

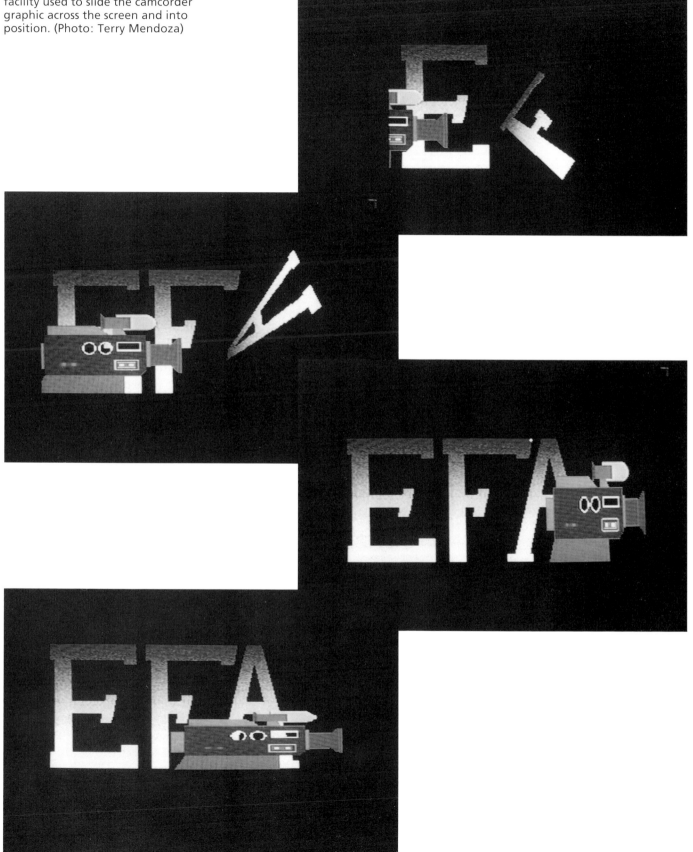

the storage and manipulation of the user's artwork.

This forces some compromises to be made on what can be achieved. On the one hand, the bigger the individual pixel size, the fewer pixels are needed to fill a screen and the less space needed in RAM or floppy disk. However, bigger pixels mean less picture definition; diagonal lines will not have straight edges and appear jagged, like a staircase.

Smooth-looking artwork needs the smallest possible pixels and this *high resolution* can be exceptionally greedy of computer space, both in RAM and on floppy disk. Similarly, with two colors on screen a single picture might use up to 8K of RAM. But if you use up to the full 32 colors, 40K or RAM is swallowed up.

Animation, too, swallows large amounts of memory for, if an animated piece of action is going to take place over, say, four frames, then four slightly differing pictures will be used. Therefore, the amount of space required in RAM will be four times that required for one picture.

RAM saving can be made by loading parts of the animation program only as needed, but this can be potentially disastrous to a novice who, having spent hours creating a complex sequence, finds there is insufficient RAM left for that part of the program which instructs the computer to save the artwork. The only way out is to erase some frames in the hope that this will free sufficient RAM for the 'SAVE' instructions.

Animation packages

Paint programs are useful and easy for creating animated logos and titles which can be made to fly or spin from one position to another. *Deluxe Paint IV*, for instance, is a good program for non-artists such as myself and tends to be the program by which all other programs are judged.

If, though, you are a reasonably competent artist and want to use true character animation, complete with

sync. sound and music, consider packages like Disney's *The Animation Studio*. It emulates the traditional filmmaker's cell animation techniques, where images are initially drawn in black and white for a 'pencil' test. This makes it possible to decide whether certain frames, during a sequence, are to be used more than once. If they are, they need to reside only once in memory.

The traditional animation technique of cycling and recycling frames can also be used, which means repetitive movements can be produced from the minimum of drawings and frames. Subtlety of expression and movement are possible using an 'onion skin', where several previous frames can be made visible beneath the artwork being worked on.

Once the 'pencil' test is acceptable, the 'Ink and Paint' department takes over, coloring the sequence ready for final viewing.

The third dimension

Although many rotating images constructed with programs such as Deluxe Paint IV appear to be flat images moving through three-dimensional space – as if drawn on a piece of rigid celluloid which may be twisted, turned edge on, or rotated or moved away from an imaginary

camera – it's an illusion.

So, also is the creation and movement of apparently solid objects. The technique here is to use the computer to define the object using mathematics; a cube, for example, might be specified by giving the eight co-ordinates of its corners.

From these the computer constructs a 'wire' model upon which it puts a textured 'skin' on that part of the object which is visible to the viewer. It doesn't, for instance, put skin on some part of the object if it is obscured by foreground. Therefore we don't see the back face of a cube while looking at the front face. This is known as filled 3D.

It can also be taken a stage further. Ultimate 'realism' occurs with *ray tracing*, where the position and intensity of one or more make-believe light sources can be specified. As the filled-3D object moves, 'light' glints realistically off its various faces. The type of surface reflection can even be specified allowing, for example, natural looking metallic gold, silver or matt rubber textures.

3D and ray-traced animation both use vast amounts of computer power as well as considerable hard disk storage and RAM. And, without additional hardware to make the computer work more quickly, this

Low-res animated walk cycle. The upper row (1-4) was copied as a mirror-image to the lower row. The same head was stamped as a brush on each body. (Photo: Terry Mendoza)

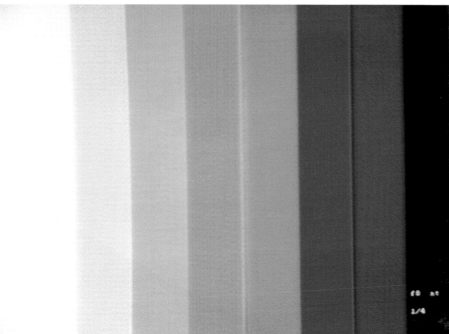

Introductory screen from ZVP's
VideoStudio post-production and titling
package. (Photo: Terry Mendoza)

type of animation can literally take
weeks to process. Perhaps, then,
these techniques are best left to the
computer boffin and the profes-
sionals.

Resolution
How clear and detailed a computer's
graphics are depends on its resolu-
tion mode. The Amiga has four dif-
ferent modes which it names 'Low-
Res,' 'Med-Res,' 'Hi-Res' and 'Inter-
lace.' Low and Med Res produce large
pixels too 'steppy' for good video

Color bar test chart produced by a paint
program. (Photo: Terry Mendoza)

images and they are designed particularly for computers with 626 lines output. This makes it impossible to superimpose such images over 625/525 line camcorder-originated tapes without causing glitches; although one method of getting round this is to switch on the interlace option before running the paint program. However, best results are invariably gained from artwork prepared using Hi-Res or Interlace.

Why interlace?

Since all TVs produce pictures by scanning the field of odd numbered horizontal lines from top to bottom then returning to the top to scan the field of even numbers, the completed picture consists of interlaced horizontal lines. Unfortunately, this is not the standard method with computers so such incompatibility can cause visual nasties.

An example will illustrate why this is so: consider a computer-generated picture consisting of a number of horizontal white lines exactly one scan line thick. Without interlace this will appear as just that – a number of steady white lines. Interlace of this picture will force the lines to jump to their interlaced position 25 times per second (30 NTSC) – an alarming judder on screen.

Therefore, if we want to mix and transfer this output onto video we must ensure such graphics do not contain very fine, and high contrast, horizontals. Don't though, get too paranoid about judder; a look at the 'inserted' visual-box on TV news programs also shows this same judder.

A further point to take into account is that the width of the computer graphic, when copied on to video, may not fill the TV screen. To overcome this, ensure that the paint program is set to 'Full Video' or 'Overscan.' Both options, though use more pixels to create the picture so it is important to estimate in advance whether there will be sufficient disk space to store the completed pictures. This is not so difficult since most paint programs give a running total of free RAM space.

Getting the artwork on to videotape

The alternative methods for transferring computer artwork onto videotape are:

1. Take the output from the computer's UHF modulator and feed it into the VCR's aerial (coaxial) input socket. The quality will not be good, though, since it will contain distortions created by the signal being modulated and demodulated before the VCR can record it.
2. The UK computer is supplied with an RGB to PAL encoder – it's the box that plugs into the back of the computer to give separate picture and sound outputs.

The picture output is connected to the 'composite video' input (usually BNC) on the VCR, and where application packages contain computer sound that is to be copied, the sound output from the encoder is fed to the VCR's audio or line input socket.

This second method, although better than the first, shares the problem of not being able to mix images. For example, it would not be possible to generate a heart-shape for a wedding video and mix live video of the happy couple superimposed in the centre. For this, an additional piece of hardware is required, the genlock.

Using a genlock

In order to mix the computer-generated images with those from a VCR or camcorder, both sets of signals must be processed through a genlock. This is because the video and computer-generated signals also contain a steady stream of pulses that tell the TV when to trigger each line scan. The genlock locks them together at identical trigger points so that they are fully synchronized. Without a genlock, the attempted mix will simply be a fuzzy mess.

A genlock output can either consist of a video signal alone, the computer image alone or a combination of both. One of the colors (usually blue) used in the computer-generated output is defined as 'transparent'. This leads to the use of a technique known as background keying or masking – where the camcorder originated shots are shown in the 'transparent' (blue) parts of the computer-generated picture.

In the example (above) of the heart-shaped mask, we would draw a heart-shape with a paint program and 'fill' it with the 'transparent' blue. We would surround this with a non-transparent color such as a virulent pink. The big close-up of bride and groom kissing is squirted into the genlock switched to background keying mode; the two images finish up as a combined shot of a large pink

Rendale 8802 genlock. (Photo: Terry Mendoza)

heart with the couple kissing in the middle of it – sigh!

In keying mode the genlock acts as a high-speed switch: when it receives the scans containing the 'transparent blue' signals from the computer it immediately switches to the video image – then switches back to the computer for the non-blue portions.

Foreground mode is a slightly different way of switching; the artwork can be set to be superimposed over the video image for uses such as subtitles.

Frame grabbers

The video input to a genlock is not stored on computer but routed through it. An exception is the *Superpic* by JSL which is designed with special circuits to digitize video pictures – to convert them into strings of numbers. In this form the computer can manipulate video pictures, frame by frame, in the same way as it does with pictures from within an art program.

This *real-time* video digitizing offers great scope to the creative videomaker since it is possible to combine real images with graphics from a paint package and even animate them. Imagine – you can take that shot of mother-in-law, separate her from the background, and paint her into the jaws of an animated lion!

If frame-grabbing appeals to you, there are numerous self-contained digitizers available and prices are usually no more than for a couple of camcorder batteries.

The visual quality of computer-generated image off tape will never be as good as the original artwork. The better quality, as you may guess, comes from hi-band formats and hi-band compatible genlocks.

Building a system

Working with computer graphics can become addictive and, if animation is envisaged, optional extras will soon be essential.

Top of the list will be additional memory such as that provided by add-on RAM boards which plug into a socket in the computer. Some

High-res title from Alternative Image. (Photo: Terry Mendoza)

Big Alternative Scroller - this package is a rapid way to generate high quality titling. There is control over lettering style, colour and shadow.

boards are 'upgradable' to give 3 to 4Mb of RAM but these invariably involve taking the computer apart to fit them – which invalidates the guarantee. To avoid this, it may be better to pay a little more and buy add-on boxes giving monster amounts of memory, that plug into a side port.

Disks

The standard Amiga has an internal disk drive for loading programs and saving data. However, an additional disk drive, which plugs into the rear of the computer, has to be an early purchase since, without one, the boredom of continually switching disks back and forth is enough to cause human error and dampen creative enthusiasm.

One of ZVP VideoStudio's many test patterns. (Photo: Terry Mendoza)

The disks themselves are made by various manufacturers. Top brands, as supplied with the computer, are guaranteed for business purposes but I have always used the cheaper non-branded floppies – as advertized in computer hobby magazines – and found them perfectly acceptable.

A double-sided, double density floppy disk holds ¾ Mb of data. That's not much when you realise that one Hi-Res 16-color picture needs 128K – approximately 1/8th Mb, and even more if overscan is used. And six frames of animation will fill the disk.

If Hi-Res and Interlace are to be used to any degree we must either increase RAM or keep artistic needs modest; limiting artwork to eight colors will double the storage space and a four-color limit will quadruple it.

Alternatively, another piece of hardware called a *hard drive* should

be obtained. It's a self-contained unit, which may feature an extra 1Mb of on-board memory, plus a non-removable hard disk with a capacity of 20Mb or more.

Genlocks

The quality and price of genlocks varies considerably; some cost more than an upmarket camcorder. It is an area where 'third party' add-ons often out perform manufacturer's own brands so a demonstration is a must. Each one, though, is purpose-built for a specific computer so cannot be interchanged between various makes.

Nearly all claim to be 'broadcast' quality but, since this term has no specified or meaningful standard, it should not be taken seriously. Ideally, find a supplier where you can get a sample tape made up, preferably with you in attendance.

25

THE SERIOUS ENTHUSIAST'S SHOPPING LIST

The basic camcorder;

Editing;

Semi-pro

Video magazines often refer to what they call the 'serious' enthusiast. I prefer to use the expression 'keen' enthusiast; the sort of person who loves the hobby but is not fooled by gimmickry and high-tech equipment. The sort of person who works out whether he is more interested in producing worthwhile material, or whether he gets his pleasure from playing with 'toys' for adults.

If, for you, the hobby is about producing a worthwhile movie and its result is more important than the toys, then my advice is to forget all the gimmicky (usually high-priced) gizmos and go for good quality basics.

For example, it is unnecessary to buy a camcorder with various trick functions and a large zoom range if it doesn't have the basics for shooting normal, good quality pictures and sounds.

The basic camcorder

For my requirements, these basics are: hi-band format, 6× zoom, WB presets or manual control, auto exposure with aperture lock, headphone and mike sockets, insert edit, hi-fi plus linear sound with auto-manual control, and auto focus with manual override. To this I would add these accessories: battery belt, skylight filter, 0.6 wide-angle converter, +3 diopter close-up lens, tripod, shotgun and tie-clip mikes, and two mains-power 1kw lights on stands.

Since, for me, the camcorder is merely the tool for gathering raw material, I would not hesitate to buy second-hand, saving my funds for my next purchase which would concentrate on editing gear.

Editing

My priorities here would again be to forget about off-air trick capabilities; I leave that to a very basic lo-band machine almost permanently located by the lounge TV for general family use and time-shifting and viewing.

I would use a corner in the house in which to set up a permanent editing bench upon which would be the following: two compatible hi-band edit-VCRs with jog-shuttles, insert-edit, audio dub, and real-time counters. Both would be capable of being synchro-linked via a cable.

Next would come soundtracking gear, followed by a vision/audio mixer. And only when I have all that would I seek an edit-controller and VITC time-code.

For most of us, buying the equipment we need is an 'as funds permit' process and we might not consider it necessary to buy new equipment because such items as lenses, tripods, filters, microphones, lights, mixers, etc. are virtually risk-free second-hand purchases. Secondly, it is not vital to upgrade from lo-band to hi-band in one go. Start with the camcorder. As long as this part in the chain is hi-band, overall quality must improve.

One point must be mentioned even though it should be obvious: do read all instruction books thoroughly. Obvious it may be but so often our desire to get on with it overrides this basic requirement. For example: some people try to edit without setting the camcorder's or VCRs 'Edit' switch, the one which enables a pure signal uncluttered by enhancement circuitry to come through. Then they wonder why their edited pictures have dark outlines or are slightly fuzzy. So please, read and read carefully!

Remember, too, that only you can decide what you need and when you need it.

Semi-pro

If, though, you get the urge to use your knowledge to earn money from a videomaking business, you will need to think about buying industrial-grade equipment. Inevitably this means higher prices, but what you get is more robust equipment that is designed to cope with full-time usage.

Cameras may still be Hi-8 or S-VHS but will have better, sharper lenses and a 3-CCD chip resolving 500 plus lines.

Edit-decks will not come with off-air tuners but will give full manual control of all functions including color burst, black and white levels, video signal strength, a five or ten-second pre-roll, plus stereo hi-fi and stereo linear audio tracks.

But do think carefully; once you turn your hobby into a business you might lose the enjoyment of this most creative and satisfying hobby.

26

JARGON BUSTER

acoustic background – the background sound environment surrounding a recording.

agc – automatic gain control.

alternating current (AC) – mains electricity.

amplifier – a device which increases the strength/output of a signal.

angle-of-view – the amount of the subject seen through a viewfinder.

aperture – the opening (measured in f-numbers) which controls the amount of light passing through the lens.

assemble-editing – editing method in which shots are recorded sequentially.

attenuating – reducing signal strength.

audio-dub – a feature which allows sound to be re-recorded without disturbing the pictures.

autofocus (AF) – a system built into camcorders which automatically focuses an image.

automatic gain control (agc) – sound – a facility which automatically adjusts sound levels during recording.

autoexposure (AE) – a facility which automatically adjusts iris and/or shutter-speed to maintain exposure.

auto white-balance (awb) – a facility which automatically makes adjustments for lighting conditions to ensure correct colors.

A/V – audio-visual.

background light – an artificial photolamp positioned to lighten the background behind the subject.

backlight – light coming from behind the subject.

backspace edit – when a camcorder or VCR is set to record/pause the tape winds back a little.

barn doors – hinged metal shades or screens fitted to a lamp.

blue gel – a filter used on artificial lamps to bring its color temperature to that of daylight.

boom – a pole used to carry a microphone so it can be suspended out of shot over the sound source.

Cannon connector – a three-connection balanced audio jack.

cardioid microphone – a microphone whose angle of sound acceptance is heart-shaped; more responsive to sounds from its front than from its rear.

character generator – a device which produces electronic 'writing'.

charge-coupled device (CCD) – the silicon chip behind the lens which contains thousands of picture-making pixels (dots).

chrominance – color.

close-up (CU) – a shot which fills the screen with one detail such as a face.

color temperature – a scale in Kelvins (K) which measures the color of light.

composite signal – the complete video picture signal containing chroma, luminance, and vertical and horizontal sync. information, but not sound.

continuity – maintaining details such as lighting, clothing, props, sound and movements from shot to shot in a particular scene.

contrast – the difference in brightness between the brightest highlight and darkest shadow.

control-track – pulses, one per frame, along the edge of a tape which helps the camcorder or VCR maintain a consistent speed.

crane shot – vertical tracking shot during which the camera is raised or lowered.

cue – an audio or visual start mark.

cut-away – a shot which is not an integral part of the main action but is related to it.

crossing the line – the line is an imaginary one through the direction of the subject's movement. Filming must be made from one side of the line if continuity of movement is to be maintained.

direct current (DC) – the electrical current from batteries or transformers.

decibel (dB) – a logarithmic measure of loudness.

depth of field – the distance in front and behind the subject which is in acceptable focus.

diaphragm – the device in a lens which allows the aperture size to be made smaller or larger.

diffraction lens – a lens or filter which produces rainbow-colored beams of light.

digital circuitry – a method of converting electrical signals into computer-style numbers.

diopter – a measurement of lens magnifying power.

dissolve – mixing two images where one fading away is replaced by another fading in.

Dolby – an audio noise reduction system.

dolly – a wheeled platform upon which a camera is mounted.

drop-out – momentary loss of sound or white specks on vision caused by flaws or wear in the tape.

dubbing – copying/mixing sound and/or pictures on to another tape.

Dynamic range – (a) the difference (in dBs) between the quietest and loudest sounds being 'played' or recorded.
(b) the difference between the lightest and darkest colors.

edit-in – the point selected during editing to be the start of a shot.

edit-out – the point selected as the end of the shot.

edit-master – the second-generation tape resulting from the editing process.

enhancer – a piece of hardware for electronically improving or altering a video image.

ENG – electronic news gathering.

equalization – process of altering or filtering sound frequencies.

erase head – an electronic device which erases a previously recorded signal.

establishing shot – usually a long-shot which establishes the geography of the location.

exposure – exposing the CCD chip to the correct amount of light controlled by the aperture and shutter speed. If the picture is too light it is overexposed; too dark and it's underexposed.

exposure lock – device which locks the exposure to a fixed setting.

eyeline – the direction in which the subject is looking.

fade out – an effect in which images turn from normal color to black or white. Fading in is the opposite.

field – half the horizontal lines needed to make a complete TV image.

filler – a light used to relieve shadows created by the key or principal light.

filter – glass, gel, or plastic disk which fits over a lens to create special optical effects.

fisheye lens – extreme wide-angle lens which produces a circular image.

flutter – unsteadiness in tape speed which causes sound to 'gurgle.'

f-number – a measurement of the lens aperture; the smaller the number the bigger the aperture. (Also known as f-stop.)

focal length – the distance, measured in millimeters, between the optical center of a lens and the CCD chip when a distant subject is in focus.

focusing – adjusting the distance between the lens and CCD chip until it produces a sharp image.

foot-candle – the amount of light falling on one square foot from a distance one foot away.

frame – one complete TV picture made up of two fields of horizontal scanning lines.

frame advance – a feature on camcorders and VCRs which allows a shot to be analyzed a frame at a time.

frequency – a wave-shaped measure of sound (Hertz). A low measure indicates a low-pitched tone.

frequency response – the range of frequencies recordable by a recording system.

full modulation – when the signal being recorded is at its optimum level, such as when the loudest sound pushes a VU meter's needle to reach zero and no higher. Also known as nought (0) VU.

gain – the amount of amplification: when one volt is amplified to five volts the gain is said to be five times.

genlock – a device which synchronizes one or more recording systems to the signal of another.

glitch – a visual disturbance between joined shots: bars of 'snow,' wobbling or shaky picture, etc.

graduated filter – a filter which is tinted at the top and gradually diffuses to clear.

head – the electronic part of a camcorder or VCR which 'writes' or 'reads' the magnetic field on a tape. Recording heads 'write' the field, playback heads 'read' them.

helical scan – the system by which a rotating head records slightly diagonal tracks along the tape.

hertz (Hz) – the frequency per second of an electrical signal's waveform.

hi-fi – high fidelity sound.

horizontal resolution – the number of vertical lines on a test chart clearly resolved by the horizontal scanning lines.

horizontal sync. – the pulses that control the line-by-line synchronization of the scanning lines.

impedance – the electrical resistance of a system measured in ohms. The impedance of microphones, auxiliary equipment and loudspeakers must be matched if they are to operate correctly.

infra-red – light rays that are beyond the spectrum visible to the human eye.

incident light – light that falls on a subject (as opposed to the amount of light the subject reflects).

insert-edit – a facility on camcorders or VCRs which allows the replacement of one video image by another.

inverse square law – lighting law which states that light intensity is inversely proportional to the square of the distance from the light source.

iris – the aperture-controlling diaphragm.

jog shuttle – a dial that controls the tape speed from slow to fast (shuttles) and frame by frame (jog) in a backwards or forwards direction.

jump cut – a cut or edited shot in which part of the action has been omitted, causing the subject to appear to jump from one part of the shot to another.

kelvin (K) – a unit of the measurement of color temperature.

key light – the principal light.

kilohertz (kHZ) – 1000 hertz.

lap dissolve – see dissolve.

LED – light emitting diode, a miniature electronic light 'bulb.'

lens – one or more pieces of curved glass or optical plastic arranged to bend light coming into the camera and form an image.

linear sound – a sound recorded by a fixed head along the edge of the tape.

line input – a socket on most VCRs and some camcorders which accepts vision or sound signals from an auxiliary source.

long-shot (LS) – a shot that includes the overall scene.

low angle – a shot where the camera is placed low down but pointing upwards.

lumen – a unit of luminous flux.

lux – one lumen per square meter. One foot-candle = 10.76 lux.

macro – high magnification extreme close-up photography.

magnetic sound – the system whereby a magnetic head converts electrical signals to the tracks on a tape coated with a magnetic surface. The playback head reverses the situation by converting the 'written track to sound.

master-shot – a shot which encompasses the entire action in a scene from one position. Other shots taken from different angles are cut in during editing.

microphone – a device that converts sound into electrical energy.

mid-shot – closer to the subject than a long-shot, it draws attention to a particular scene within the established location.

mixer – a device which may combine several video and/or audio sources.

multi-track – a recording system in which four, eight or sixteen tracks may be recorded separately or simultaneously, then mixed and balanced to produce the final track.

neutral density filter – reduces the brightness of a scene being recorded by a camcorder.

NiCad – nickel cadmium batteries which may be rechargeable.

'noise' – electronic interference to an audio or video signal caused by the inherent limitations of equipment.

NTSC – National Television Systems Committee; used to describe the 525-line TV/video system commonly used in the USA and Japan.

omnidirectional microphone – a microphone which records and responds equally to sounds in all directions.

overexposure – too much light entering camera, causing picture to be too light or 'washed' out.

oxide – the magnetic particles or coating on some tapes.

PAL – Phase Alteration Line. Other than in France, it is the European standard 625-line TV color system.

pan – to rotate the camcorder horizontally to provide a 'panoramic' view.

pan head – the rotating part of a tripod which supports the camcorder allowing it to be panned or tilted.

parallel action – where two sequences are intercut so that the audience knows that the two are taking place simultaneously.

perspective – a sense of three dimensions in a two-dimensional image.

photoflood – photographic screw-thread light bulb producing a color temperature between 3,200–3,400K.

pixel – a picture element; the smallest unit of a screen or video picture, and that of a CCD chip.

pre-roll – the process whereby the record-VCR and playback-VCR run in sync. from the 'paused' position before making an edit.

radio-microphone – portable transmitter linked to a microphone which transmits to a receiver linked to a recording device.

reaction shot – a shot which shows the reaction or response of someone or something to the preceding action.

resolution – the extent to which fine detail can be seen in the image.

RF – radio frequency which may carry the complete video and audio information.

RGB – (a) Red Green Blue; or (b) a connector for some video equipment.

rule of thirds – the rule of basic composition which states that vertical and horizontal lines should split the picture in thirds not halves.

saturation – the intensity of colors.

Scart plug/socket – a 21-pin audio/video connector used in Europe.

Secam – French and Russian TV color system.

sequence – a series of shots linked to provide a theme, narrative or scene.

set – the area, whether real or fake, in which the action takes place.

shooting script – list of shots in the order of shooting.

shotgun microphone – a highly directional microphone that rejects most sounds from its rear.

signal – once sound has 'passed' through a mike or line-input, or light through the CCD, it is converted to electrical energy known as the signal.

signal-to-noise ratio – a ratio between the recordable signal and the equipment's inherent electronic noise. The higher the figure the better.

slave – when one or more machines (player or recorder) are controlled by a master-machine, such as an edit-controller, they are said to be slaves to that master.

S-terminal – a connector which keeps hi-band chrominance and luminance signals separated for improved picture quality.

starburst filter – an optical filter which converts points of light into star shapes.

stop – any of the range of f-numbered aperture settings.

storyboard – a series of 'cartoon-style' sketches of the shots to be used.

subjective track – a tracking shot which shows the point of view of the subject.

synchro-edit – a means by which two pieces of editing equipment are linked to enable signals to synchronize.

telephoto a long focal length lens or shot.

tilt – a vertical pan.

timebase corrector – a device that corrects a video signal slippage through tape-stretch, etc. when dubbing or transmitting.

time-code (a) Vertical Integrated Time-code (VITC): a system of recording electronic information, while shooting, in the unused video lines between frames that identifies each frame with a series of eight-digit, consecutive address numbers such as 07:49:32:17 representing hours, minutes, seconds and frames. When played back in 'slo-mo' or paused on a VCR or edit-controller with 'reading' circuitry, they can be seen on a monitor; (b) rewritable consumer time-code (RCTC) is similar to VITC but can be added to after shooting, and (c) Longitudinal Time-code (LTC) is recorded on a tape's linear soundtrack which then cannot be used for other sound.

tracking – physically moving the camera to keep the subject in frame.

TTL – through the lens.

tungsten light – a yellowish light as distinct from normal household 'bulbs.'

two-shot – a shot which shows two people as in an interview.

UHF – ultra high frequency.

uni-directional microphone – this records sounds mainly from one direction.

underexposure – darkened image caused by allowing insufficient light to enter the lens.

VU (volume unit) meter – this measures the loudness of sound in decibels. When a sound is fully modulated the meter needle reads 0 (zero). Too loud, and the meter goes 'into the red'.

wipe – can be horizontal or vertical effect where one picture 'wipes' or replaces another.

zoom lens – a lens of variable focal length.

27

INDEX